The Australian Geographic Book

The Great Barrier Reef

Text and photography by Mike McCoy

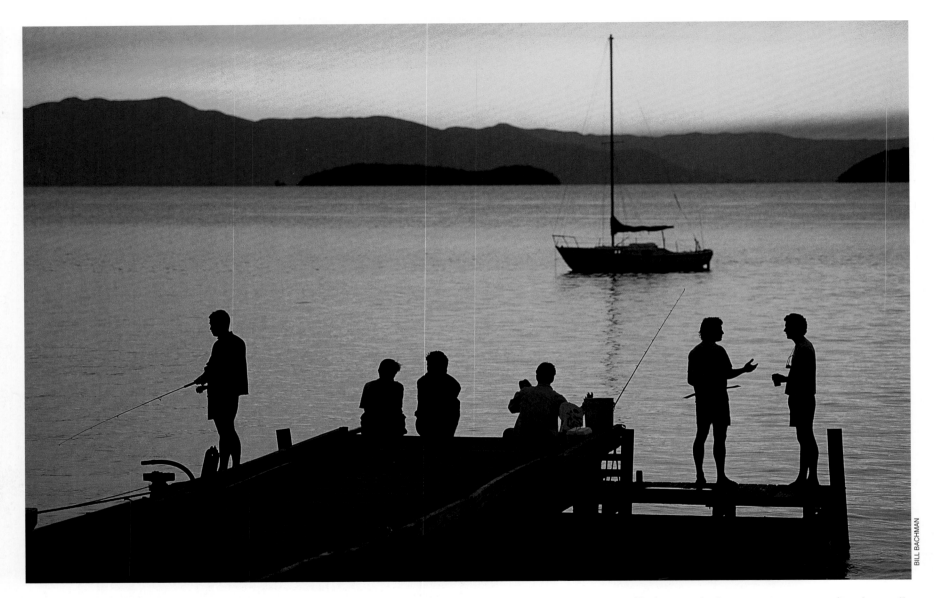

The Great Barrier Reef (GBR) is a placename that brings to mind a range of images, from coral cays and wilderness islands topside, to a world waiting to be explored underwater. Whether you're dangling a line from Hinchinbrook Island jetty at sunset (above) or coming face-to-face with a school of big-eyed trevally (opposite), the Great Barrier Reef is above all a unique community of animals and plants that has, until recently, been spared the impact of human attention.

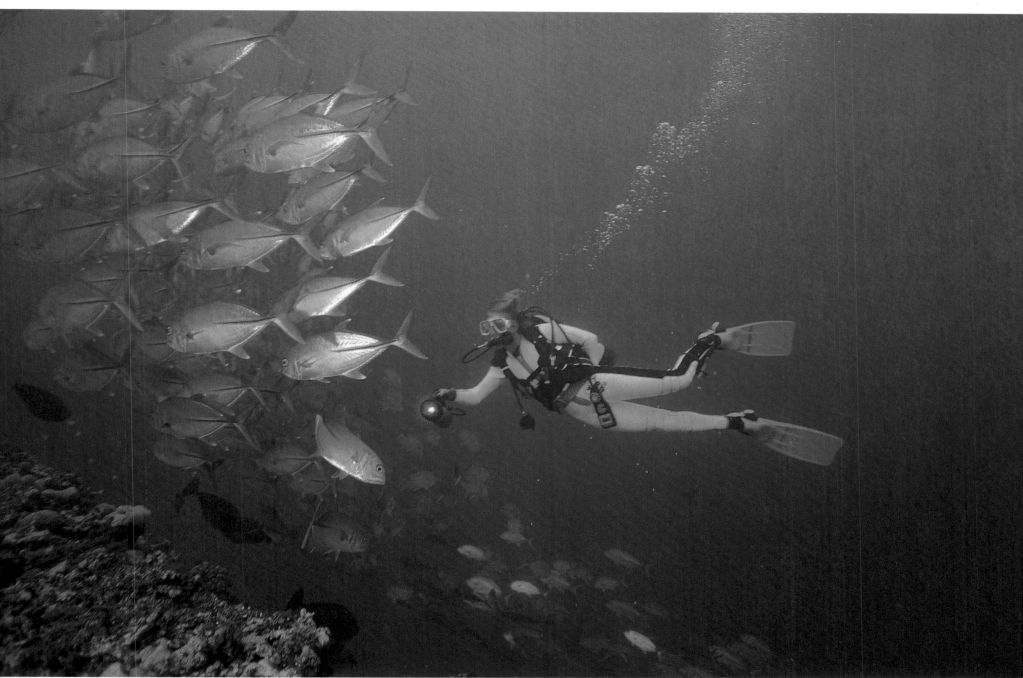

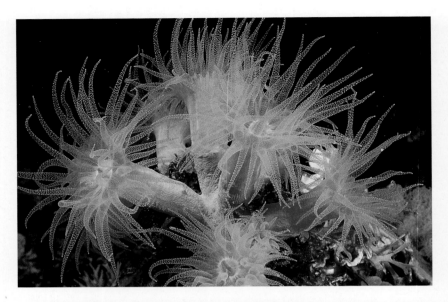

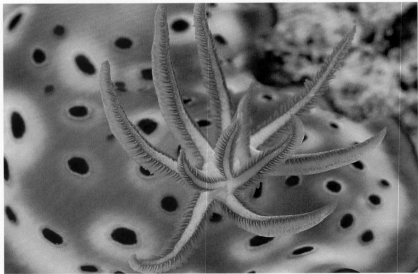

*The GBR is a world of exquisite miniatures – such as the golden polyps
of a tube coral (top) or the gills of a gaudy nudibranch (above). It is
also a vast world, where fragile offshore cays such as Heron Island
are mere specks in the immensity of the surrounding seas (right).*

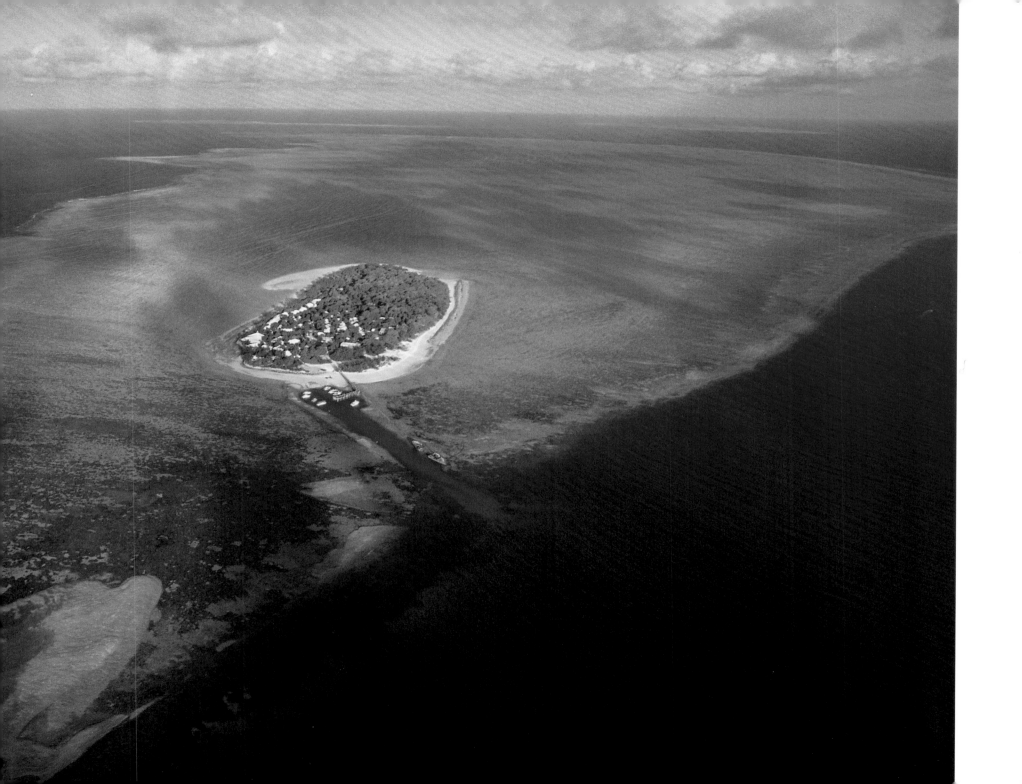

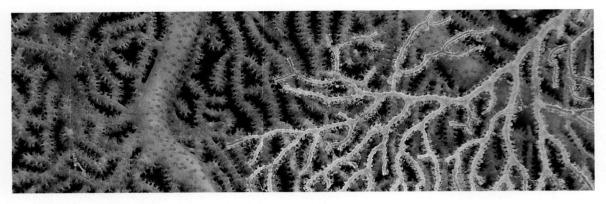

First published 1999 by Australian Geographic Pty Ltd
PO Box 321, Terrey Hills NSW 2084, Australia
Phone: 02 9450 2344, fax 02 9450 2990
email: books@ausgeo.com.au

Managing Director: Paul Gregory
Publisher: Howard Whelan
Production/Creative Director: Tony Gordon
Managing Editor, Books: Averil Moffat
Editor: Kerry Davies
Design and Photographic Edit: John Witzig
Production Manager: Jozica Crncec
Picture Research: Chrissie Goldrick
Cartographer: Yvette Gnauck
Proofreading: Frank Povah
Editorial Assistant: Sandy Richardson

Printed in Australia by InPrint Limited

Acknowledgements
For their assistance with this book, Australian Geographic
thanks Dr Gregg Brunskill, Dr Kathy Burns, Dr Peter
Doherty, Peter Isdale, Australian Institute of Marine Sciences
(AIMS); Dr Bill Rudman, Roger Springthorpe, Australian
Museum; Ian Connellan; Shane McNally, Shelly Parer,
Dunk Island Resort; Rick Braley; Linda Craig, Sam Dibella,
Environmental Protection Agency; Robin Aiello, Great
Adventures; Dr David Goodie; Leon Jackson, Richard
Kenchington, Craig Sambell, Great Barrier Reef Marine Park
Authority (GBRMPA); Russell Watson, Great! Keppel Island
Resort; Dr Ian Whittington, Heron Island Research Station;
Martin Perkins, Heron Island Resort; Patricia Parsans,
Hinchinbrook Island; Howard Choat, Dr Peter Corkeron,
Dr Helene Marsh, Jamie Seymour, Peter Veth, James Cook
University; Gill Cook, Kangaroo Explorer; Steve Heath,
Lady Elliot Island Resort; Anne Hoggett, Lizard Island
Research Station; David Lloyd; Wayne Hodgson, Monash
University; Dr Peter Arnold, Museum of Tropical Queensland;
Tim Stranks, Museum Victoria; Michael Guinea, Northern
Territory University; Russell Cumming, Queensland
Herbarium; Jon Elcock, Queensland Maritime Museum Assn;
John Hooper, Jeff Johnson, Sue List-Armitage, Queensland
Museum; Brendan Malone, QPWS; Max Shepherd, Quicksilver
Connections; Martin Jones, Reef HQ; Roy Sonnenburg;
Walter Starck; Warren Mahon, Sunlover Cruises; Dion Eades,
Tourism Tropical North Queensland; Jodie Mott, Tourism
Whitsundays; Dr Bruce Livett, University of Melbourne;
Mark Hamann, University of Queensland.

Special thanks to Tony Walsh and Dominique White,
Queensland Tourism; Dr John Veron, AIMS; John Camplin,
GBRMPA.

National Library of Australia Cataloguing-in-Publication Data:

McCoy, Michael
 The Australian Geographic Book of the Great Barrier Reef.

 Includes index.
 ISBN 1 876276 28 2.

 1. Great Barrier Reef (Qld.) – Guidebooks. 2. Great Barrier
Reef (Qld.) – Description and travel. 3. Great Barrier Reef
(Qld.) – History. I. Australian Geographic. II. Title.

919.43

Cover: Floatplane landing at Hardy Reef, Whitsundays
Inset: Royal dottyback and sea fan
Back cover: Diver and long-nosed emperor
Title page: Yachts off Watsons Bay, Lizard Island
This page: Sea fan (detail)
Opposite: Snorkelling in the Brook Islands
Contents pages: Panorama of Hardy Reef, Whitsundays

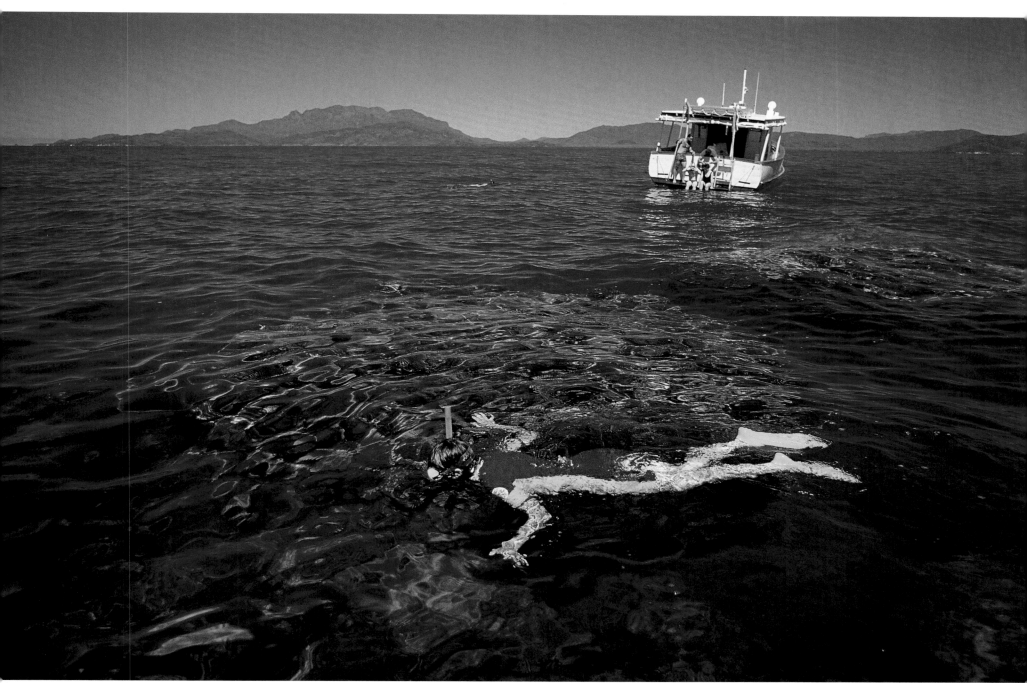

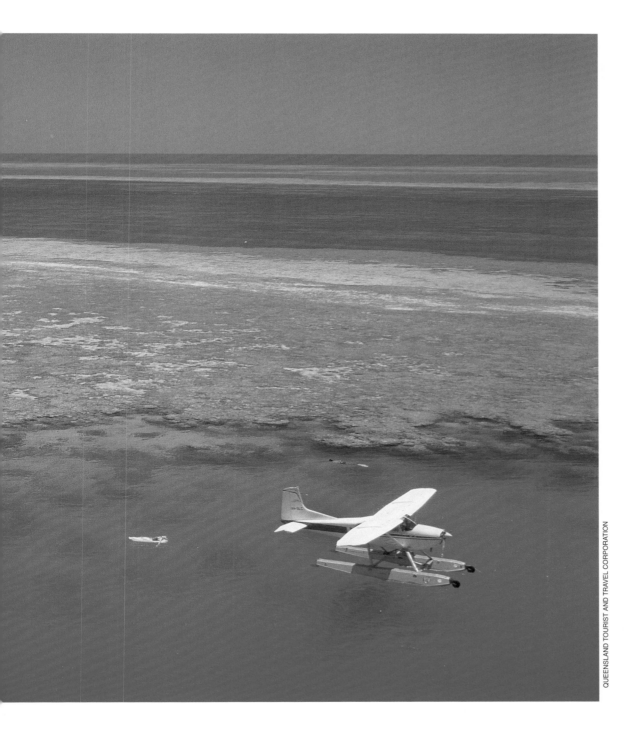

QUEENSLAND TOURIST AND TRAVEL CORPORATION

Contents

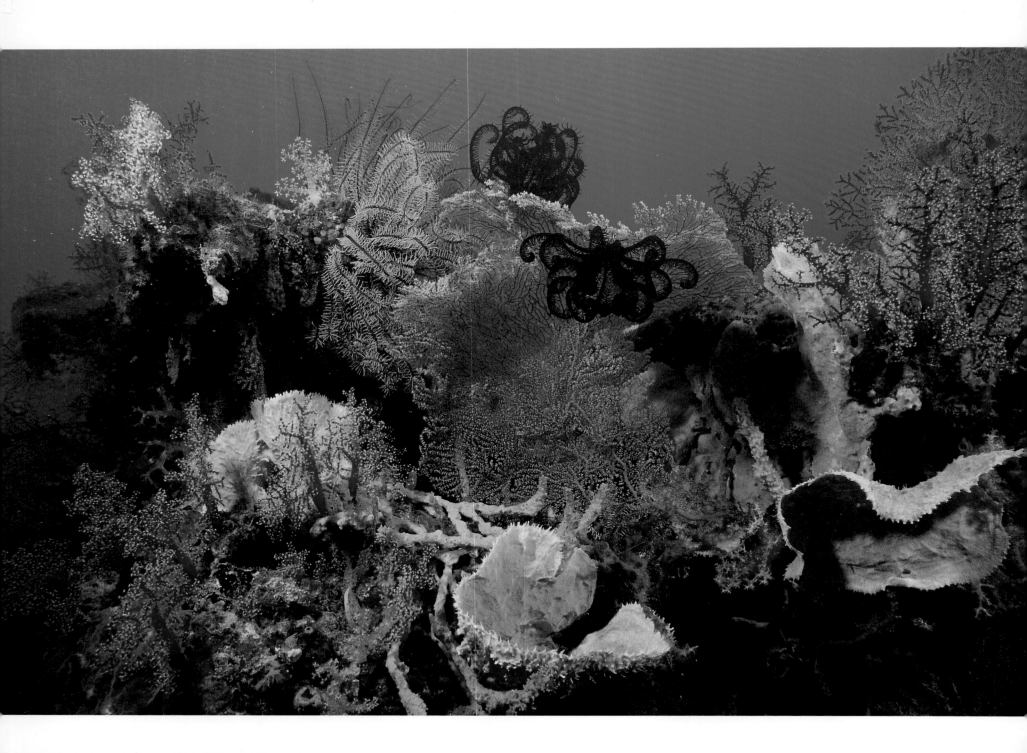

In the 1940s the late Professor Dakin, zoologist, had been asked by the editor of *Walkabout* – the AUSTRALIAN GEOGRAPHIC of the day – to contribute a series of articles on the Great Barrier Reef. He needed more photographs and information so in 1946, as his research assistant, I joined a group organised by the Australian Museum in Sydney to visit Hayman Island and Lindeman Island in the Whitsundays – continental islands with fringing coral reefs.

Oh that it were possible for the people of today to see those islands as they were then!

In 1950 in a battered old motor launch, I made my first visit to a "true" coral island, a coral cay with its encircling reef – and the world was well lost.

Many visits later and more than 50 years on – cyclones, helicopters, fast catamarans and tourists have not robbed that magic reef of its enchantment for me.

No visitor to the Great Barrier Reef can appreciate to the full the incomparable beauty of the coral reefs and their surrounding seas without some knowledge of their vast extent and the complexity and interaction of their living builders. This Australian Geographic guide will give you that, and its format is such that you could fit it easily into any luggage.

The chapters range the length and breadth of the region, covering aspects from the number, formation and type of reefs to the builders, the living, delicate polyps which construct them, and the vast array of incredibly curious, exotic and beautiful animals and plants that live among them. Geological history, early navigation and Aboriginal habitation are included too.

PETER AITCHISON

Isobel Bennett has contributed widely to our understanding of temperate seashores, intertidal zones and the Great Barrier Reef itself. Through her lifetime of study, and her books, others can share her enthusiasm for the wonders of marine life. In the garden-like tableau opposite, every life form is an animal, not a plant.

With its descriptions of various reefs and islands, this guide will help intending visitors decide where to go, how to get there, the best time of year to choose and the best diving and snorkelling spots.

Take heart, those who neither swim nor dive, there is still very much to be seen and admired by merely wading across the reef. My many hundreds of slides, some quite beautiful, were all taken on reef flats exposed at low tide.

For those who may never have the opportunity to visit the Great Barrier Reef, this book, with its many superb colour photographs, paints a broad picture of the region and some of the multitude of living forms.

Appreciating this unique part of our country helps Australians understand the need for the reef's protection. It was only dawning awareness and public campaigning which led to the establishment of the great Barrier Reef Marine Park Authority in 1975.

Coral reefs today, everywhere, are under immense stress both natural and man-made – from cyclones, tornadoes, natural predation, the fishing industry and ever-increasing tourism.

Recent investigation has revealed a new and devastating event – coral bleaching – which has been occurring on coral reefs worldwide over the last decade or so. Reef scientists believe that increasing global sea temperature and lower salinity may have caused the corals to expel their important life source, their symbiotic algae.

Take this book and enjoy the reef today, valuing its beauty and respecting its fragility.

Isobel Bennett

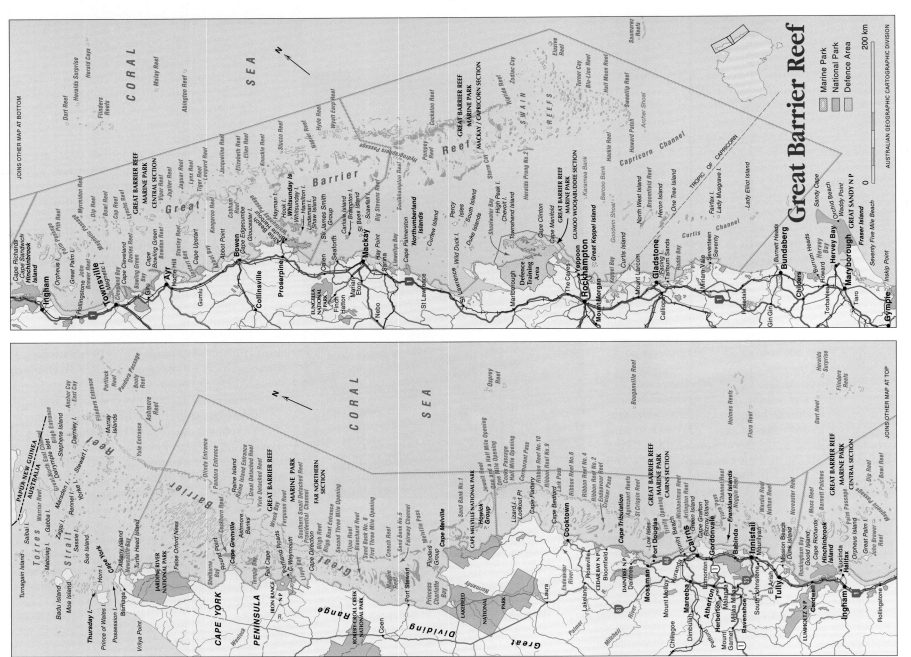

Great Barrier Reef

Marine Park
National Park
Defence Area

200 km

AUSTRALIAN GEOGRAPHIC CARTOGRAPHIC DIVISION

Introduction

Mike McCoy

In the summer of 1960, when I was 12 years old, I went for my first scuba dive. A group of us had gone to the harbour swimming enclosure at Manly, in Sydney, with our scoutmaster and his single set of equipment. I remember the brevity of the "safety" instructions: "Breathe normally and don't hold your breath when you come up." I was the first to go down, after being told to surface in five minutes so someone else could have a go. It must have been half an hour later that I came up – the small air tank was almost empty – and I caught hell from the scoutmaster and the other kids. But I didn't care, I was high on the pure exhilaration of being able to *breathe* underwater and take a good look at things: rocks and weeds, and the occasional silvery fish flitting in and out of my field of view.

I was hooked. I devoured books depicting underwater life, revelled in television episodes of *Sea Hunt* and longed to dive on the Great Barrier Reef (GBR). In 1966 I got my wish. With only a facemask I swam over fields of living corals off Green Island, near Cairns. Coral reefs have, one way or another, played a major role in my life ever since.

In 1969 I went to live in the Solomon Islands, in the tropical South Pacific, and stayed there for 26 years. Scuba diving became, quite literally, a way of life. I spent four years on a marine research vessel, completed various underwater photographic assignments in the Solomons and the Philippines for the National Geographic Society, and undertook consultancies for Australian, US and European television productions and Australian and US academic institutions.

It was with real pleasure then, that I anticipated renewing my acquaintance with the Great Barrier Reef when Australian Geographic offered me the job of producing this book. Innocently, I wasn't overly daunted by the task. I'd recently moved to Kuranda, just north of Cairns, had all the necessary equipment, diving experience and a pretty good idea of what Australian Geographic expected from me. What I didn't allow for was the sheer magnitude of the reef, its all-too-fickle mood swings in the form of wind and waves, and coping with these weather changes while doing my best to keep one step ahead of deadlines. But, many dives, many rolls of film and several thousand kilometres later, it all came together.

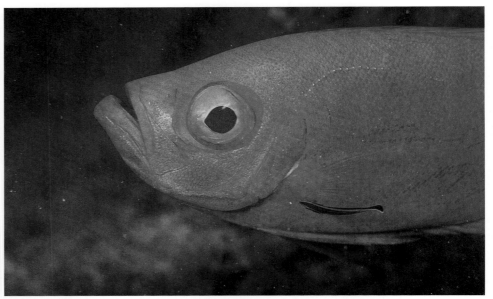

However, despite the combined efforts of the many talented people who were instrumental in creating this book – artists, cartographers, designers and editors – it can only ever claim to provide a brief, though I hope intriguing and stimulating, insight into one of our country's most enduring and renowned natural treasures. For the definitive book of the GBR can never be written. This becomes obvious when you consider that the Great Barrier Reef Marine Park Authority (GBRMPA) describes this World Heritage area as "the world's largest coral reef system, and therefore the world's largest living structure".

The GBR stretches for more than 2000 kilometres along Australia's north-east coast. Its waters, embroidered with 2900 reefs and almost 1000 islands, are home to 400 coral species, over 1500 fish species, more than 200 types of bird, about 4000 mollusc species and 500 different seaweeds. Six turtle species breed in the region, which also hosts 22 different kinds of whale. Add to this another imponderable: the millions, if not billions, of daily interactions between the myriad life forms and their environments on the reef. For the fact is that, with increasing technology and expertise, we are only beginning to understand how *little* we know about the GBR. I hope this situation will persist for a very long time to come, for in this way we will continue to be awed by its magic.

I believe that an understanding of the reef's natural history can go a long way towards a greater appreciation of it, and to this end the first part of the book is dedicated to the reef as a natural wonder. It describes the formation and development of

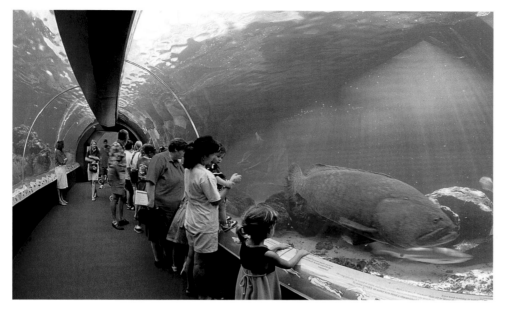

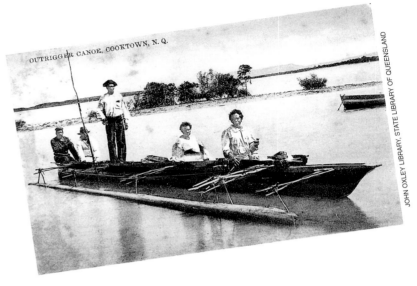

the various reef structures and reveals how the GBR's teeming life forms survive and thrive in a complex natural jigsaw. It also chronicles humankind's relationship with the region, from times of Aboriginal stewardship to the present, when conservation is a prime consideration in reef management.

The book's second half will satisfy the many readers who are considering a reef holiday: it's primarily an account of my GBR explorations from 1997 to 1999. About 2 million people visit the reef each year, and this section answers some questions about where one might travel and what one might see and do. But I stress that it is only an overview of the destinations and experiences that the reef region offers. Most libraries, travel organisations and airlines have GBR literature or information in abundance. For those readers who have access, the Internet is also a great source of detailed information. For this reason we have included travel information and relevant websites (pp. 110, 140, 157), although I emphasise that these lists are not exhaustive.

Finally, as I write this I read that the Great Barrier Reef Marine Park has been extended by more than an additional 6000 sq. km. This is welcome news. For many years the GBR was either ignored or viewed as ripe for exploitation. Its recognition as a magnificent natural wilderness worth preserving has largely come in recent years through public pressure backed up by the ongoing research of dedicated scientists.

The Great Barrier Reef belongs to us all, and the survival of its astonishingly diverse ecosystems, and its wild beauty, are the responsibility of us all.

A day in the life of the Great Barrier Reef – off a Frankland Islands beach, tour guide Hiroe Aoki finds a common spider conch (opposite left), while a nocturnal big-eye is groomed by a cleanerfish in a coral cave at Lizard Island, (opposite right). Further south, in Townsville, "Dominator", the resident giant groper, enthrals visitors to the predator display at Reef HQ (above left). Dominator was captured in a saltwater creek adjacent to the aquarium. And a glimpse of times past – this photograph of Aboriginal people in a dugout canoe with outrigger (above) was taken in the Cooktown area, possibly in the Endeavour River, about 1906. The use of the outrigger reflects the contact northern coastal Aboriginals had with Torres Strait and Papuan peoples.

Acknowledgements

This book has become a reality due largely to the generosity of many individuals and organisations who freely and enthusiastically made their time, expertise and services available.

First, I would like to thank the major supporters. Queensland Tourism took care of all the necessary travel and accommodation, often at very short notice, but nonetheless with great efficiency; thanks especially to Tony Walsh and Dominique White. Quicksilver Connections and Quicksilver Dive provided numerous trips to, and dives at, their Agincourt Reef pontoons, where a major part of the underwater photography for this book was undertaken; thanks to Mike Burgess, Kerry Eckersley, Megan Bell, Sue Thompson, Linda Fawcett and Matt Masters. Kevin Smith of Kangaroo Explorer Cruises very kindly contributed with a voyage from Cairns to Thursday Island on *Kangaroo Explorer*, allowing coverage of a section of the reef that would not otherwise have been possible.

Additionally, I would like to express my sincere gratitude to the following people, listed in rough geographic order from south to north: Roger Springthorpe, Australian Museum, Sydney; Liz Mason, P&O Australia Resorts, Sydney; Mark Hamann, The University of Queensland; Sharon Prater, Peter Matthews and Linda Behrendorff, Lady Elliot Island Reef Resort; Tracey and Gary Williams and Owen Duggan, Heron Island Resort; John Barker, Marine Helicopters, Gladstone; Russell Watson, Great! Keppel Island Resort; Jon Davies, Air Whitsunday, Airlie Beach; Adrian and Suzette Pelt, Queensland Yacht Charters, Airlie Beach; David Hutchen, Fantasea Cruises, Airlie Beach; Wendy Trigg, Whitsundays Tourism, Airlie Beach; Artie Jacobson and

Meredith Hall, Queensland Parks and Wildlife Service (QPWS), Airlie Beach; Dr Gregg Brunskill, Dr Kathy Burns, Dr Peter Doherty,

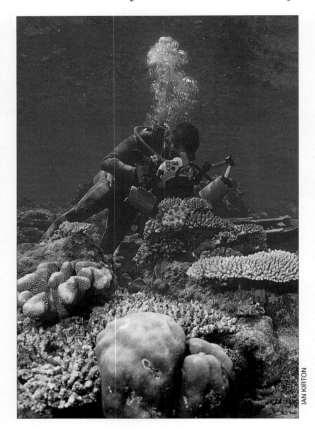

It definitely beats working for a living: Mike McCoy photographing on a coral reef (above). From the lookout on the Cardwell Range, the majestic peaks and gullies of Hinchinbrook Island in the late afternoon light (opposite).

IAN KIRTON

Dr Janice Lough, Dr John Veron and Dr Eric Wolanski, Australian Institute of Marine Science, Cape Ferguson; Dr Rick and Mrs Nell Braley, Magnetic Island; Dr Walter and Meredith Starck, Townsville; Peter and Jacinta Mollross, Townsville; Dr Martin Jones, Loretta Saunders and Belinda Kilcullen, Reef HQ, Townsville; Kayleen Allen, Townsville Enterprise; Professor Howard Choat and Associate Professor Peter Veth, James Cook University, Townsville; Russell Cumming, Queensland Herbarium, Townsville; Susan Noonan and Shelly Parer, Dunk Island Resort; Julie Bailey, QPWS, Cardwell; Roger Steene, Cairns; Captain Gill Cook, Cairns; Sheridan Catt, Sunlover Cruises, Cairns; Paula Wallace, Big Cat Green Island Cruises, Cairns; Paul Summers, Franklands Cruise & Dive, Cairns; Bob Pagget, Heli-Adventures, Cairns; Ian Button, Sunlover Helicopters, Cairns; Linda Craig, QPWS, Cairns; Kirsty Christison, Cape York Land Council; Douglas Baird and Shawn Depper, Reef Biosearch, Port Douglas; Dr Anne Hoggett and Dr Lyle Vail, Lizard Island Research Station.

Particular thanks to the Great Barrier Reef Marine Park Authority and the Queensland Parks and Wildlife Service.

Grateful thanks to people who provided invaluable assistance with photography above and below water: Ted Berry, Ian Kirton, Annie McCoy, Roger Springthorpe, Steve Walker and Murray Wellington.

Lastly, I am very grateful to the numerous people and organisations who kindly provided the additional credited photographs in this book.

Mike McCoy

BILL BACHMAN

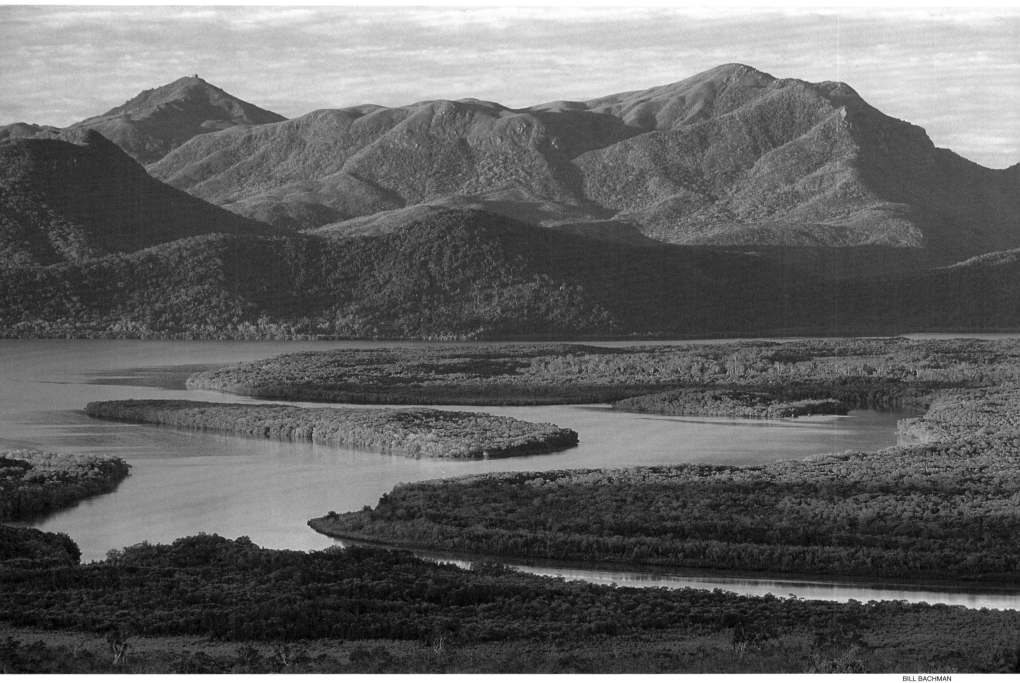

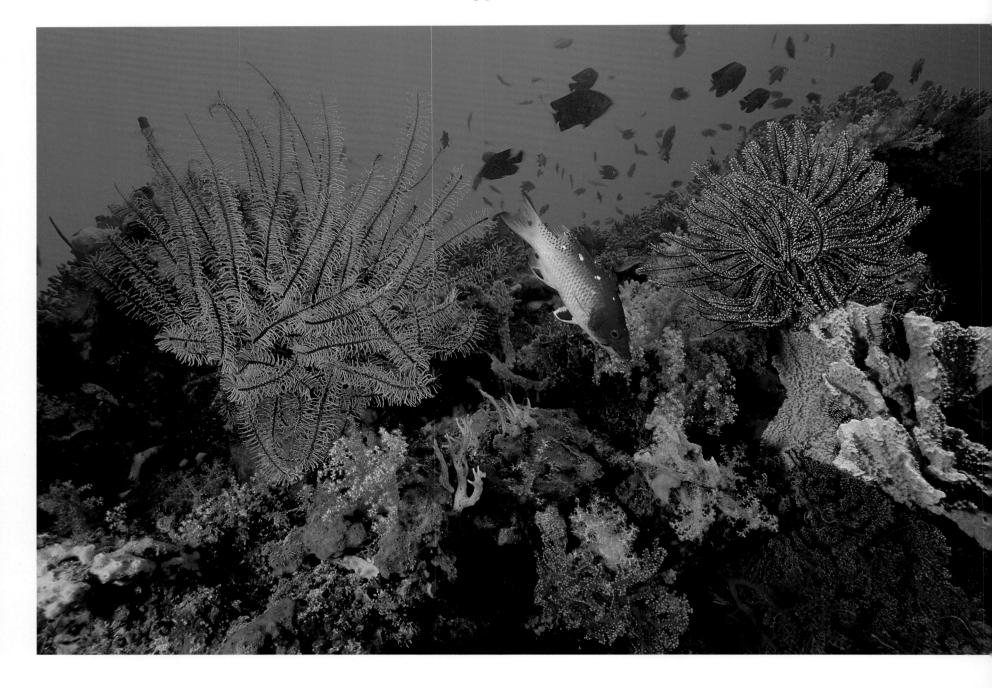

The living reef

Origins and biological systems of the Great Barrier Reef

The Great Barrier Reef is the sum of its parts and, while comparatively young in its present form, is the culmination of millions of years of evolution of its many biological components. It is the largest coral reef system in the world, and one of the least affected by human influence. A Diana's hogfish (opposite) is framed by a pair of feather stars on a pristine fringing reef.

The Great Barrier Reef as we know it today is about 8000 years old; a mere heartbeat in the aeons of geological time. This age reflects a period during which the sea level has remained more or less constant. However, we could also claim a much greater age for the GBR, for its origins go back to a time when sea-floor spreading caused Australia to separate from the great southern landmass of Gondwana.

For 160 million years we've been drifting northwards. By 25 million years ago the north-eastern continental shelf of Australia had reached the warm seas of the tropics, waters already rich in coral growth. In these shallow, sunlit seas the first coral colonies of what would become the GBR began to form. With the continuing movement northwards, more of the continental shelf was washed by warmer waters and so the reefs spread south. This is why the GBR's oldest parts are in the north and its youngest in the south.

Over the past 2 million years there have been extended periods of cooling and subsequent warming in Earth's climate; a phenomenon that continues today (we're currently living in a warm interglacial period). At the peak of the most recent ice age, around 18,000 years ago, almost a third of Earth's water was frozen in polar icecaps and consequently the sea levels on the Australian continental shelf were as much as 120 metres lower than today's. Around 10,000 years ago the polar ice began to melt and gradually flooded Earth's low-lying regions. Along Australia's north-eastern coast, segments of the mainland became isolated by these rising seas, giving birth to the so-called high, or continental, islands, such as the Lizard Island group, Hinchinbrook and the Whitsundays.

While sea levels rose and fell on the GBR during this period of climatic change, coral growth responded accordingly. As the seas rose, the reefs grew. With falling sea levels, the corals died off on exposure to the atmosphere and over time their calcium skeletons became chemically transformed into limestone. This limestone was slowly eroded by rain and wind, and formed terraces that in many cases provided the foundation for new coral growth at the next rise in sea level.

"If you went back in time you wouldn't see coral reefs as we see them now," Dr John "Charlie" Veron, a recognised world authority on reef-building corals, told me. "You'd see isolated

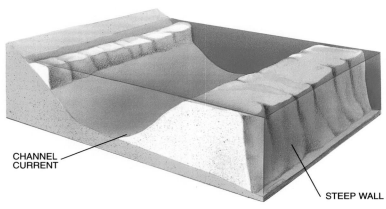

Barrier reef

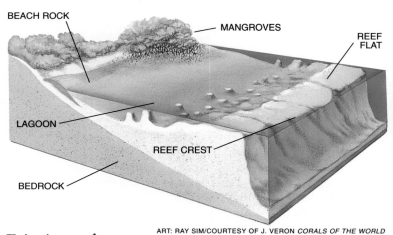

ART: RAY SIM/COURTESY OF J. VERON *CORALS OF THE WORLD*

Fringing reef

The two main forms of reef on the GBR are barrier reef and fringing reef. Barrier reefs form on the edge of the continental shelf and have a distinctive shape. The side facing the open ocean is usually steep while the leeward side slopes gently. A strong current often flows between the reef and the mainland. Fringing reefs form along the shoreline of the mainland or an island. Rising sea levels may form a lagoon between the shore and the reef.

coral communities in what is now deep water. So what we see as the Great Barrier Reef today is really only the living veneer of a much older structure."

I met Charlie when I visited the headquarters of the Australian Institute of Marine Science (AIMS) near Townsville. Chief scientist at AIMS, Charlie is an affable, quietly spoken man of imposing intellect. He explained that the GBR's huge reef platforms are really very unusual – an aberration – and their formation reflects the long period of constant sea level.

Living corals may be the dominant feature of a reef, but it's only a part of a much more complex physical structure. While the coral provides the framework for the reef, other organisms hold it all together. Many molluscs have a calcium carbonate shell, and creatures such as soft corals, starfish and sea cucumbers have calcium structures in their body tissues that help them to maintain rigidity. Likewise, many of the marine algae and seaweeds have calcium-carbonate-rich tissues. Sponges and diatoms have structural tissues made of silica. When these organisms die, their remains accumulate in sediments and are carried by waves or currents into the gaps between the coral where the calcium carbonate binds and cements the overall reef structure.

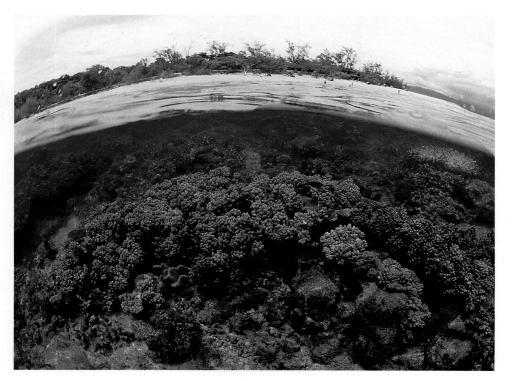

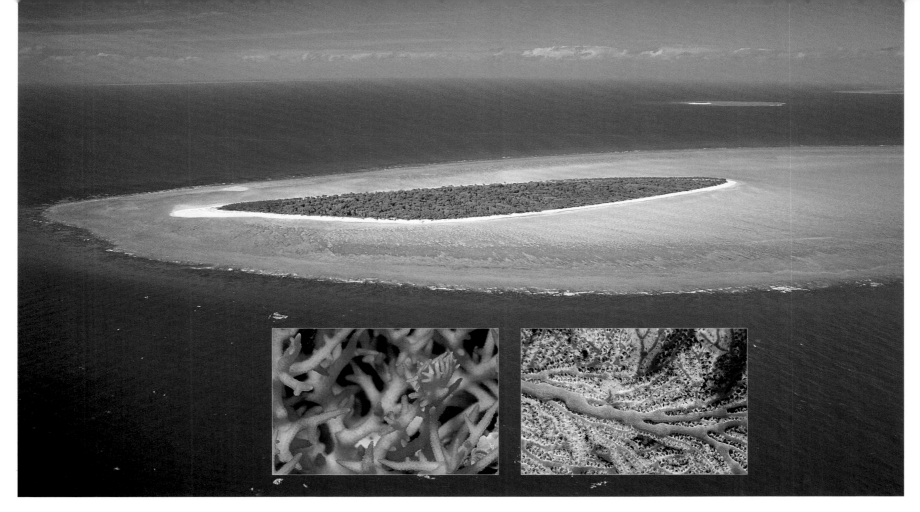

Reef types

The name Great Barrier Reef is somewhat of a misnomer. The GBR is actually a vast complex of several reef types, including those known as barrier reefs.

Fringing reefs

The fringing reef could be thought of as the "basic" coral reef as it is the first reef to form along the shoreline of a landmass, mainland or island. Although not solid limestone (as it lacks the cementing algae that consolidate outer reefs, a fringing reef may be quite wide – a kilometre or more – or only 30–40 m, depending on the slope of the shoreline. On the mainland coast in the GBR region, sedimentation and freshwater run-off from rivers has inhibited the formation of extensive fringing reefs. However, fringing reefs are common near many of the near-shore continental islands, and those some distance offshore such as the Brook Islands, Palm Islands and Lizard Island group, and they're usually continuous around an island's circumference.

Colonies of soft corals are the dominant types on this fringing reef at Normanby Island (opposite), one of the Frankland Islands group. Uninhabited Mast Head Island (above), in the Capricorn Group more than 50 km offshore from Gladstone, is a classic example of a stable vegetated cay that has formed at one end of a large platform reef. The fringing reefs of such offshore cays support hard corals such as the delicate lilac SERIATOPHORA HYSTRIX *(left inset) and the red* SIPHONOGORGIA *sea fan (right inset), whose polyps are extended to capture their planktonic food. Sea fans, which can reach a spread of several metres, typically grow in abundance on reef walls or drop-offs, especially where ocean currents are at their strongest.*

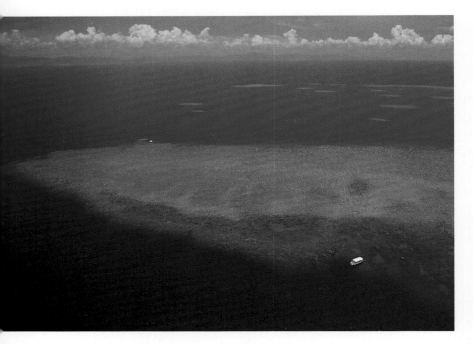

Barrier reefs

True barrier reefs face the ocean and the prevailing trade winds; they develop on the edge of the continental shelf. Typically, barrier reefs have steep, sometimes vertical, seaward-facing walls that may be terraced and are often cut with surge channels. The slope on the sheltered lagoon side is gentle and may be dotted with numerous coral heads.

Ribbon reefs

Ribbon reefs, found in the GBR'S northern section, are classic examples of barrier reefs whose expanse is punctuated with passes. On some of the ribbon reefs you can dive down the outer walls and see wave-cut notches that represent the coastline when sea levels were lower.

Platform reefs

Platform reefs usually, but not always, form leeward (on the sheltered side) of barrier reefs. When corals have grown upwards to reach the levels of the lowest tides, they expand outwards, forming platform reefs. Such reefs are a hallmark of stable conditions, particularly constant sea levels. The shape of a platform reef is determined by a variety of factors: waves and currents, prevailing winds and the shape of the sea-floor. If its surrounding water is shallow, a platform reef may grow to be several square kilometres and may enclose a lagoon.

The Agincourt Reefs (above) are ribbon reefs. A gently sloping section of the main reef is obvious to the right of the dive boat in the foreground, as indicated by the hues of the water. Left of the boat the edges of the reef drop away more steeply, forming vertical walls. Behind the main reef is a series of isolated patch reefs. A tabletop coral, more than a metre across (right), is the dominant coral in this typical scene on the reef front. Most of the corals here are the more robust varieties, rather than the fragile branching forms. This is a reflection of the fact that the shallower parts of the reef front, or fore reef, are prone to heavy wave action and storm surges, which the sturdier corals are better able to withstand.

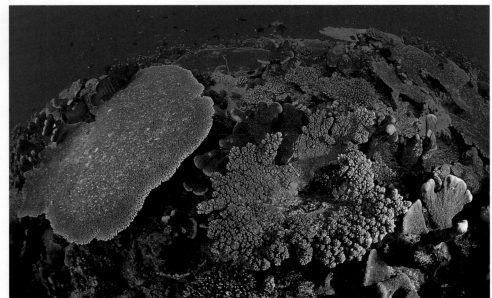

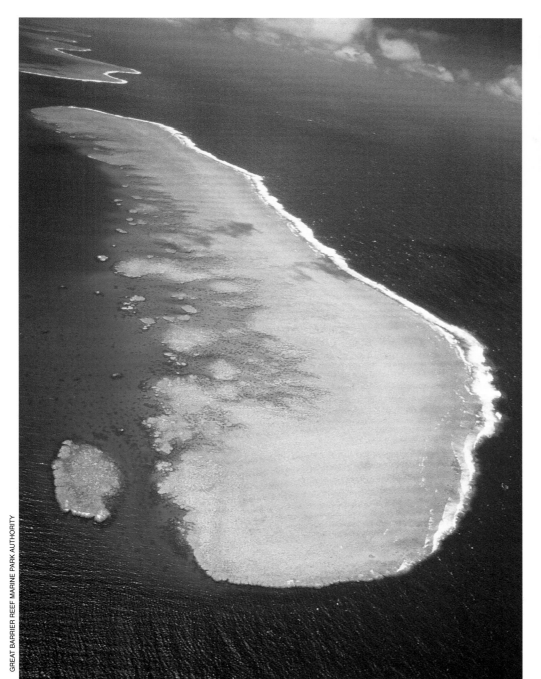

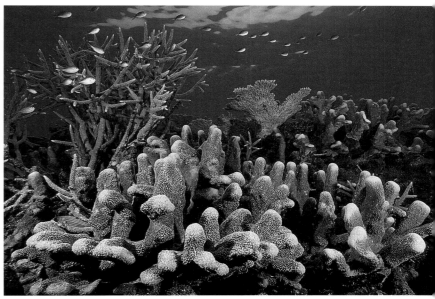

Ribbon Reef No. 6 (left) is a classic barrier reef. On its seaward face, at right, heavy swells, driven by the south-east trade winds, break for most of the year, restricting shallow-water growth to a few types of heavy boulder corals, though more delicate branching corals (above) grow below the surge zone. On the reef flat, or back reef, a beige colour here, the covering is mostly rubbly sand or shingle with little or no living coral growth. At its leeward side, where it slopes down into deeper water, the reef breaks up into a series of patch reefs, or bommies, interspersed with areas of white coralline sand, which appear turquoise from the air. In the lower left is a large detached patch reef; the darker specks behind it are individual coral heads or patches of hard corals.

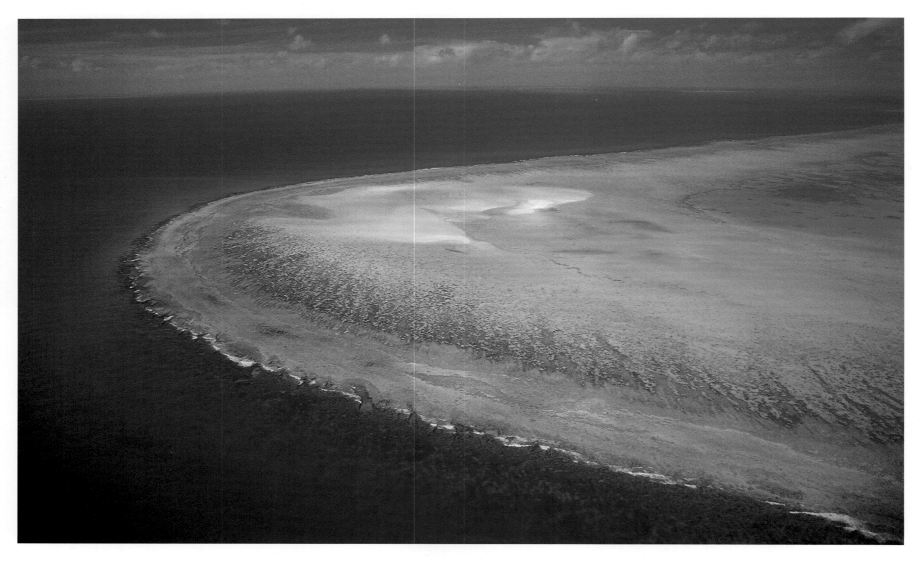

At the end of Wistari Reef, in the Capricorn Group, several small sand cays have begun to form on the reef flat as a result of the prevailing wind and wave action. At the top right, the reef flat deepens into a central lagoon with a series of small patch reefs. Over time, the lagoon will be filled in by the action of waves carrying coral sand and shingle from the outer reef and reef flat.

Patch reefs

Patch reefs, or bomboras ("bommies"), are small versions of platform reefs. They are usually circular in shape and occur in lagoons in both shallow and deeper waters. In the latter they may form as towering pinnacles rising almost to the surface.

Coral cays

Coral cays develop when reef sediments are carried by waves or tidal currents and deposited on the leeward end of a reef. The force of the winds heap up finer sediments, forming dunes above the high-tide level. Storm-generated waves bring with them larger pieces of mostly staghorn corals broken from the reef, which form banks of shingle on the emergent cay. Over time this shingle becomes a chemically "cemented" cay, forming a protective outer rampart. Cays become vegetated when seeds, carried by waves or in the droppings of birds, germinate and grow, resulting in additional stability. Stable, established cays – such as Green Island, off Cairns – are generally referred to as "low" islands.

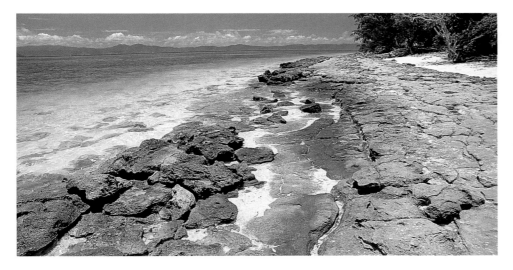

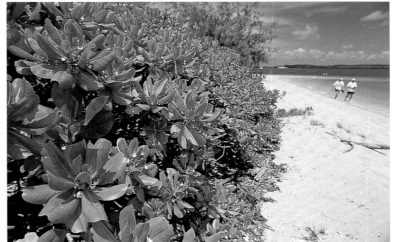

This terraced beach rock at Green Island (above), once living coral, has been chemically transformed over thousands of years into beach rock. The beaches of many cays in the northern GBR are largely comprised of the calcium remains of HALIMEDA, a calcareous green algae (top right). Vegetation such as this luxuriant growth of ARGUSIA shrub on Low Island, off Port Douglas (bottom right), ensures the stability and long-term survival of the cays.

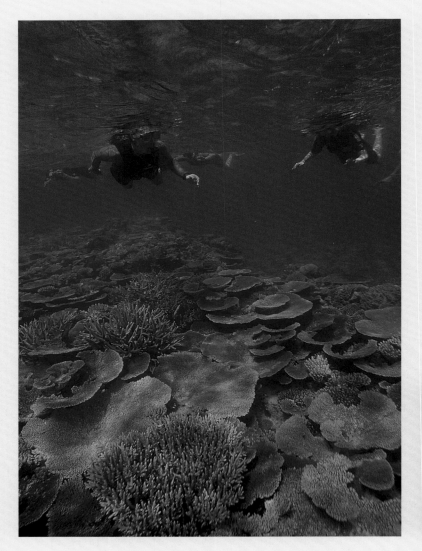

WHERE ARE THE COLOURS?

For many first-time reef visitors, that initial glimpse of coral reef – whether viewed through a face mask, semi-submersible or glass-bottomed boat – is a little disappointing. "Where's all the colour?" they ask. This is a fair comment for anyone prompted into a reef holiday by glossy brochures and television advertisements depicting rich and colourful underwater life. Most people don't realise that these vibrant images are almost invariably produced with the aid of artificial light. In natural light, the reef presents a predominantly blue-green vista.

The colours of the visible spectrum of sunlight are red, orange, yellow, green, blue, indigo and violet. As sunlight enters clear seawater, about 40–50 per cent of red and 30–40 per cent of orange are absorbed in the first metre of water. This is known as selective absorption of light, and the effect increases with depth. For example, at a depth of 10 m, about 99 per cent of red light has been absorbed, along with about 85 per cent of the orange, perhaps 70 per cent of the yellow, 40–50 per cent of the green and 10–20 per cent of the blue. While these figures are dependent on water clarity and the angle of the sun, the end result for GBR snorkellers and divers is a marked decrease in warm colours – the reds and oranges. You'll get a surprise if you happen to cut yourself at a depth of 10 m: the flow of blood will appear dark green.

When artificial light such as a submersible flash or a powerful waterproof torch is used underwater, the missing natural warm colours are replaced and the full spectrum of the reef's colours is revealed in all its splendour.

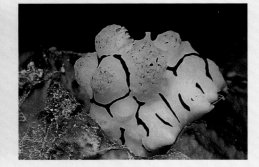

For snorkelling tours such as this one led by marine biologist Doug Baird at the Agincourt Reefs (left), the underwater scenery is magnificent – but lacking in colour range. This is more graphically shown above, with the dorid nudibranch (left) photographed in ambient light at a depth of 10 m and (right), the same species photographed with the aid of an underwater flash.

Reef zones

Scientists partition coral reefs into distinctive zones that reflect the biological make-up and physical and chemical characteristics of the reef. While you're diving on the reef, the subtle changes between the zones probably won't be very apparent; you have to go for the bigger view. If you take a flight over the reef, the zones described in the following pages will be immediately apparent to you.

The reef front

For divers, the reef front or fore reef is the most visually rewarding section of the reef, as it's the region where the marine life is at its most varied and intense. It extends from the mean low-tide level down to at least 20–30 m. Below the turbulent surge zone of the surface, coral growth is incredibly rich and fish life is abundant. At depths below 10 m, there may be huge colonies of tabletop corals several metres across, beautiful stands of delicate lettuce coral and fields of intricately branching staghorn corals.

Surrounded by its resident school of damsel fish, a large staghorn coral colony grows on the reef front, 15 m deep, on the face of an outer reef (below left). On the outer reef slope of an isolated patch reef, at a depth of 20 m, a pack of predatory bluefin trevally – a species that can reach a metre in length – patrol over a bottom completely covered with living corals (below). Underwater scenes such as these are typical of the outer reef fronts, where reef life is at its most vibrant.

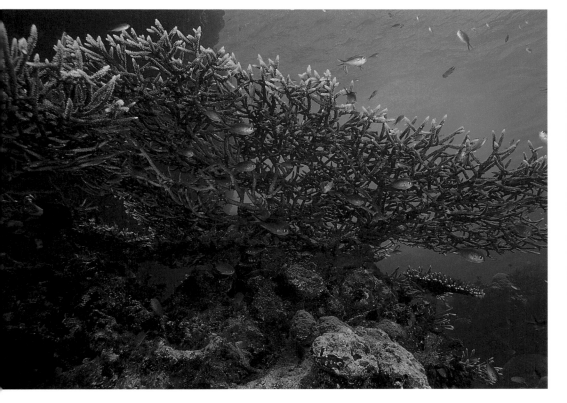

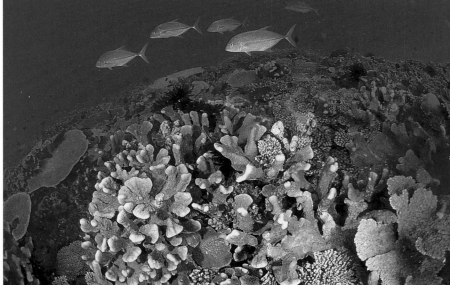

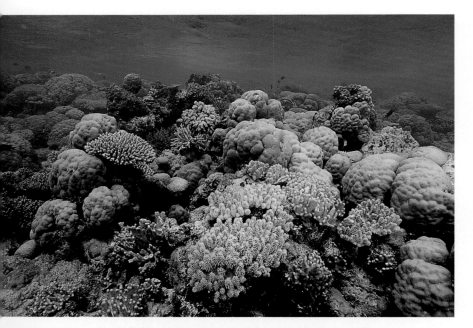

The reef crest

The reef crest may lie up to half a metre above the level of the lowest spring tides and so is subject to the constant onslaught of wave and wind. For this reason, almost no corals grow here; those that do are either the large boulder-like forms or small, sturdy corals that can best withstand the turbulent waters. However, algae are plentiful. Red and brown encrusting coralline algae cover almost every available rocky surface. Small "lawns" of several varieties of leafy green algae are constantly browsed by large schools of herbivorous fish such as surgeonfish and parrotfish.

The reef flat

The reef flat, or back reef, occurs in the lee of the reef crest and its coral growth is somewhat sparse and normally parallel to the prevailing wave direction. Most of the corals growing on the reef flat are branching types, with a scattering of larger boulder-like forms. The bottom of the reef flat may be a mixture of limestone rock, coral shingle and sand.

IAN KIRTON

In the shallow depths at the reef crest, various forms of boulder corals predominate (top). There are usually some branching corals, but these are the first to be destroyed during storms, their remains carried by waves to form the shingle banks on the reef flat or on emergent cays. HALIMEDA is the most important of the calcareous algae on the reef (left). Its calcium remains are vitally important as a crevice filler in the overall reef structure. Staghorn corals assume their most delicately branching forms in the calm, sheltered waters of the lagoons (opposite top). With little water movement, lagoons tend to be somewhat murky and underwater visibility poor. A myriad of patch reefs form an intricate living maze in the lagoon on Wistari Reef (opposite right).

Sand flats

The sand flats are formed from pieces of coral and coralline algae that are broken from the reef front by fish or waves and carried back across the reef by wave action. There may be a few small colonies of branching corals growing on the sand flats; some are covered with meadow-like expanses of seagrasses. In spite of appearing to be underwater deserts, the sand flats actually support a rich and varied fauna – most of which are burrowers or dwellers within the sand.

Lagoons

Lagoons are the dumping grounds for all the sediments and organic materials that have been carried leeward from the reef and, as such, they are in the process of slowly being filled in. Depths vary, depending on the age of the lagoon, from 3 to 20 m. Lagoons are usually enclosed, though occasionally they are open to the sea. In fact the whole region of the GBR that lies shoreward of the outermost reefs is commonly referred to by marine scientists as the Great Barrier Reef lagoon.

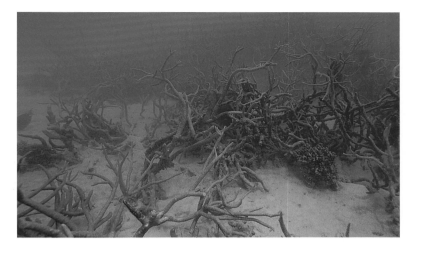

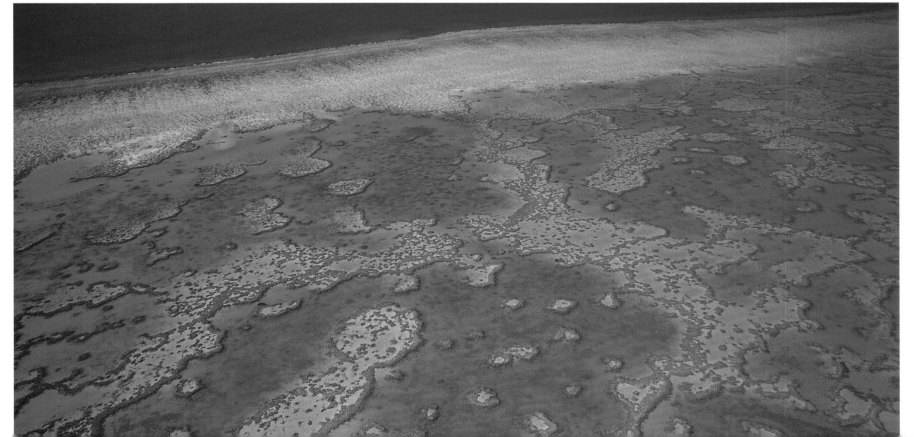

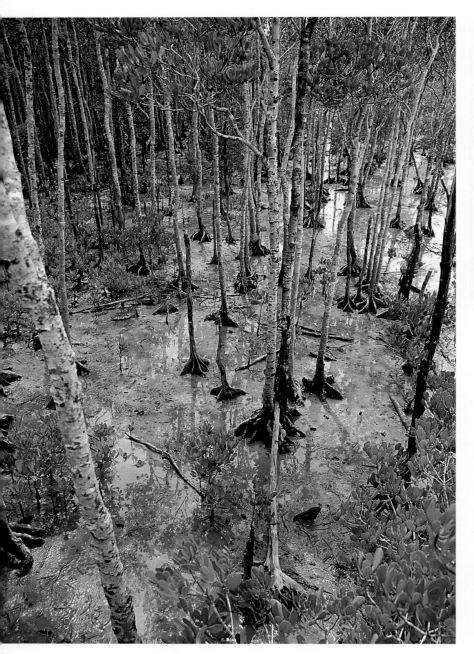

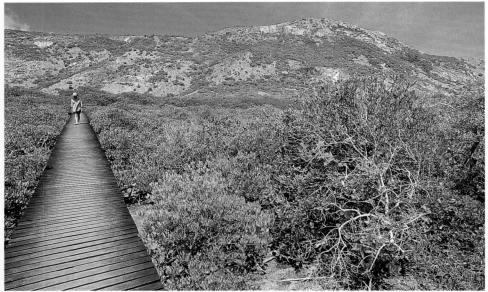

Mangroves

Strictly speaking, mangroves are not one of the reef zones, but because inshore reefs are so vitally dependent upon them, it's reasonable to include mangrove communities when we consider the GBR as a whole.

Sir Maurice Yonge, leader of a British Museum Great Barrier Reef expedition in 1928–29, wrote of mangroves: "This was a region of mud, of black and decaying stumps and dead trees that lay procumbent like long-extinct reptiles wallowing in a steaming Jurassic swamp." With this somewhat Victorian approach to natural systems, Yonge failed to appreciate the critical importance of mangroves to the overall well-being of the GBR. We now know that coastal mangroves act as vital nurseries for the young of many reef fish, and also as sediment traps.

Dr Gregg Brunskill, an AIMS research scientist whose work involves the detailed study of coastal sedimentation, takes a more enlightened view of mangroves than did Yonge.

"One of the reasons the GBR continues to exist is because the supply of fresh water and mud from mainland catchments is very limited. Mangroves and coastal wetlands act as a trap for river-supplied materials," Gregg said, adding that mangroves have probably acted as such filters for a very long time. "It is only over the past hundred years, with land-use change altering the delivery of fresh water, sediments and contaminants to the GBR, that the vital importance of mangroves as coastal filters has been realised," he said.

A grove of spurred mangrove (opposite left) near Cairns airport. Stands of mangroves often grow as a single species in many areas. This is a reflection of the fact that the saltiness of the soil suits that species' particular tolerance and it is thus able to outgrow its competitors. Mangroves are considered an important shoreline protection against storm surges during cyclones. At Lizard Island (opposite right), a QPWS boardwalk runs through a grove of stilted mangrove, enabling visitors easy access to the mangrove environment. During the 1928–9 British Museum GBR expedition to the Low Isles, records of the daily physical environment were meticulously kept to augment biological observations. The wife of expedition leader Sir Maurice Yonge (right) checks the sunshine recorder and wind gauge.

The first European settlers of Australia's tropical north cleared mangroves with a vengeance, seeing them as nothing more than pestilential swamps teeming with diseases. Although mangrove clearing is now very carefully regulated, it still occurs for urban, agricultural and tourism development, causing concern among conservationists and scientists.

Nutrient cycles on the reef: the food web

It's a paradox that the GBR exists in nutrient-poor waters, and all the more surprising when you consider that in terms of sheer weight of living matter, coral reefs are one of the richest communities on Earth. The answer to the riddle is that virtually all the food energy produced on the reef stays there by means of a complex recycling system.

It is the sun's energy that fuels the myriad life cycles that comprise the GBR's ecosystems. And it's plants, not animals, that initially harness this energy – they are the very heart of the nutrient cycle. Countless millions of microscopic single-celled plants, known as phytoplankton, drift in the upper sun-drenched waters of the GBR. Like other plants, these tiny organisms use sunlight to photosynthesise, converting carbon dioxide and water to carbohydrates. These carbohydrates enter the food web when phytoplankton is eaten by other organisms, typically zooplankton, the animal component of the reef's planktonic soup. Zooplankton includes miniature crustaceans, worms and jellyfish as well as the larvae and juveniles of both pelagic, or open ocean, and reef animals.

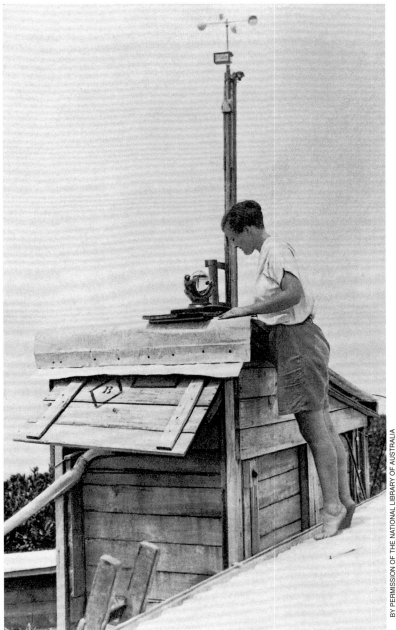

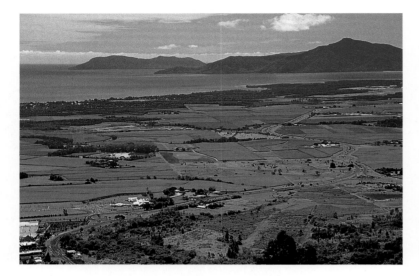

Run-off of agricultural fertilisers and other contaminants into GBR waters is normally minimal. However, at least once a decade there may be extensive flooding, resulting in floodwaters reaching as far as the outer reef. These photographs of sugarcane fields north of Cairns were taken a week apart, the lower picture showing the extensive flooding that followed Cyclone Rona in 1999.

The zooplankton is in turn consumed by animals such as small fish, which are eaten by predators or parasites. These predators are then preyed upon by still larger predators and so on. The planktonic stage of the food web may be bypassed by herbivorous animals that graze directly on seagrasses and the algal turf that abounds over much of the reef's surface. But again, these herbivores are eaten by predators or parasites and thus become part of the food web. Animal wastes and dead animals and plants are broken down by bacteria; this bacterial decay releases trace elements – essential for plant nutrition – back onto the reef. And so the cycle begins anew.

As a dynamic natural system, the nutrient cycle does have its ups and downs over time and space, and the reef as a whole can cope with these minor hiccups. However, the cycle can be more seriously disturbed by human activity, as when excessive amounts of nutrients – the residue from agricultural fertilisers used on the mainland – are washed onto inshore reefs. It is not that excess nutrients are directly harmful to corals, as is popularly believed.

"Corals love nutrients; you can't kill a coral with nutrients," Charlie Veron told me. "The problem nutrients create is that other organisms also love them. An excess of nutrients upsets the fine balance of the system by affecting the competitive arrangements between corals and other organisms, especially algae."

Symbiosis: living together

Every individual living organism on the GBR is dependent on a number of other living things, either directly or several steps removed. This is symbiosis – literally "living together". Certain aspects of the food web may be a function of symbiosis; some organisms may be the particular target of certain parasites, others are the specific, sometimes sole, food of predators. However, the prey–predator relationship is only one of many associations necessary for survival, for evolution has brought about an enormous range of relationships on the reef.

In many cases, these relationships are, for at least one of the partners, absolutely essential for life. Such specialisation can, however, be very risky – in evolutionary terms it's skating on thin ice. Once an organism is committed to a certain evolutionary path, there's no turning back. If the resource upon which that organism has become totally dependent is suddenly removed from the partnership for whatever reason – disease, environmental change, human agency or whatever – then that organism is likely doomed.

In some of the symbiotic associations on the GBR, such as parasitism, the relationship may be harmful to one of the partners. In most instances, however, the arrangement will be of mutual benefit, termed mutualism, or at least benefiting one partner and causing no harm to the other, called commensalism.

The clownfish and their anemone hosts are one of the best-known examples of commensalism on the GBR. Unlike many of the reef's fish, which are generally wary of divers, clownfish can be closely approached. This obliging trait, together with

their vibrant colours, makes them ideal subjects for underwater photography or simply observing their behaviour at very close range.

Although clownfish can survive in an aquarium without an anemone, in nature they are never found without one, and it's not fully known why. Certainly the stinging tentacles of anemones afford clownfish protection from predators, as well as being essential for reproduction – clownfish will only lay their eggs beneath anemones' protective tentacles. On the other hand, anemones can do quite well without resident clownfish. They are not dependent on the fishes' presence for their survival – though admittedly the clownfish do appear to keep away other fish that are potential anemone predators.

Observant scuba divers can witness the classic mutualism between the nearly blind burrowing shrimps and their attendant gobies. The shrimp digs a burrow on the sandy floor of the reef and spends much of its time maintaining it, dumping clawfuls of excavated rubble every few minutes. The goby sits at the entrance to the burrow, alert for any potential predators that may attack the defenceless shrimp. As the shrimp exits with the rubble from its excavations, it continually checks with its antennae for the presence of the goby . If the goby senses danger, it gives a flick of its tail, warning the shrimp, and both disappear down the burrow. In this relationship the goby gets a home dug for it and the shrimp gets an ever-watchful "security guard".

As it emerges from its burrow beneath a coral rock, a 3 cm blind alpheid shrimp (below) lays its right antenna against the side of its sentinel goby, assuring itself that the fish is on guard. Getting close enough to photograph this symbiotic pair requires a good deal of patience; the gobies perform their duties well, and more often than not will disappear down their burrows before a single photograph can be taken. Clownfish (below left) are much easier to film; secure in the protective tentacles of their anemones, they will cheekily peer out, even emerging to nip at intruders who come too close – including curious divers.

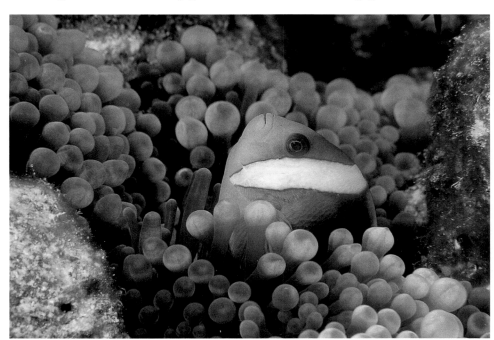

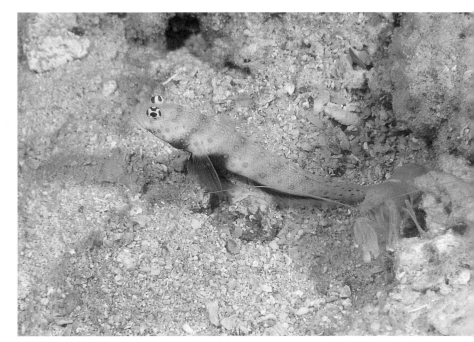

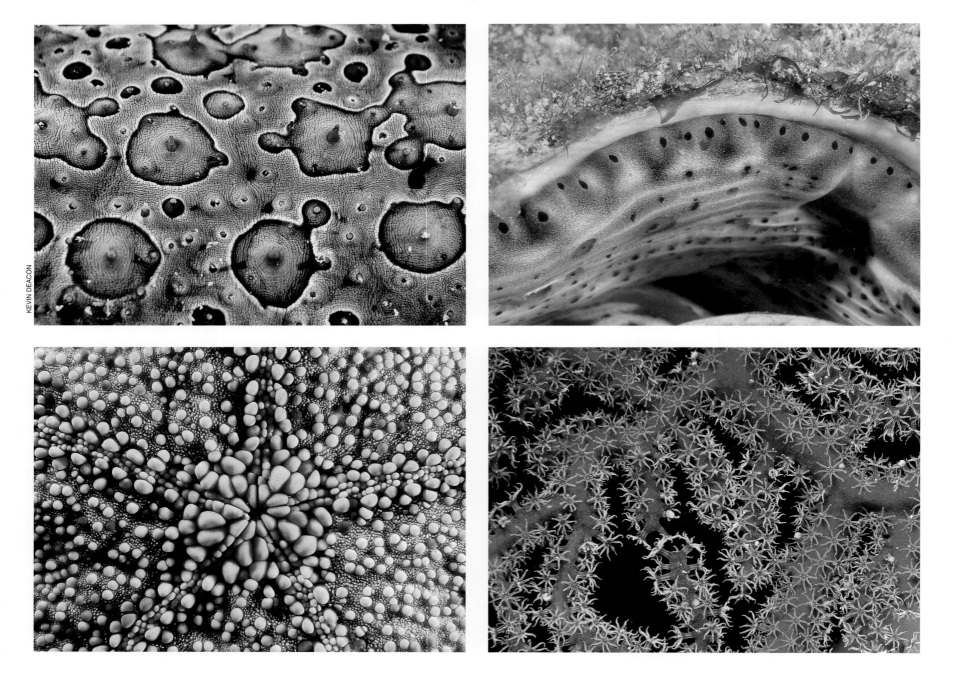

KEVIN DEACON

Quiet lives

Invertebrate animals of the Great Barrier Reef

Like candidates for a "what is it?" quiz, the assemblage of GBR invertebrates opposite provides some idea of the enormous diversity of form in these animals. Clockwise from top left: the surface detail of a leopard sea cucumber; part of the mantle of a clam showing the distinctive eye spots; a sea fan with polyps extended and feeding; and a close-up detail of the mouth area of a pincushion star.

Roger Springthorpe and I were washing our scuba gear outside the Australian Museum's GBR field station at Lizard Island, about 250 km north of Cairns. Roger's research – he's a specialist in crustaceans – often takes him to Lizard; we'd been photographing an antennae-twitching congregation of hingebeak shrimps in a coral cave.

As we washed we spoke of how the first scientists working on the GBR would have been greatly envious of the underwater freedom our modern dive gear allowed. Scuba has only been used as a research tool by marine scientists since the mid-1960s.

"Scuba has given us the ability to directly observe the creatures we're studying in their own environment, something the early marine naturalists never had," Roger said. "But even so, we still know very little of the life histories of many of them – how these animals live and their role in the ecology of the GBR."

Roger pointed out that some GBR marine invertebrates – corals and echinoderms such as staghorn coral and crown-of-thorns starfish for example – have been fairly well studied, but there are few biologists specialising in this huge and diverse group.

"We're talking about such an enormous number of species that there would be many lifetimes of work just to scientifically categorise them," he said. "You have to collect them, examine them, sort them, illustrate them and then publish your findings. And this whole process is incredibly time-consuming – even with the resources of a modern museum."

Corals

To fully appreciate the grandeur and immensity of the GBR, we must first consider those humble creatures responsible for its very existence – the reef-building corals. Termed cnidarians (pronounced ny-darians) by biologists, they are related closely to the sea anemones and more distantly to the jellyfishes. Cnidarians are animals with a very simple body structure and a single opening, ringed with tentacles, for both eating and excretion. Their tentacles have specialised cells that contain stinging structures, called nematocysts.

While there are many different types of corals, it is the hard, or stony, corals that build reefs through their ability to form colonies from a founding individual. The coral animal, the

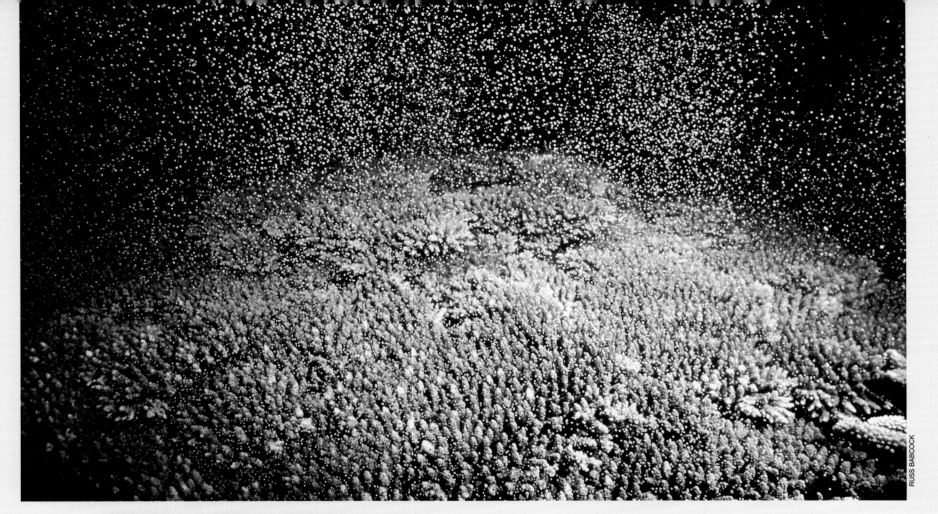

RUSS BABCOCK

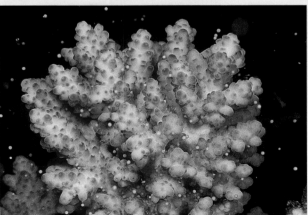

The description of the mass coral spawning on the GBR as an "inverted underwater snowstorm", is very apt, as this tabletop coral releasing its egg/sperm bundles illustrates (above). In the detail (left) the "ripe" polyps about to release their egg/sperm bundles appear as brown pimples with bright pink centres. Most of the polyps within a single colony will release the bundles within a period of no more than three minutes – usually less. When I witnessed the coral spawning in 1997 and 1998, the synchronicity was less than dramatic, with corals on a single reef spawning over several hours and sometimes days. A disappointment to the legions of divers who had travelled to the GBR for the occasion, the lack of synchronicity has been linked to the concurrent bleaching event.

SYNCHRONISED SEX

The annual mass coral spawning is one of the highlights of the Great Barrier Reef's biological calendar. First observed by AIMS scientists in the early 1980s, the mass spawning is renowned for its synchronicity, with many corals releasing their eggs and sperm within seconds of each other.

Popular wisdom has the mass spawning beginning a few hours after sunset one or two days after the November full moon for most of the GBR, and continuing for perhaps three or four nights. However, if the full moon occurs in the first week of November, the main spawning event may not take place until after the December full moon. In the southern GBR, at places such as Heron and Lady Elliot islands, the spawning may take place as late as January or February.

If a coral species is comprised of separate sexes, individual coral polyps in a colony release either ripened eggs or sperm. However, the majority of hard corals are hermaphroditic, and a compact bundle containing both eggs and sperm is released. The resultant cloud of pinhead-sized eggs or egg/sperm bundles has been aptly described as an inverted underwater snowstorm. The eggs and sperm from the nightly spawning of entire reefs slowly drift towards the surface, where they form huge brownish-red drifts that may cover hundreds of square metres before being dispersed by currents and winds.

Each fertilised egg develops into a free-swimming larva called a planula. After several days drifting in the water column, the planula settles on the reef where it attaches itself and so begins a new coral colony.

KEVIN DEACON

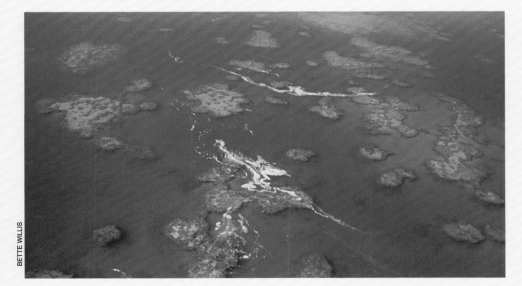

BETTE WILLIS

The morning after synchronised coral spawning on the reef, surface drifts of fertilised eggs can stretch for several kilometres as they are pushed by winds and waves (left). Other invertebrate animals, such as sea cucumbers, also engage in synchronous reproduction. The male spiny green sea cucumber (above) is releasing its sperm. It has been postulated that these invertebrates take advantage of the coral spawning, releasing their own eggs and sperm at the same time in order to reduce predation. With the sheer mass of eggs in the water, the chance of a predator eating any particular egg is considerably diminished.

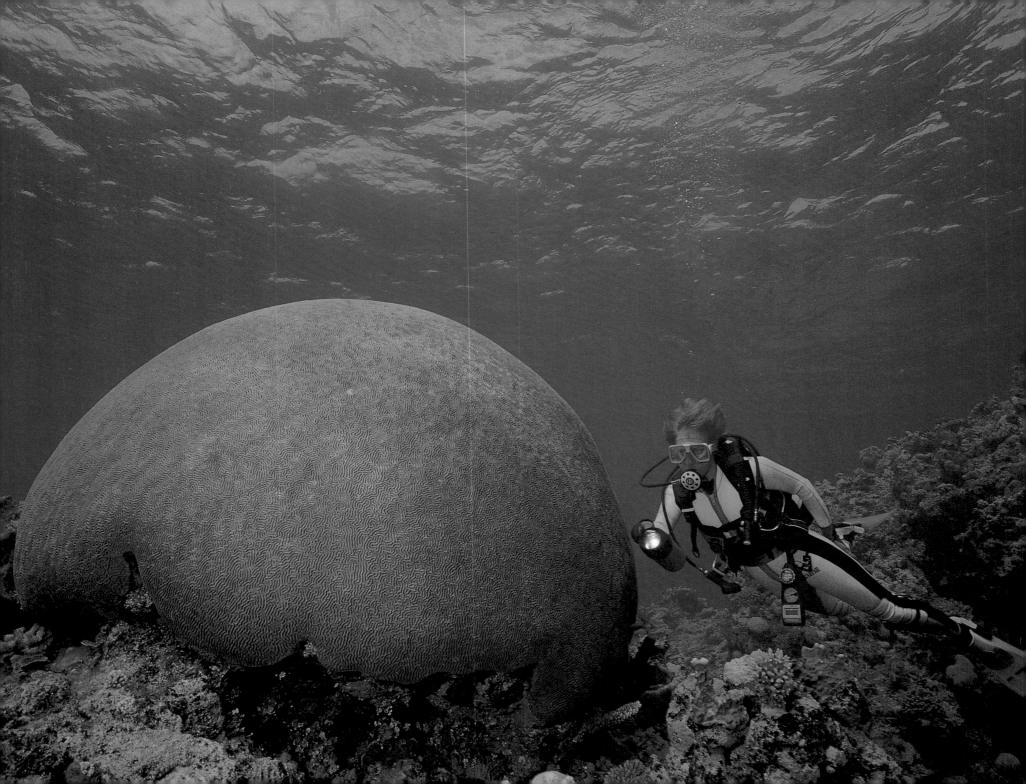

polyp, forms a limestone cup around itself using calcium carbonate from the sur-
rounding seawater. These limestone cups are cemented to those of adjacent polyps
and built upon the skeletal remains of their predecessors. Polyps divide into "daugh-
ter" polyps, each a perfect clone of its "mother" and each forming its own limestone
cup. In this way the colony multiplies and expands, a constant renewal, though of
the thinnest veneer.

Hard corals' ability to build reefs is reliant on the presence of microscopic plants
– a type of algae called zooxanthellae – in the tissues of the living coral polyp. In
addition to giving each coral colony its characteristic colour, these minute plants
greatly enhance the polyp's ability to manufacture its limey skeleton. They also use
the carbon dioxide and other waste products produced by the coral polyp. Being
plants, the algae require a certain amount of sunlight in order to photosynthesise
(the same biological process used by all plants, above and below water), and they
also need warmth. These two conditions determine where and how coral reefs grow.

"The GBR exists primarily because of the wide continental shelf and the tropical
conditions," AIMS coral specialist Charlie Veron told me. "The tropical areas have
expanded and contracted over the millennia and coral reefs have formed in response
to this. Coral reefs do not grow unless the water temperature stays above about 18°C.
Corals can survive, but they cannot build reefs at temperatures lower than this."

When the environment gets hostile or coral gets sick for whatever reason, the
algae is lost from their tissues and the coral dies – this algal loss is commonly known
as coral bleaching.

"Sometimes the coral can grow its algae back and recover, sometimes it can't,"
Charlie explained. "This expulsion of algae is the result of stress of some sort. It might
be reduced salinity or a rise in sea temperature. And right now [1998] we've got one
of the most dramatic bleaching events we've ever recorded. It's a breakdown in the
symbiosis between the plant and the animal, for reasons that are not entirely clear."

*The physical difference between a hard coral with its polyps retracted
and extended can be quite marked. The convoluted underlying structure
of this faviid, or boulder coral (above right) can easily be seen. However,
when the polyps in the colony extend their tentacles – as in a closely
related species (right) – the change is obvious. The full view of a faviid
coral on the opposite page gives an indication of the scale of these close-
up images.*

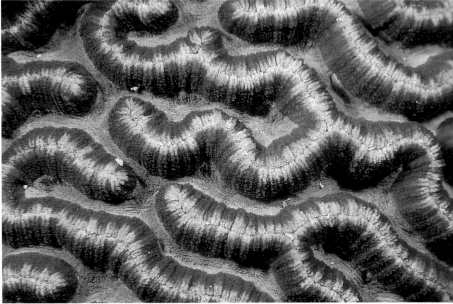

PHOTOS: IAN KIRTON

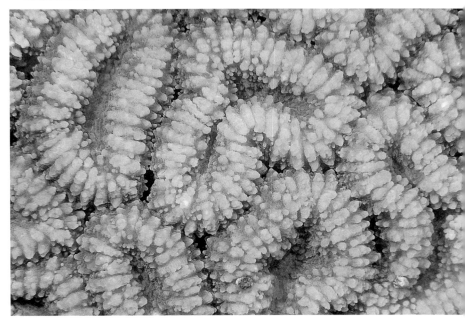

The pink mouth of the coral polyp is evident at the base of the extended feeding tentacles of flower soft coral, XENIA (below). In the reef scene at right, most of the corals are soft species that grow below the rough and tumble of the surge zone in the upper 10 m of the reef. This includes species such as the beautiful DENDRONEPHTHYA soft coral tree (below right).

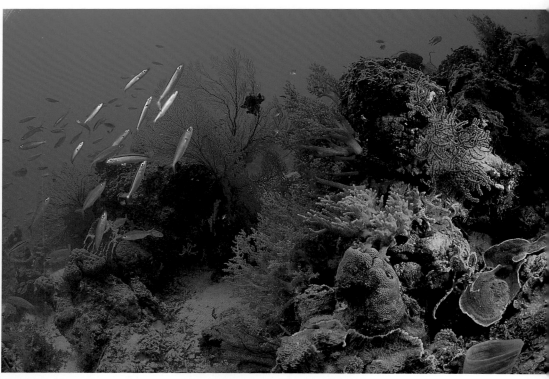

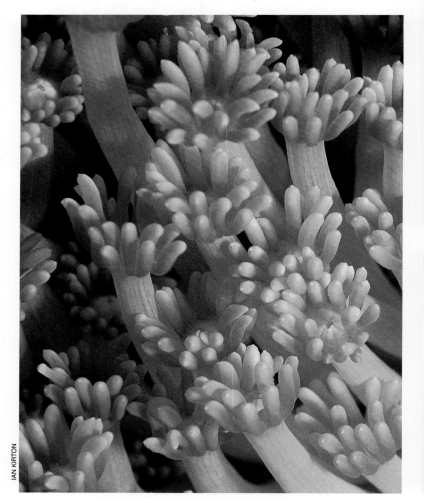

IAN KIRTON

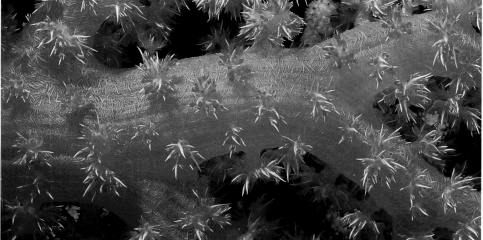

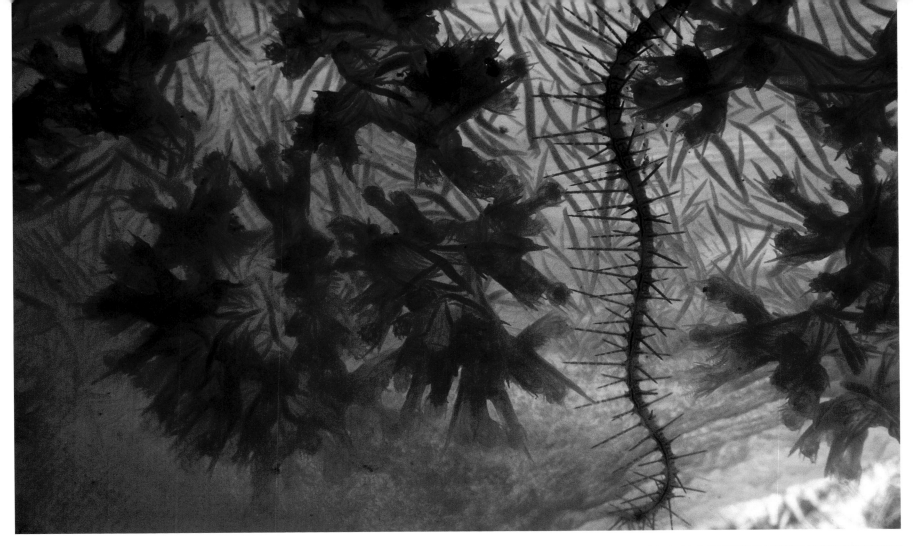

Like randomly fallen fiddlesticks, the calcite spicules in the tissues of this backlit soft coral tree can be easily seen (above). Lacking the limey skeleton of the hard corals, the soft corals are dependent on their internal spicules to provide a certain amount of rigidity. The spiny arm to the right belongs to a brittle star. Coral bleaching (right), which reached unprecedented levels on the GBR in 1998, occurs when the coral polyps eject the zooxanthellae algae from their tissues – apparently due to stress. This is popularly thought to be due to a rise in sea surface temperatures or an excess of ultraviolet light. However, many scientists believe the causes are many, rather than a single environmental factor.

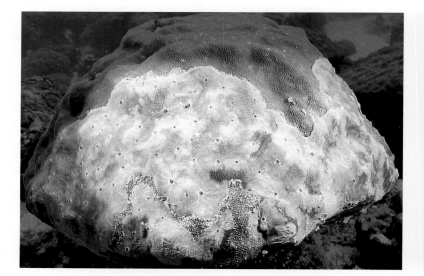

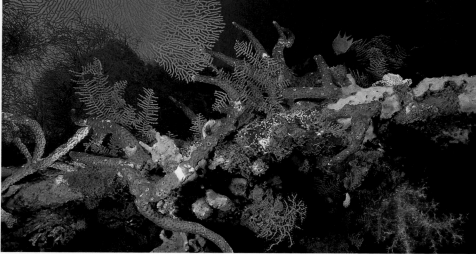

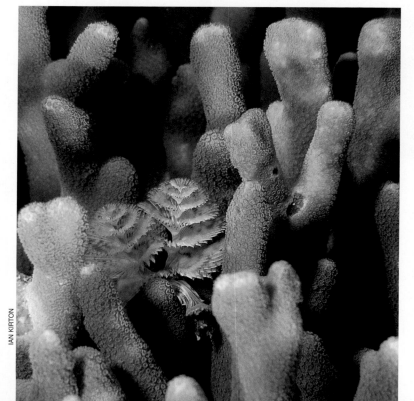

IAN KIRTON

Sponges

Because of the huge variety of form among the reef's sponges, you could be excused for mistaking them for soft corals – many of them are distinctly coral-like in shape. Sponges are one of the animal kingdom's true survivors, having been around for more than 500 million years. Like the sea squirts, sponges are highly efficient filters, the vacuum cleaners of the reef. A fist-sized sponge can process several thousand litres of water through its body in a single day as it filters out the bacteria that provide the bulk of its nutrition. Like the hard corals with their symbiotic algae, the tissues of many sponges contain bacteria that produce carbohydrates as a by-product of photosynthesis, augmenting the sponge's bacterial diet.

Marine worms

You're swimming over a huge boulder-like head of *Porites* coral and you notice part of its surface is covered with clusters of what appear to be tiny delicate flowers of many different colours – reds, blues, yellows and whites. Moving in for a closer look, you blink – and they've disappeared. What you saw were the feeding tentacles of Christmas-tree worms, a type of segmented worm not so very far removed from the common earthworms in your garden.

The Christmas-tree, or feather-duster, worms are the marine worm you are most likely to see on the reef. Dr Richard Smith, working at James Cook University (JCU), Townsville, observed that the larva of the Christmas-tree worm settles on coral skeletons near the edge of the live coral. It initially secretes a mucous bag and then lays down a calcareous tube. The coral overgrows this tube and, from then, the

A fraction of the truly amazing variety of GBR invertebrates is depicted here (clock-wise from right): a 4 cm turbellarian flatworm; the feeding tentacles of a spaghetti worm extending from its shelter in a reef crevice; a Christmas-tree worm emerging from within the branches of a living coral; a pink encrusting sponge partially covering a boulder coral and a red branching sponge surrounded by sea fans, soft corals and other encrusting growth. Very few of the reef's invertebrates have common names – other than simple generic forms. However, even the correct scientific names are not easily applied to photographs of the living creatures. For some groups, such as sponges, which are notoriously difficult to identify, most experts acknowledge that they must have the actual animal in hand before they are able to make a definite identification.

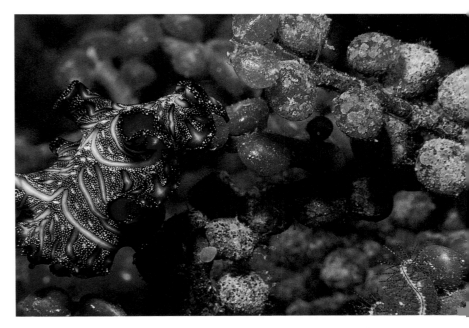

worm grows and lays down its own tube, keeping pace with the growth of the coral. They are very sensitive to small changes in pressure or light, and their disappearing trick is a response to their detection of your presence.

While Christmas-tree worms are an obvious reef inhabitant, other marine worms are not. But the GBR is literally full of worms. Most species are burrowers – in sand and also in the living coral – and so are not usually seen. But to give some idea of their abundance, a single football-sized coral head has been known to harbour more than a thousand worms of more than a hundred species.

Among the other marine worms commonly seen on the reef are flatworms – relatives of the notorious human tapeworm, but the coral-reef variety is definitely harmless. These animals are often similar to the resplendent nudibranchs in shape and size, and like the nudibranchs come in a dazzling variety of colours and patterns. You can usually pick the worm from the nudibranch – a mollusc – by the absence of gills at the rear of the worm's body; external feathery gills are a feature of most types of nudibranchs.

You may also notice long white threads radiating out for more than a metre from a common source in the coral. These spaghetti-like strands are the feeding tentacles of terebellid worms, which live in tubes deep in the sand and snake out their tentacles to gather the micro-organisms they feed upon.

Crustaceans

Every GBR visitor will know a crustacean when they see one – hardly surprising given the popularity of crab, lobster and prawns in virtually every restaurant in the

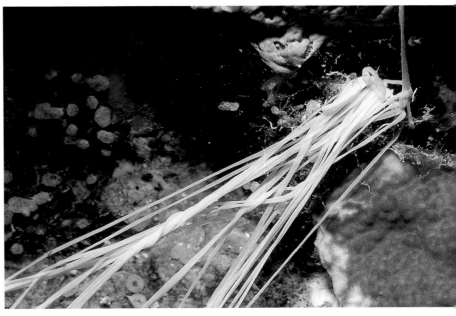

region. But of course there are countless thousands of crustaceans that are never seen on dinner plates. The tiny isopods, amphipods and copepods that live in the sand or occur as a component of the drifting plankton in reef waters are all crustaceans, as are the barnacles that are the bane of yachties.

If you look carefully on the reef you'll find many crustaceans where you least expect them. The beautifully latticed sea fans, or gorgonians, are home to many small commensal crabs, and almost every large sea anemone shelters a number of resident semi-transparent shrimps and perhaps a porcelain crab or two. Check the bases of feather stars and you might find a tiny shrimp whose colours and patterns perfectly match those of its host. And if you can get close enough to some of the large reef fish you may notice little cleaner shrimp moving over their bodies and heads, even entering their mouths and gills as they feed on the fish's mucous coating.

Crustaceans are also one of the main contributors to the underwater background noise – the "white noise" – on the reef. When diving, pause for a moment between breaths and when the noise of your exhaust bubbles has died away – listen. The clicking and cracking that you can hear are snapping shrimp. Using a kind of plunger-and-bore apparatus in their claws, they create a loud sucking pop, popularly believed – but not proven – to stun small animals in their immediate vicinity, though the noise may be associated with mating.

The 2 cm anemone shrimp (below), as its name suggests, is found as a partner of anemones. It is also found on the tentacles of some corals, such as mushroom coral. It rarely occurs singly, with several animals usually present. This shrimp's purplish clutch of eggs can be seen through her transparent body. The colourful xanthid crabs (below right), each about the size of a 10 cent coin, as adults never leave the shelter of their host coral. While the reason for their gaudy colours is not known, it is believed that they may have a symbiotic relationship with the coral they inhabit. They have been observed driving off fish that feed on coral polyps. In this way the coral provides them with a home and they protect the coral from predators.

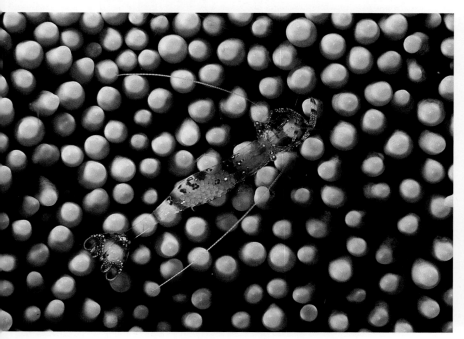

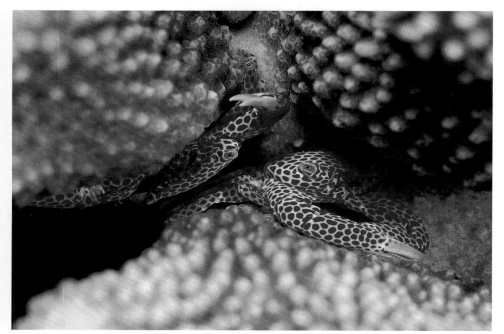

Molluscs

What do a cowrie and an octopus have in common? They're both molluscs, one of the largest groups of all the marine invertebrates in terms of sheer number of species. Representatives of all three major classes of molluscs (gastropods, bivalves and cephalopods) are found on the GBR. The most common are the gastropod snails, such as cowries, the external shells of which have long been held in esteem. The brilliantly patterned nudibranchs, admired by underwater photographers for their vibrant colours, are another type of gastropod. Gastropods move by means of a "foot", a muscular organ that protrudes from the shell and secretes a mucous that the animal partially "glides" on – much like common garden snails, which are also gastropods. Well-known representatives of the bivalve class of molluscs are oysters, clams and mussels. Bivalves either burrow in the sand or attach themselves to the rocky floor of the reef. The giant clams of the reef are the largest of all bivalves, growing to well over a metre wide and perhaps living for centuries. And you can forget the fictional depiction of the giant clam as the villain in the coral garden. A giant clam will immediately open after closing reflexively on something as alien as a human limb – in fact, it derives almost all of its nourishment from sunlight, through its symbiotic partnership with the coral algae, zooxanthellae.

The third major class of molluscs, the cephalopods, includes squids, cuttlefishes

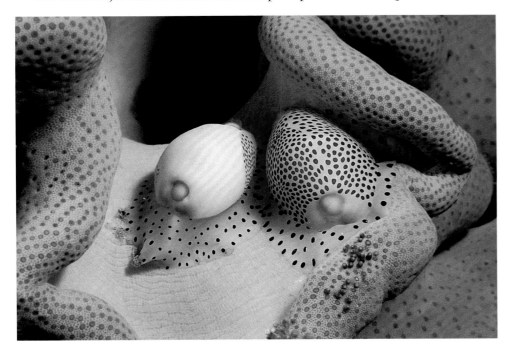

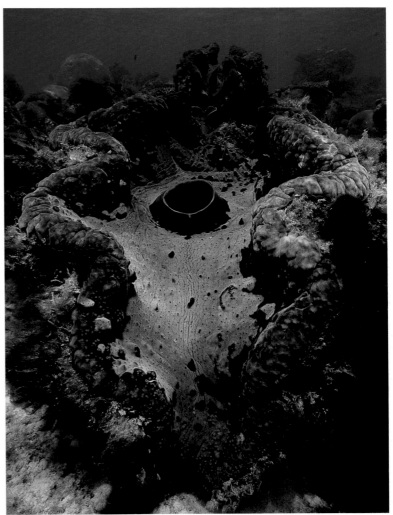

The giant clam (above), like hard corals, has symbiotic algae in its tissues. For this reason it is often found in shallow lagoon areas where sunlight is plentiful and its crop of algae is able to photosynthesise. Many marine invertebrates only occur in association with a single host, such as this pair of allied cowries in the folds of a leather coral (left). The cowrie on the right has its spotted mantle extended over its shell.

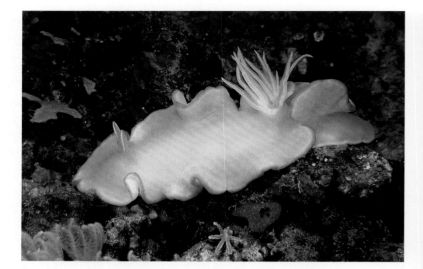

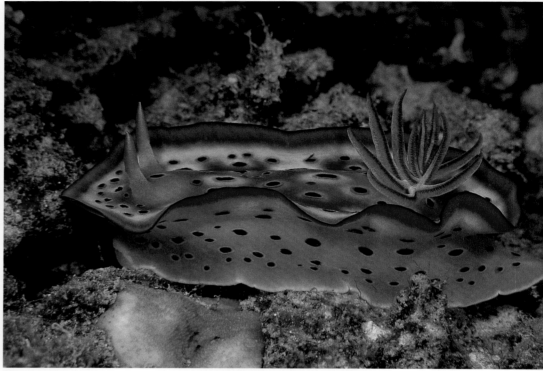

The brilliant colours and patterns of dorid nudibranchs, such as Ardeadoris egretta *(top) and Kunie's chromodorid (above right) are thought to advertise the fact that their toxic flesh is inedible. Like the nudibranchs, the cuttlefish (above) is a mollusc. This juvenile animal has adopted a mottled camouflage pattern to conceal itself in the surrounding* Halimeda *algae.*

and octopuses. These animals have rightly been referred to as the "quiet intelligence". They have the most sophisticated nervous system of all invertebrates and frequently exhibit an apparent reasoning ability that is amazing.

I once encountered a large octopus craning from a crevice in the reef, its head swaying and eyes bulging as it focused on my approach. Flushes of colour mottled its body, indicating its apprehension at my presence. My hand was at the entrance to its shelter and the octopus snaked one of its tentacles out from another hole some distance away. It touched my gloved hand and with a gentle delicacy, carefully felt the shape and texture for several minutes before its curiosity was satisfied. I then took off my glove and moved my hand to where the octopus could see it. This time, after a brief touch with its tentacle, the octopus swiftly threw a loop over my bare hand and tried to pull my arm down into the crevice. When I resisted, the octopus quickly released its grip and shoved my hand away before withdrawing into its hole with a flash of angry mottling. I was delighted by this encounter. The octopus had clearly demonstrated both curiosity and responses that could only have been dictated by real intelligence.

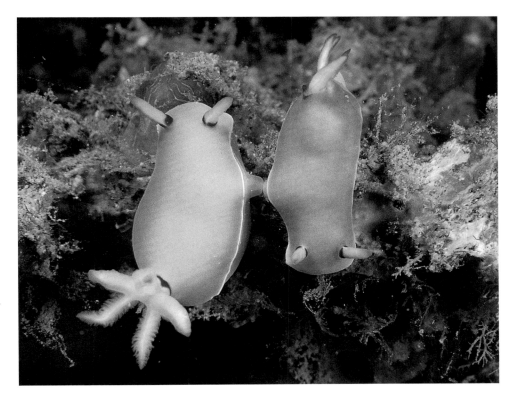

Although nudibranchs are hermaphroditic, they do not fertilise themselves, instead, two individuals will exchange sperm capsules, as the 3 cm HYPSELODORIS BULLOCKI *mating at left are doing. Subsequently, eggs are laid in beautifully delicate, coiled, ribbon-like bundles, hatching into free-swimming larvae called veligers. Veligers may drift in the currents for days, weeks or even months until they settle on a suitable reef substrate, which is often the pre-ferred food, such as a sponge. The bryozoan colony (below) has attached itself to the branches of a black coral tree. This species is somewhat erroneously called a lace coral. While it is not a coral – though it does have a limey skeleton – the reference to lace is obvious. This particular colony is about the size of a thumbnail.*

Bryozoans

Bryozoans – the name means "moss animal" – are inconspicuous creatures, easily overlooked or mistaken for algae, as 19th-century naturalists considered them to be. With origins stretching back half a billion years, bryozoans are one of the first colonisers of the coral reef, their moss-like encrustations soon covering bare reef rock exposed by storm damage. The fact that they are highly variable in both colour and form – sometimes within a single species – is probably due to factors such as current and wave action, the material on which they're growing and the amount of available light.

Bryozoans, like reef-building corals, grow as colonies. Some species, such as lace corals, with their rigid skeletons with many openings (hence the reference to lace), may be highly branched, tube-like or markedly folded, resembling delicate plants. You'll find them on the undersurface of rocks in shallow water or growing on the ceilings and walls of coral caves.

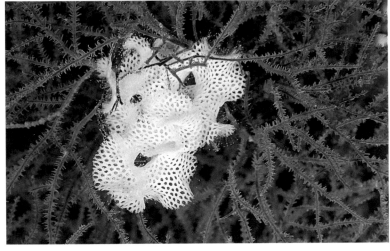

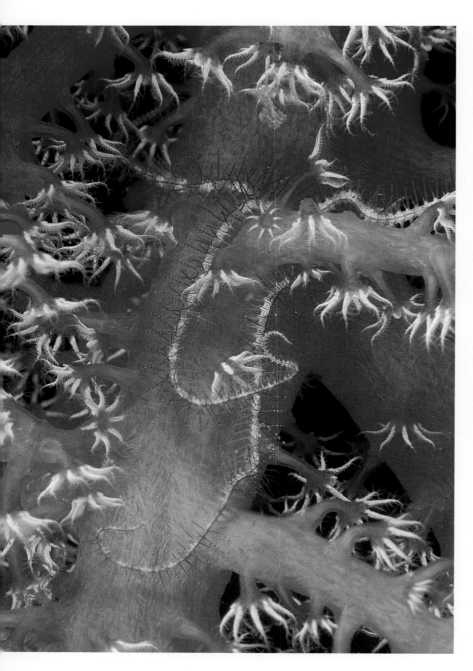

Echinoderms

The echinoderms – meaning "spiny skin" – are easy to recognise: they're the sea stars, brittle stars, feather stars, sea urchins and sea cucumbers. Most divers or snorkellers will be familiar with these animals as they are abundant on the reef and, after the corals, are some of the most obvious invertebrates. You'll spot the sea stars just about everywhere, among the corals, on the sand and seagrass flats and on rocky outcrops.

The colourful feather stars, or crinoids, like to position themselves where the currents can deliver their planktonic food. You'll find some of them attached to high points on the reef – often crowding together on rocky outcrops and perched on sea fans and the long flexible ropes of whip coral, or sea whips. Others are hidden in crevices and under rubble during the day, emerging to feed only at night.

The long-armed brittle stars are less obvious, preferring a somewhat secretive existence. Turn over a rock in a tidal pool and you'll often see several brittle stars rapidly squirming for shelter (don't forget to replace the rock in its original position). The most notorious of the GBR echinoderms is the crown-of-thorns starfish – or COTS as it's popularly known. This animal feeds on coral polyps and huge population out-breaks have seen it virtually destroy the coral cover on some reefs. Once thought to

Brittle stars – like the species at left draped around a soft coral tree – are highly mobile echinoderms. They frequently use sea fans, sponges and corals as a daytime platform for catching microorganisms carried by the currents. It is thought that the spines on the arms of this type of brittle star discourage predators and so allow it to expose itself during the day (most brittle stars are secretive animals). They take their name from their habit of dropping their arms at the slightest pressure, this is a defense mechanism analogous to a lizard dropping its tail.

be a serious threat to the reef's long-term survival, nowadays COTS outbreaks are generally regarded as a naturally occurring event in the reef's continuing life cycle.

The sea urchins, with their characteristic array of spines, are easily recognisable. Most species are nocturnal, sheltering by day in crevices in the reef where they lodge themselves firmly by means of their spines. However, one GBR type, the long-spined black *Diadema*, is sometimes exposed in some areas during the day and may congregate in large numbers on shallow rubble areas. You should be wary of this urchin's very long needle-like spines, which will break off in your skin at even the slightest touch. Urchins move by means of many tube "feet" on their undersurface, as do the sea stars, and can also use their spines. Urchins primarily graze on algae, though some species feed on sponges and sea squirts.

The sea cucumbers, or holothurians, usually found in sandy areas, are also known as trepang and bêche-de-mer, and are a highly prized delicacy in Asia. Like all echinoderms they possess the characteristic tube feet, which they use for movement to a greater or lesser degree, depending on species. They ingest large amounts of sand, extracting the edible organic material and expelling the grains and, through this feeding process, appear to play a major role as cleaners of the sandy ocean bottom.

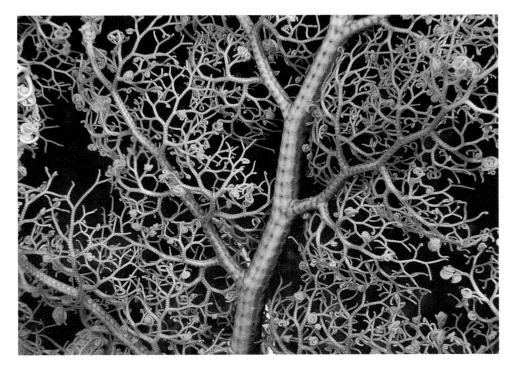

The animal at left – for it is an animal and not a plant – is a species of starfish called a basketstar. By day these creatures shelter in crevices, coiled up to about the size of a grapefruit. At night they move out to a high point on the reef where they fully open their multibranching arms to trap planktonic food – the tightly coiled small branches of the animal here hold such prey. The spiny sea cucumber (above) discharges sand and mucus after extracting the bacteria and other organic material it feeds on. The discharged sand forms a major part of the substrate of the reef.

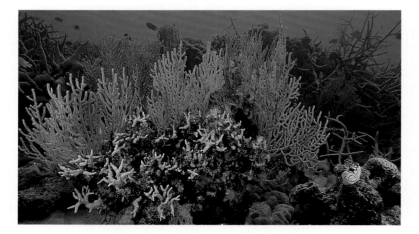

In the reefscape above, a solitary ascidian, or sea squirt, stands out as a splash of bright yellow at the right, though this species occurs more commonly as a purple and white colour form. Colonial ascidians can grow as large, flat sheets or form complex three-dimensional structures. The species at right grows to about the size of a marble. During its tadpole-like larval stage – which may last from 10 minutes to 6 hours – the free-swimming animal must settle on the reef in a site suitable for its future development as an adult. Field studies have shown that the larva will swim away from bright light to find a shaded place on the reef. This is why ascidian colonies are at their most abundant on the ceilings and walls of coral caves or under rocky overhangs on the reef.

Ascidians

Ascidians – or sea squirts as they are commonly called – are one of the filters of the reef. Basically they are a simple sac with two openings; one for drawing water in – the incurrent aperture – and the other for expelling it – the excurrent aperture. As the water passes through their bodies, microscopic food particles such as plankton and bacteria are filtered out. One 3 cm long ascidian can filter a litre of water in an hour.

Interestingly, they are classified as chordates – the same group of animals that includes the vertebrates, as the tail of the larval ascidian has a primitive cellular structure similar to the backbone of a vertebrate embryo. Ascidians come in a bewildering array of colours and forms. A couple of the more common types that you will see on the reef are the fist-sized, purplish-white solitary ascidian and the clusters of fingernail-sized colonial ascidians crowded tightly together, looking like so many miniature greenish-grey urns.

DANGEROUS INVERTEBRATES OF THE GREAT BARRIER REEF

Think of a sponge – a more benign creature would be hard to imagine. Yet I still have scars on my arm more than 30 years after accidentally brushing against a stinging fire sponge. Sponges are among the many marine invertebrates that defend themselves with a stinging apparatus or by exuding a toxin from their bodies. In most cases these mechanisms have little or no effect on humans, but the possibility of injury from contact with an unknown marine invertebrate always exists. The simple message to divers and snorkellers is: if you don't know what something is, *don't touch it.*

The box jellyfish

The most feared invertebrate in the GBR region is the box jellyfish – and rightly so. Contact with its stinging tentacles can cause death within five minutes from heart and breathing failure. Box jellyfish don't normally occur on the reef proper; they are inhabitants of shorelines and estuaries. During the summer months they're seen along the inshore northern coast, where stinger nets are placed at popular swimming beaches. You should not enter the water – even to ankle depth – outside the nets from October to May.

Immediate first aid for a box-jellyfish sting is to drench the wound liberally with vinegar, which inactivates the stinging cells within a few minutes. Tentacles sticking to the victim should be removed after the vinegar wash, preferably using tweezers or even a twig. Cardiopulmonary resuscitation (CPR) and expired air resuscitation (EAR) may be necessary should breathing failure or heart failure develop. Medical attention should be sought without delay.

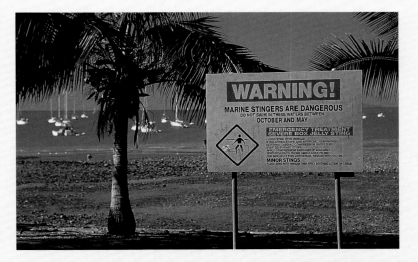

The risk of contact with the deadly box jellyfish (right) is very real in inshore waters of the GBR from spring to autumn, when they gather at river mouths and estuaries to spawn. Warning signs, such as this one at Airlie Beach in the Whitsundays (top) are prominently sited at all popular mainland swimming beaches. Box jellyfish are quite large. The "box" or bell, can be more than 15 cm across, and the trailing tentacles can reach a length of more than 4 m. With the stinging cells on their tentacles containing enough venom to kill 60 adult humans, the box jellyfish is the most venomous creature on the planet. An antivenom for box-jellyfish stings was developed in 1980 by scientists at the Commonwealth Serum Laboratories.

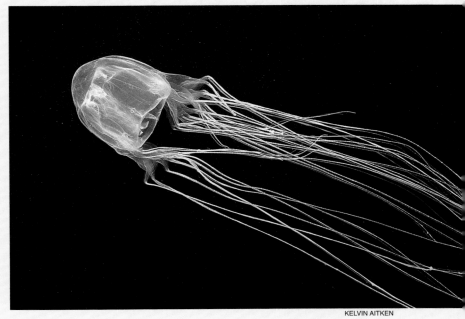

KELVIN AITKEN

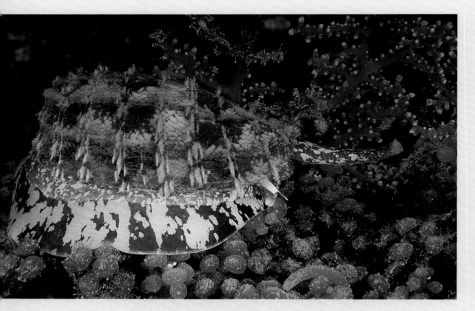

The geography cone (above) has been responsible for human deaths on the GBR. These large molluscs, which reach a length of around 8 cm, are fish eaters. They catch fish by firing from their proboscis a tiny harpoon that injects venom into the prey. This harpoon is attached by a long, thin filament to the inside of the mollusc's mouth. The captured prey is then reeled in and eaten. In humans, death from cone-shell venom usually results from respiratory or cardiac failure. Cone shells are nocturnal, by day they shelter under dead coral slabs – sometimes in tidal pools on the reef. Reefwalkers often turn over coral slabs when searching for hidden invertebrates. Picking up a cone shell is potentially life-threatening as it may result in a sting.

Irukandji

The Irukandji is a small jellyfish (a body length of only 1–2 cm), but the four stinging tentacles can vary in length from 5 cm to 1 m. Because of its size it often goes unnoticed, and most stings occur during summer near the surface in shallow water, though they also occur out to sea 30–60 cm from the surface. The earliest and most common symptom is lower-back pain, with muscle cramps, nausea, severe sweating and respiratory distress experienced for as long as 2–6 hours after the sting. These symptoms should dissipate within 12 hours. Treat as for box jellyfish and always seek medical attention.

The blue-ringed octopus

The blue-ringed octopus does occur on the GBR, though it is not often seen, more likely due to its secretive habits than to actual rarity. It is a small animal, the spread of its tentacles about the size of a human palm. The bite of this octopus, while usually painless, is potentially fatal and death can occur within hours from breathing failure. Immediate first aid is to wrap the bite site firmly in a crepe bandage (if the bite is on a limb the entire limb should be wrapped) and the victim should be taken to a medical facility without delay. If you are a long way from shore, you may have to keep up EAR until you reach medical help.

Cone shells

Cone shells are also venomous and, while most are harmless to humans, some large species such as the textile and geography cones are potentially deadly. Cone shells are very common on the reef, both in tidal pools and at depths down to more than 30 m. Treatment of a cone shell sting is the same as for blue-ringed octopus bite.

The crown-of-thorns starfish

The spines of the crown-of-thorns starfish are covered with a toxic substance and are capable of delivering a very painful sting, so take care not to place your hand on one.

Corals

Contact with fire coral and hydroids can result in a sharp burning pain that leaves raised welts and may itch for some hours afterwards. You should familiarise yourself with the appearance of both these common reef animals and avoid contact with them.

The real danger from coral cuts and scratches lies in secondary infection, so coral wounds should be thoroughly cleaned and a suitable antiseptic applied.

Sea urchins

The needle-spined sea urchins, *Diadema* spp., are often very common on fringing reefs and it's easy to step on one. The spines can penetrate deeply (even through a flipper or wetsuit boot), invariably break off and are very difficult to remove.

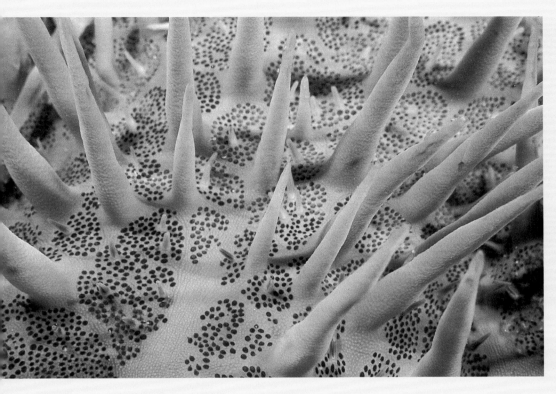

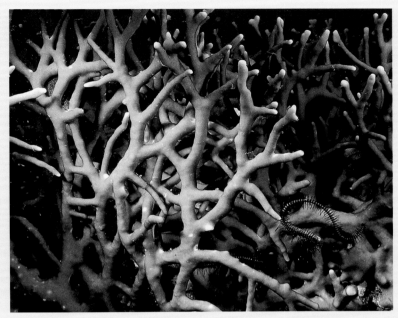

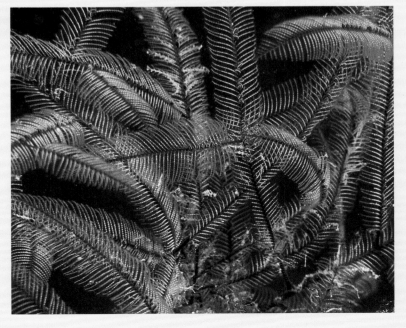

The skin on the spines of the crown-of-thorns starfish (above) is toxic, causing severe pain if the spines break the skin of an unwary swimmer. The spines, which can be 5 cm or more in length, are capable of penetrating a wetsuit. There are several species of fire coral (top right) on the GBR. These corals, which can grow as large colonies more than a metre across, occur both in shallow water, where they are a threat to snorkellers, and on reefs in greater depths, where scuba divers may come into contact with them. Much easier to overlook are the almost transparent delicate fronds of stinging hydroids (right). These are often only a couple of centimetres in length, though some species have fronds growing to 10 cm. Wetsuits and lycra body suits protect against stings from fire corals and hydroids.

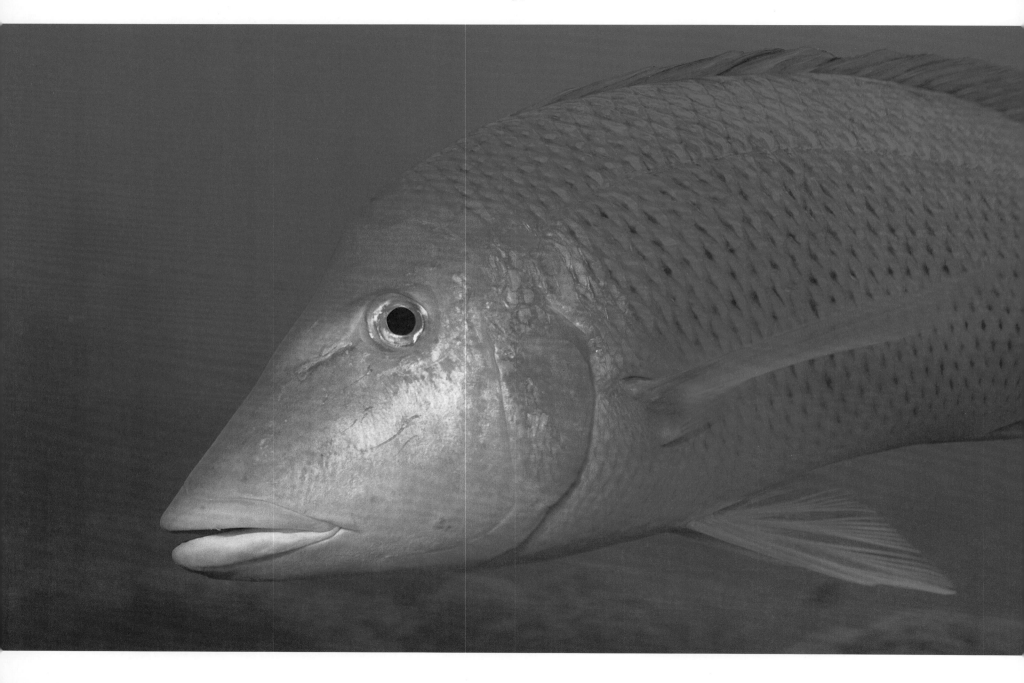

Backboned denizens

Vertebrate animals of the Great Barrier Reef

Fish have exploited almost every conceivable submarine niche on the GBR, immeasurably contributing to the character of the reef with their gaudy hues and patterns, and providing a kaleidoscope of colour and movement that has no terrestrial rival. Also, unlike land vertebrates, many coral reef fishes – like the long-nosed emperor opposite – seem possessed of an innate curiosity towards humans, and will often initiate a close approach.

Fish

Of the 1500 or so species of fish that have been recorded on the GBR, more than a third may inhabit a single reef of one hectare. Not surprisingly then, for the first-time visitor it is the fish living in, above and around the corals that are the most immediately obvious denizens of the reef.

Whether gained from an underwater observatory, a glass-bottomed boat, or while swimming among them with snorkel or scuba, the overwhelming impression you have of GBR fish is one of frenetic activity. As you pass over a tabletop coral, the clouds of blue-green *Chromis* damselfish hovering above it immediately sink down into the coral branches as one. Sleek wrasses dash here and there, only pausing momentarily to peer into crevices in the reef. Gaudy butterflyfish pick daintily at the living coral, extracting the polyps and other tiny invertebrates that they feed upon. Goatfish nose through the sand, clouds of dust streaming from their gills as they filter out tiny worms, molluscs and crustaceans. Brilliantly coloured clownfish bob and weave through the tentacles of their anemone host, flaunting their immunity to the potentially deadly stings. Minute plankton-feeding gobies rest upon the branches of sea fans while other larger species perch at the entrances of their burrows in the sand, disappearing into them in the blink of an eye if danger approaches.

To the casual observer all this activity may seem chaotic; nothing less than milling confusion. But this is not so. Every fish species is part of the reef's complex ecosystem and every individual fish is going about the very ordered business of its daily existence. Take the time to carefully watch the fish on a small section of reef and you will be rewarded with an insight into their lives.

Colours, camouflage and mimicry

In a coral-reef ecosystem where competition for available resources is fierce and population densities are high, it's important to be able to recognise kin. Colour and pattern can help to identify a potential mate among so many other species, or to indicate to your own species that a particular patch of reef is occupied. Conversely, camouflage can assist if you are an easy meal for a predator or if your prey is quicker than you. Many small gobies are almost transparent, rendering them

effectively invisible, whereas the bright colours and patterns of other fishes may be an equally effective camouflage, the high contrast breaking up their body outline. Inactive species such as the scorpionfishes, lizardfishes and flathead have evolved a colour and pattern similar to the mottled surfaces on which they perch. When a potential meal passes close by they are instantly alert, seizing their prey with a speed that belies their apparent sloth. Still other fishes are effective mimics of corals and seaweeds or other marine species that predators recognise as toxic or otherwise unpalatable.

Territories and home ranges

If you dive on the same reef often enough, you'll soon come to recognise individual fish and their behavioural traits. The majority of coral-reef fish have a well-defined territory and they're almost always to be found within its confines. For some species, such as certain damselfish, the territory may be quite small – perhaps only a few square metres – and they will vigorously defend it from any interlopers. Other fish have a wider, less-defined, home range; a large section of reef that they regularly patrol. While territoriality in coral-reef fish is a very complex aspect of the reef's social structure and is not yet fully understood, there are two basic motivators that usually play a major role – feeding and reproduction.

Even the eyes of this flathead, or crocodile fish (below right), are camouflaged, matching the mottled, disruptive patterns on its body. This enables it to escape detection by the smaller fish it preys on, grabbing them with its gaping mouth should they pass close to it as it lies partially buried in the coral rubble on the reef floor. The juvenile hawkfish (below) relies more on speed than camouflage for capturing prey. Having no swim or gas bladder, to maintain equilibrium in the water column, it perches on coral and rock outcrops on the reef, its eyes constantly turning this way and that as it waits for careless small fish or invertebrates to come into range – whereupon the hawkfish will dart out from its perch and seize its prey.

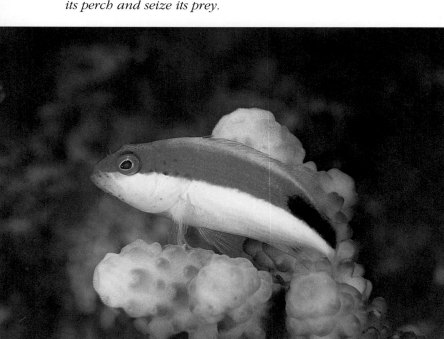

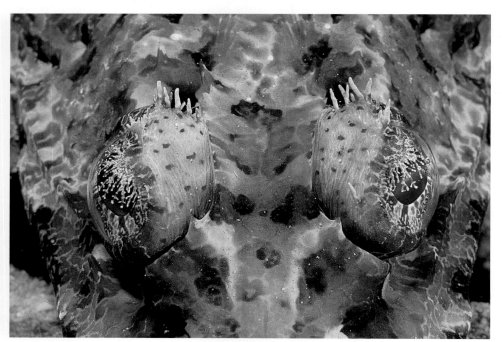

THE CHEMICALLY CAMOUFLAGED CLOWNFISH

Why isn't a clownfish stung by the tentacles of its host anemone? Like all fish, the clownfish has a protective mucous coating on its skin. But clownfish coatings contain chemicals that literally take the sting out of anemone tentacles. Anemones don't sting themselves because the nematocysts – stinging capsules – on their tentacles chemically "recognise" the anemone's own mucus, and the nematocysts don't discharge. A clownfish's mucous coat acts in much the same way.

There are currently two schools of thought on where or how the clownfish got its marvellous protective coat. One theory is that it obtains the chemical elements directly from anemone tentacles. This is based on observations of both wild and captive fish. When clownfish encounter an anemone after not having been in contact with one for several days or longer, they go through an elaborate "acclimatisation" procedure. Initially they lightly brush against the tentacles, often reacting in a way that indicates they've been stung. Gradually they increase the amount of contact until finally they're able to nestle comfortably among the tentacles. The period of acclimatisation may last from 10 minutes to several hours.

The other theory is that the clownfish comes complete with its own chemical "armour" as a result of evolution.

Many scientists now believe that both theories are correct. The clownfish does produce its own chemical camouflage, but this still needs to be "topped up" by regular contact with anemone tentacles.

A female spine-cheeked clownfish (right) peers from the shelter of her protective host anemone, while below her, partially obscured by the tentacles, is another fish, possibly her mate. Among clownfish the dominant fish in the anemone is always female. Unlike many other groups of reef fish, which undergo a sex change from female to male, the clownfish opt for the reverse – in their small family group confined to the tentacles of the anemone, there is normally a single breeding pair and several juveniles. If the dominant breeding female dies or is removed from the anemone, her male partner changes sex and at the same time the largest juvenile will rapidly mature and assume the sexually reproductive male role.

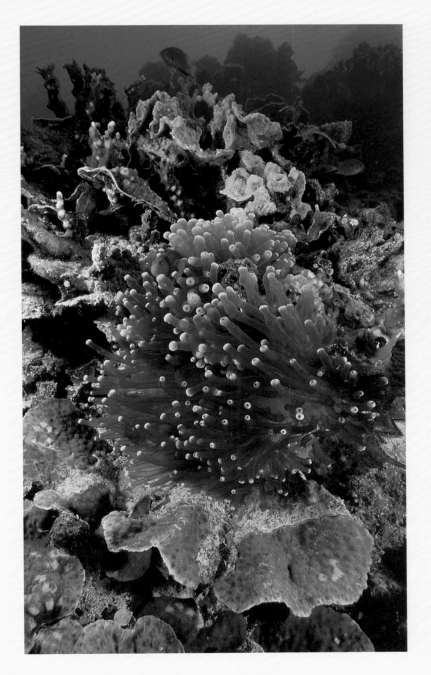

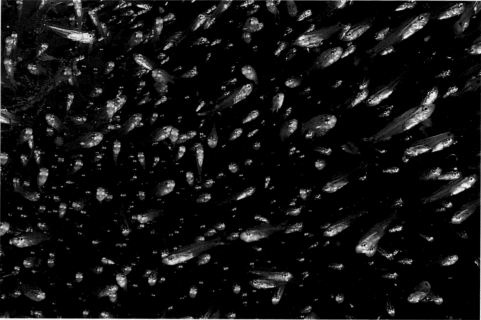

KEVIN DEACON

The minifin parrotfish (above) is an inhabitant of the outer reefs, where it occurs in large schools, often in very shallow water. Parrotfish take their name from their beak-like mouth, an adaptation used for grazing on algae-covered rocks. Reef caves shelter golden sweeper in their thousands during the day (top right). The sweeper emerge to feed on plankton at night. A school of damselfish (opposite) feed on drifting plankton. The staghorn coral below them and the water column immediately above it represent their whole world. The branches of the coral provide them with shelter from predators and the currents bring them food. For this latter reason, schooling damselfish and other plankton-feeding fish are at their most active at the change of the tide, when currents reverse.

Feeding

Parrotfish, surgeonfish, rabbitfish and other such herbivorous species are the grazers of the reef. Foraging widely in large, often mixed, schools, they crop the coating of algae that grows on almost all exposed rocky surfaces. However, most GBR fishes are carnivores and both their food items and feeding strategies are as varied as the fish themselves. Many of the butterflyfish feed exclusively on coral polyps. Others such as the bumphead parrotfish and some of the triggerfish and pufferfish are less delicate – they eat corals, limey skeleton and all.

Some of the reef's smallest and largest fish feed on plankton. The diurnal damselfish and fairy basslet feed in the water column above the reef, taking individual planktonic organisms as they drift by in the current, as do the night feeders – the nocturnal squirrelfish and cardinalfish. The giant whale sharks and manta rays also feed on plankton, straining it from the water through their gaping mouths as they cruise the deep waters outside the reef. Grouper and snapper patrol through the coral, seeking out the unwary fish that may become a quick meal. Fish that occur in huge schools of many thousands such as the sweeper and silverside would seem to be an easy mark for predators, but in fact their sheer numbers afford them protection; in such a constantly moving mass, a predator has difficulty homing in on an individual.

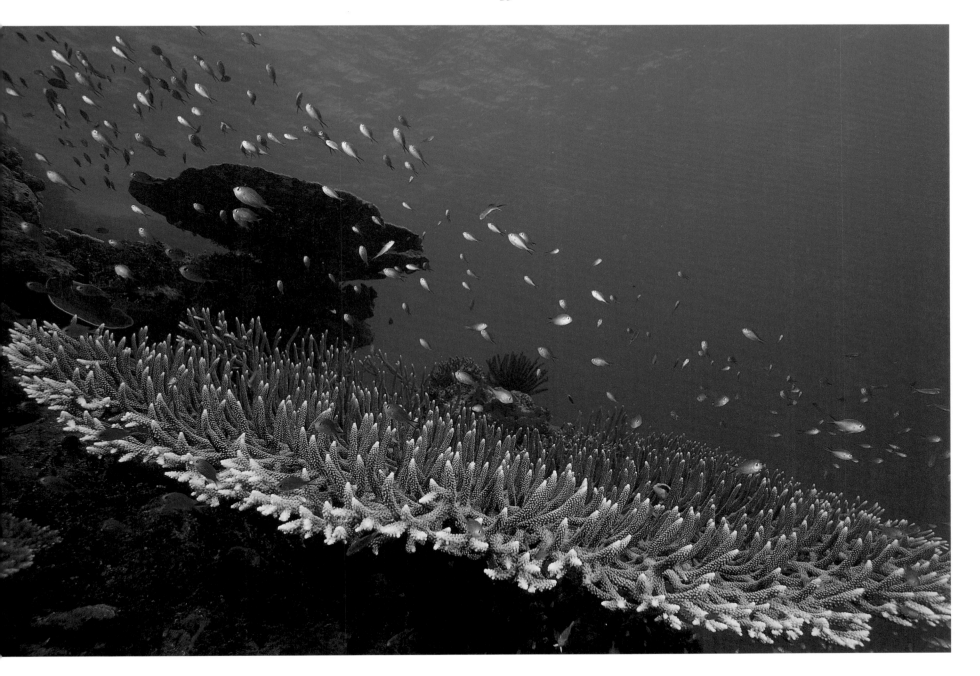

The drummer, or sea chub (above) usually occurs in small schools near the surface above the reef. Although they are omnivorous, their main food is comprised of drifting particles of algae. The lateral line of the fish in the centre is very distinct. This is a sensory structure used for detecting vibrations in the water, which could indicate the approach of a predator. The damselfish (opposite top) will zealously and aggressively guard its clutch of eggs, which appear as a grey area covering the branch of the sea fan behind it. Many fish form life-long pair bonds. This is true of the angelfish and the batfish, a pair of which indulge in some synchronised swimming above a Heron Island reef (opposite below).

Reproduction

Most reef fish lay eggs. Only a very few, such as some of the sharks, bear live young. Some species, including butterflyfish and wrasse, spawn in open water, usually at dusk. The male and female fish swim toward the surface, releasing sperm and eggs simultaneously before abruptly turning back to the bottom and allowing their fertilised eggs to drift away in the currents. Others lay eggs in crevices or at the bases of corals or sea fans. Damselfish, gobies and blennies belong to this group. They carefully clean the rocky surface of algae and other detritus before laying their eggs, which are then usually guarded by the male parent. Other species have more unusual breeding behaviour. The male cardinalfish carries the fertilised eggs – and later the hatchlings – in his mouth. In a similar manner, male pipefish and seahorses have a special brood pouch on their bellies where the eggs are incubated.

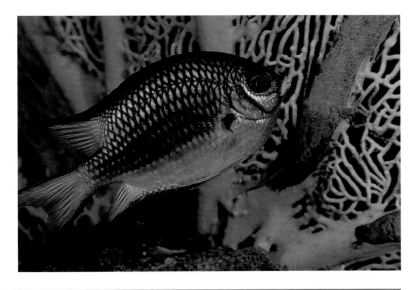

Amazingly, a number of fish change sex. Most wrasse start life as females, later changing to males, as do the grouper, parrotfish and basslet. In these fish there is a social structure akin to a harem: a dominant male will have a group of females in his charge. If the male dies, one of the females will change sex and take his place.

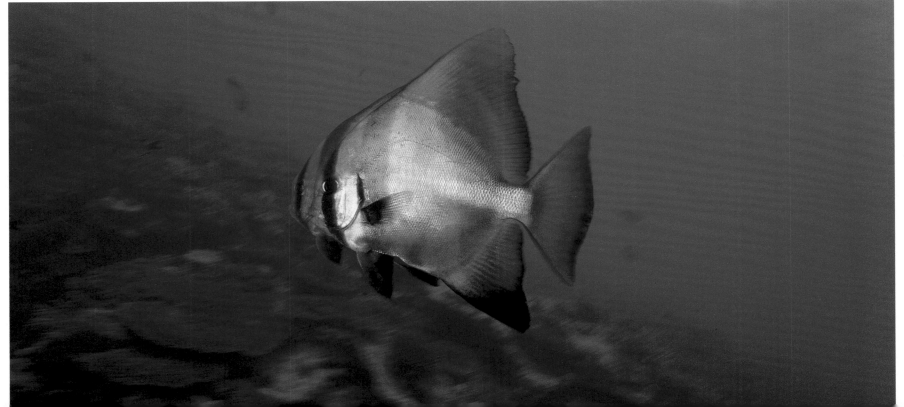

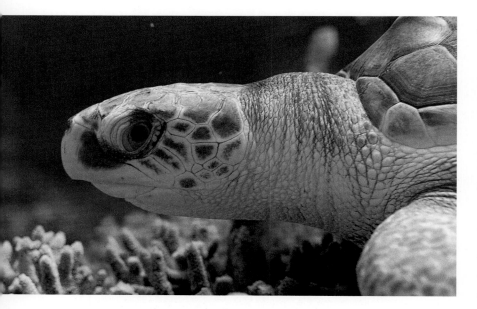

Marine reptiles

Turtles

While diving on a reef slope one night, something hit me from behind; a tremendous blow to my right shoulder that spun me around and knocked the torch from my hand. My thoughts turning to sharks – I knew it was not one of my diving companions who had collided with me as I could see their lights further down the slope – I quickly grabbed my torch from the sand. Illuminated in its beam was the rear end of a hawksbill turtle, blithely paddling off into the darkness. As the adrenaline rush subsided, I mumbled a few choice words into my regulator concerning the turtle and its immediate family – but with a smile, for I must admit to having a great deal of affection for these beautiful marine reptiles.

The green turtle is the most likely of this group to be encountered on the GBR. It is abundant in the lagoons and outer reef, down to depths of 30 m. Like all turtles, the green is protected in Australia (though it may be legally taken for food by Aboriginal people and Torres Strait Islanders). The green turtle is exclusively herbivorous when adult, feeding on various seagrasses, though very young greens do take fish and crustaceans. Other turtles occurring in GBR waters are the loggerhead and one of the smaller of Australia's sea turtles, the hawksbill. Less often encountered

Although common around the coast of the Northern Territory, the Pacific ridley (above) is only occasionally encountered in the far northern region of the Great Barrier Reef, though it is by no means common. It feeds mainly on shellfish and crustaceans. The hawksbill (right) is also a carnivorous species, feeding on a variety of vertebrates and invertebrates. They have even been observed eating the deadly box jellyfish. The animal here is a male, indicated by the length of its tail, which accommodates the penis; in female turtles the tail barely protrudes beyond the edge "of the carapace. Hawksbill turtles are found in tropical waters around the world and, although they are not uncommon on the GBR, they rarely nest here.

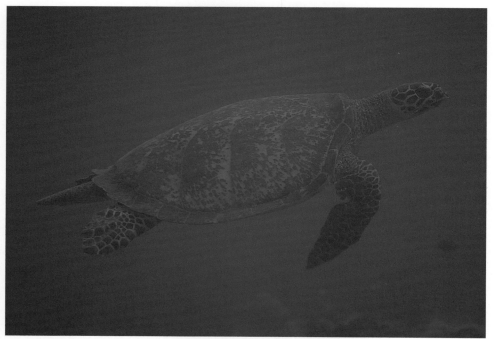

are the Australian endemic flatback turtle and the huge leatherback, or luth, while the Pacific ridley is a very infrequent visitor.

You can sometimes get quite close to a turtle while diving, if you move very slowly and do not alarm the animal. Indeed, mature male turtles may actually approach a diver, particularly during the nesting season when they are actively seeking females. It may well be that a scuba diver appears sufficiently similar to a potential mate as to stimulate sexual curiosity in the male turtle.

Sea snakes

About a dozen species of sea snake occur on the Great Barrier Reef and all are venomous; however, like terrestrial snakes, most are by nature inoffensive and will avoid contact with divers or snorkellers. The notable exception is the olive sea snake, which possesses an insatiable curiosity where divers are concerned. Not only will it often make a beeline for you, it may decide to wrap itself around your arm or leg – its disconcerting familiarity extending so far as to peer into your face mask. While the snake is venomous, it will generally only bite if provoked – so remaining calm will see you through such an encounter. The wreck of the *Yongala* off Townsville is renowned for its large resident population of olive sea snakes.

Green turtles usually return to the same place on the reef to sleep, often in a coral cave, sometimes in the open. This young green turtle (above) was sleeping on the reef top at a depth of 10 m (I have seen them at 30 m) when I encountered her on a night dive. The banded sea krait (left) is not common on the GBR. It feeds exclusively on eels and is highly venomous, though there are no known instances of it biting a human. Unlike all other sea snakes, which bear live young, the sea kraits lay eggs on land, leading herpetologists to believe they are venomous land snakes that live in the sea, rather than true sea snakes.

Seabirds

The first sensations to assail you at a large seabird colony on one of the GBR's many offshore cays will be sound and smell. The boisterous screeching of the birds is deafening and the rich heady smell of accumulated guano hangs heavy in the air. Michaelmas Cay off Cairns is one of the most accessible and popular of the seabird rookeries for visitors. It is also one of the largest in terms of bird numbers – during the peak of the breeding season, from September to March, there may be up to 30,000 birds on this small sandy cay, mostly sooty terns. The islands and cays of the Capricorn and Bunker groups are arguably the most important of the seabird rookeries of the entire Great Barrier Reef Marine Park. Many hundreds of thousands of wedge-tailed shearwaters, black noddies and several species of tern use these islands for both roosting and breeding. Heron Island is seasonally home to upwards of 75,000 black noddies.

Nesting seabirds are highly sensitive to disturbance; some species more than others. Adult birds under stress may abandon their nests, leaving eggs or hatchlings to perish. Ongoing management plans for seabird rookeries attempt to balance human intrusion – whether it be from recreational use, fishing, research, boating or low-flying aircraft – against the wellbeing of the bird colony. For this reason, many of the larger rookeries are closed to visitors from September to March.

Seabirds – such as the masked booby feeding its chick (below) and the juvenile lesser frigatebird (below right) – were inhabitants of the GBR islands for many thousands of years before the arrival of humans. They play a major role in the exchange of nutrients between the sea and the offshore cays where they roost and nest. Their droppings contain essential fertilisers for the vegetation on those cays; and such vegetation is essential for the long-term stability of the cay. It has been found that a single person entering a seabird colony during the nesting season may seriously disrupt egg-laying and parental care of the eggs and chicks throughout the entire colony. Even without human interference, there is a high mortality from natural causes in seabird colonies; many chicks die from starvation or exposure, or are killed by predators.

PHOTOS: GRAHAM ROBERTSON

Marine mammals

Whales and dolphins

Whether you're a first-time sailor or seasoned mariner, the thrill of watching dolphins ride your vessel's bow waves never diminishes. I vividly recall travelling by boat over an oil-smooth sea one moonless night, accompanied by a large pod of dolphins. As they cavorted around the bow, their entire bodies were ablaze with the bioluminescence of tiny marine organisms, appearing as glowing green torpedoes hurtling through the dark water. Once-in-a-lifetime encounters such as this live forever in your memory.

Strictly speaking, the cetaceans – whales and dolphins – are not coral-reef animals. However they do occur in the GBR region, and dolphins are common in the lagoon waters. The common bottlenose and smaller spinner dolphins are the species most likely to delight visitors to the reef with their bow-riding antics. Spinner dolphins are so named because of their acrobatic habits, leaping vertically out of the water to a height of several times their body length, somersaulting and twisting around in the air before crashing back into the sea.

While blue, fin, sei and minke whales have all been recorded in GBR waters, it is the humpbacks that have captured the hearts of visitors to the southern section of the reef. Every year more than a thousand of these gentle giants make the 5000 km journey from Antarctica to their tropical breeding grounds off the eastern coast of Australia. Pods of whales arrive at the southern end of the reef around the middle of June and over the following weeks they move northwards to congregate in the southern Whitsundays.

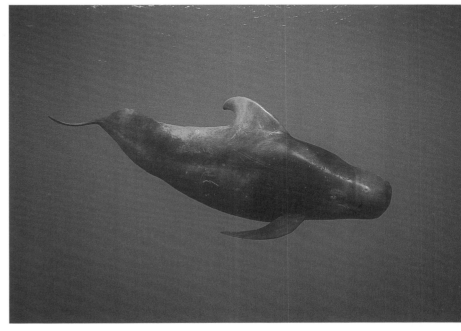

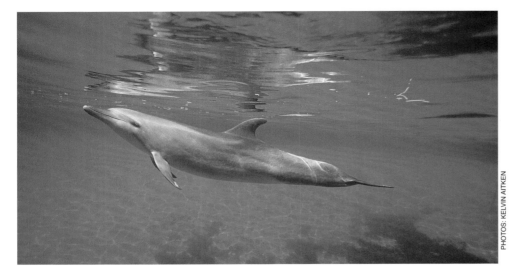

PHOTOS: KELVIN AITKEN

Pilot whales (above) are potentially dangerous to humans – there are records of bull pilot whales behaving aggressively towards divers and snorkellers who have approached them too closely. Bottlenose dolphins (left) are the most common dolphin species encountered in GBR waters, with groups of them sometimes seen only a few hundred metres off mainland beaches.

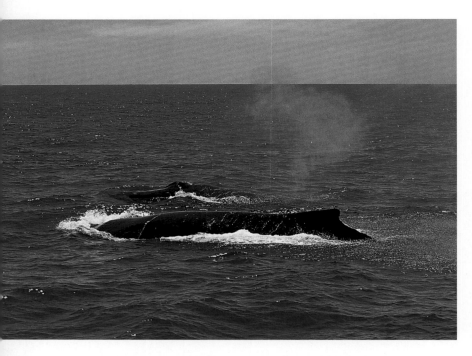

Winter visitors to the southern GBR are most likely to encounter humpback whales as a pair (above). In this case it is a bull escorting a cow, though it may also be a cow–calf pair. Organised whale-watching cruises are popular in the Whitsundays during winter and bareboaters often encounter humpbacks at this time of year. There are strict marine-park regulations regarding small boats and whales, and anyone planning a bareboat holiday in the Whitsundays during the humpback migratory season should be familiar with these guidelines. The dugong (opposite) is a distant relative of the elephant and belongs to an order of marine mammals termed Sirenia, derived from the sirens of Greek mythology. They eat seagrasses, which they uproot from the sea bottom, using their very muscular lips.

Dugong

The dugong, or sea cow, is under serious threat over most of its range in the tropical Indo–Pacific and is listed as vulnerable to threat of extinction by the World Conservation Union. The large numbers of dugongs in GBR waters was one of the reasons the region received World Heritage listing, and Australia's tropical northern seas may provide its last hope of survival.

Living for more than 70 years and bearing a single calf every 3–7 years, the dugong feeds almost exclusively on several varieties of seagrass that grow in shallow coastal areas. This dependence puts it in direct contact with humans who use the same marine areas for recreation and commercial activities such as fishing.

A cottage industry for dugong oil, which was thought to have miraculous medicinal properties, was intermittently established at several places along the coast of the GBR region from the middle of the 19th century until the 1960s. Aboriginal people and Torres Strait Islanders still accord the dugong great cultural and dietary significance and regard dugong hunting as a very important expression of traditional life. It is still allowed under permit in some parts of the region.

A series of aerial surveys conducted since the mid-1980s suggests that dugong numbers are stable in the remote regions off the coast of Cape York. However, along the more urban coast south of Cooktown, aerial surveys indicate that the population has declined significantly, and anecdotal information suggests that this has been occurring for decades.

In August 1997, the Australian and Queensland governments agreed to several measures aimed at arresting this decline, including a resolution not to issue permits for hunting dugongs south of Cooktown. The agreement also established a two-tiered system of Dugong Protection Areas, with the aim of reducing dugong deaths caused by gill nets.

Because dugongs are such slow breeders, it will be many years before the results of these efforts can be measured. One of the most important protection areas is based in the waters around Hinchinbrook Island where there are concerns about the impacts of large-scale tourism and marina development on dugongs. Another is close to Townsville where there is extensive port development.

The Australian Government has placed a high priority on conservation of GBR dugong populations, but maintaining dugongs and their habitats throughout this vast region will be a considerable challenge.

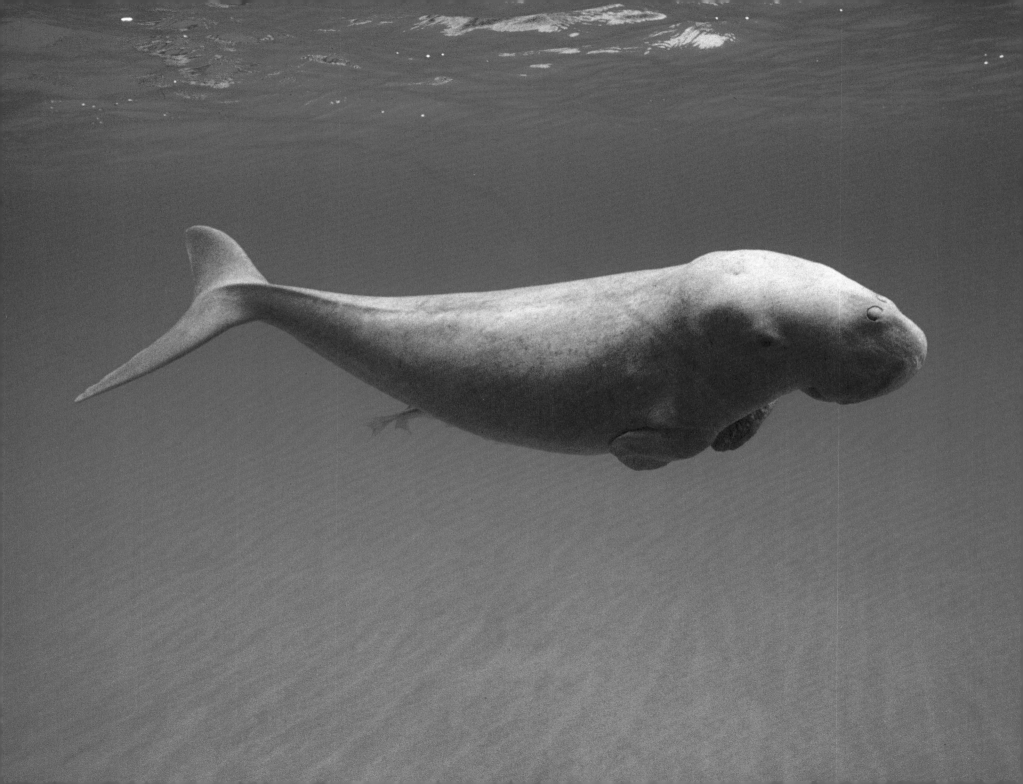

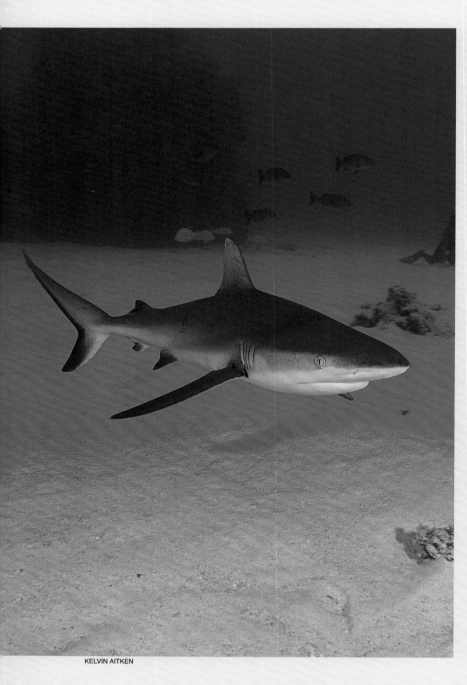

KELVIN AITKEN

Dangerous marine vertebrates of the Great Barrier Reef

Sharks

Close encounters with sharks are always exciting and scuba divers who visit the drop-offs on the outer reef have a good chance of meeting one – or more. In most cases this will be the grey reef shark, a species of whaler that grows to about 2 m. While grey reef sharks may come in quite close to have a good look at you, they will seldom behave aggressively. However, you should keep in mind that they are a potentially dangerous species and have been involved in attacks on divers in the tropical Pacific region – typically a single slashing bite in response to the shark feeling threatened in some way by the diver's presence.

In the GBR's lagoon areas two species of small sharks are commonly encountered. The blacktip reef shark is often seen in very shallow water over reef flats. It grows to a little over 1.5 m and, like most sharks, is timid and normally avoids humans, although it has been known to bite at the feet of careless waders. The other shallow-water shark is the whitetip reef shark. This animal is sometimes seen resting on the bottom or under coral ledges and is regarded as harmless.

Large tiger sharks and hammerheads do occur on the Great Barrier Reef, but are rarely encountered by divers, preferring the deeper waters beyond the reef. Tiger sharks, however, are known to come into the shallows at night to feed.

Acting with foolhardy bravado while diving with sharks is asking for trouble. For the responsible diver however, the possibility of being attacked by a shark on the GBR is extremely remote.

Sea snakes

As with sharks, the message is simple: behave sensibly in the presence of sea snakes. If one does happen to make you the object of its underwater attentions, stay calm; a panicky diver is at great risk, not only from sea-snake bite, but also from drowning. Immediate first aid for sea-snake bite is the same as for the blue-ringed octopus (p. 51).

Venomous and poisonous fish

Step on a stonefish and you won't forget the encounter in a hurry. The pain resulting from a wound caused by the venomous dorsal spines of these fish is excruciating – I can vouch for this from experience. Stonefish occur on shallow reef flats and estuaries. If you walk in such areas, always wear sturdy sneakers or heavy-soled wetsuit boots.

If you do get stung, the immediate first aid is to immerse your foot in water that's as hot as you can bear. This breaks down the protein in the venom and the relief is almost instantaneous. This also works for stings from lionfish and scorpionfish.

However, if further symptoms occur – such as paralysis or difficulty in breathing – following a stonefish sting, treatment as for sea-snake bite should be applied and medical attention sought without delay.

Stingrays can occur in the same habitats as stonefish and the same precautions should be taken. If you are unfortunate enough to be stung by a stingray you should seek immediate medical attention. The tail spines are venomous and, because of their size, can cause severe wounds. Some of the sheath that surrounds the spine might be left in the wound, and this can result in serious infection.

Ciguatera – fish poisoning – is caused by a toxic algae that is passed upwards through the reef food chain as predators feed on smaller algae eaters. Such predators cumulatively store the toxin in their tissues. While some species such as the chinaman-fish, red bass, some groupers, mackerel and barracuda are known to be potential ciguatera carriers, it will depend largely on the area of the reef in which they are caught. A fish caught in deeper offshore waters has less chance of carrying significant amounts of the toxin. The best rule is: if you're not sure, don't eat it.

The grey reef shark (opposite) is a very common GBR species of whaler, or requiem, shark growing to around 2.5 m. Grey reef sharks are potentially dangerous and will often approach divers closely, occasionally behaving aggressively, though attacks are almost unknown on the GBR. Whaler sharks take their name from their habit of following the old whaling vessels. Kuhl's stingray (below) grows to around 75 cm in length and occurs in sandy areas adjacent to reefs. It may also occur in shallow estuarine areas, usually burying itself in the mud with only its eyes exposed where it may easily be stepped on by waders. There are several species of lionfish (below left) on the GBR. They all have venomous dorsal spines, though their ornate appearance makes them immediately noticeable.

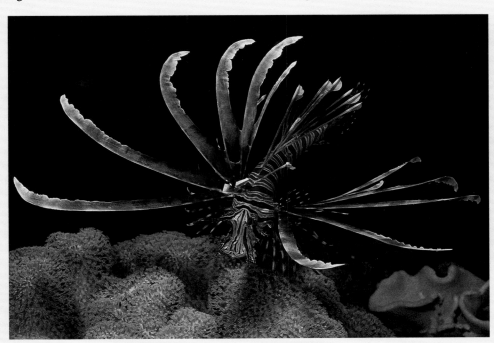

Human contact

40,000 years on the Great Barrier Reef

Aboriginal people and the reef

Tourism on the GBR is generally perceived as a recent advent and, while there is a certain truth in this observation, it is also true that decades before luxury island resorts, high-speed catamarans and scuba diving became synonymous with the GBR, many Australians holidayed in the region. This happy group were visitors to Hayman Island in the Whitsundays around 1920.

With obvious delight, Charlie Veron told me one of his favourite anecdotes relating to early Aboriginal people and the Great Barrier Reef.

"I was once talking with Robin Williams from the ABC and I made the comment that there was a time when Aboriginals hunted kangaroos on the Great Barrier Reef and probably lived in caves under the reefs," he said. "When the interview was broadcast on *The Science Show* the then Director of AIMS was absolutely livid. I was summoned down to his office and told: 'You be a smart alec like that once more and you're fired!' A day or two later he realised his mistake and meekly apologised to me. For of course he hadn't connected sea-level changes on the Great Barrier Reef with the time span of Aboriginal settlement of the region."

Charlie's comments were indeed accurate. Over the past 40,000 years or more, during which Aboriginal people are known to have inhabited the GBR region, fluctuations in sea level and climate produced dramatic environmental changes. How this affected early human populations remains largely a mystery, as much of the archaeological record is now under water.

However, some observations can be made regarding more recent Aboriginal contact with the GBR. Peter Veth, Associate Professor of Archaeology and Anthropology at James Cook University told me of evidence that Aboriginal people had a thriving maritime culture in the region for thousands of years.

"They hunted for shellfish, dugong and turtles – the latter two mostly by spearing," Peter said. "They also took fish using very large fish traps comprising circular stone enclosures. They used bark canoes as well as dugouts in the far north, often with outriggers – most likely because of contact with Torres Strait and Papuan peoples. They also traded goods up and down the coast – shellfish, turtle eggs and such. Although there is no evidence of the elaborate 'saltwater' tradition of some of the Melanesian peoples in the South-west Pacific region, nonetheless they were pretty much exclusively maritime in their lifestyles."

After the formation of the GBR's continental islands around 6000 years ago, Aboriginal people occupied them over the following millennia. Detailed archaeological site surveys and excavations, however, have been undertaken on only a

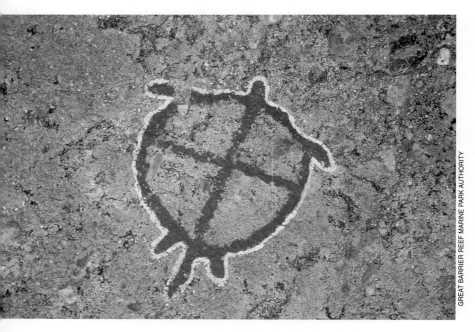

GREAT BARRIER REEF MARINE PARK AUTHORITY

People have left their mark on the GBR in many ways. On a cave wall at Nares Point on Stanley Island, just off the coast near Cape Melville, is a depiction of a turtle (above). There are numerous paintings in the area of sea creatures and ships and it is likely that these walls have been used for paintings throughout human occupation here in the last 2000–3000 years. Careened on the bank of the river named after it, is Cook's Endeavour *(right). The engraving, by Ignaz Sebastion Klauber, is taken from the original drawing by Sydney Parkinson, artist aboard the* Endeavour. *Aboriginal women process sea cucumbers or bêche-de-mer in this photograph (opposite left) taken in the 1890s by early GBR researcher, William Saville-Kent. At Lizard Island, Australian Museum biologist Roger Springthorpe (opposite top) examines a dugong bone at the site of an Aboriginal shell midden estimated to date back almost 4000 years. Off the Fitzroy River, on the mainland opposite Heron Island, in the 1920s a group of turtle hunters (opposite bottom right) pose with their catch.*

few GBR island groups; it's known that the Keppels, Whitsundays and Torres Strait islands were all settled on a permanent or semi-permanent seasonal basis as early as 4500–3200 years ago. Their greatest attraction would appear to have been the bountiful food resources of the shallow surrounding seas and the relative ease with which these resources could be collected.

Exploration and exploitation

There is some circumstantial evidence to suggest that the Macassans, seafaring traders from South-East Asia, and explorers from Portugal and Spain may have sailed GBR waters in recent centuries. Certainly in 1606 the Spaniard Luis Vaez de Torres travelled through the strait that now bears his name. However, it was James Cook's voyage through the reef in 1770 that heralded the beginning of the modern era of GBR exploration.

Cook's voyage of discovery was followed in 1802 by that of Matthew Flinders who, as master of the *Investigator*, cruised the outer reef and made tentative forays into the inner lagoon. His journal entries reflect the hazards of sailing in uncharted coral-reef waters: "The appearance of shoals were very numerous this morning, the shadows of white clouds, ripplings, and smooth places, being scarcely distinguishable from reefs." Captain Phillip Parker King made the first recorded European surveys of the inner reef in the *Mermaid* and the *Bathurst* during 1819–21. Over the subsequent decades, the need for the Port Jackson (Sydney) settlement to establish a reliable supply route to Asia through Torres Strait meant that a passage through at least part of the GBR was unavoidable.

Inevitably, as the waters of the reef were charted in more detail, would-be fortune

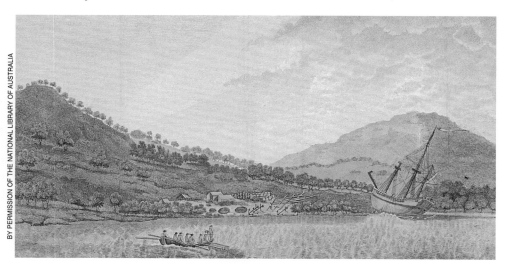

BY PERMISSION OF THE NATIONAL LIBRARY OF AUSTRALIA

seekers soon appeared on the scene. Maritime industries began to proliferate and trade in the reef's resources flourished. Bêche-de-mer (the sea cucumber, also known as trepang), trochus shell and pearl shell were collected with no consideration of the sustainability of the resource and consequently, by the end of the 19th century, these industries were in decline.

During the 1800s many coastal towns were established and with the influx of new settlers demand for regular shipping services increased. Many sailing craft plied the eastern seaboard, competing vigorously for cargo and passengers.

A barter system was also developed between the region's Aboriginal inhabitants and white settlers, traders and fishermen. The Aboriginals supplied fresh food and water in exchange for tools and other manufactured items, particularly steel axes. Relationships were generally cordial, but misunderstandings occurred, and the north did not escape the common colonial pattern of incursion, resistance and reprisal, resulting in bloodshed on both sides.

From a modern perspective, the activities of the region's European settlers were little short of horrific. During the early 1900s, short-lived commercial enterprises made serious inroads into populations of the slow-breeding dugong, killed for its meat and oil, and green turtles, which were processed into soup. Guano was mined for fertiliser on several GBR islands, the miners stripping the vegetation and removing the soil down to almost bare limestone rock. Goats were released as food for possible shipwreck victims on Lady Elliot, Lady Musgrave, Fairfax and North West islands. Almost a century on, the islands have still not fully recovered from the ravages of the miners and goats and, in spite of revegetation schemes, will probably not do so for many years to come.

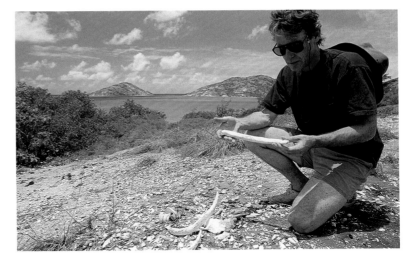

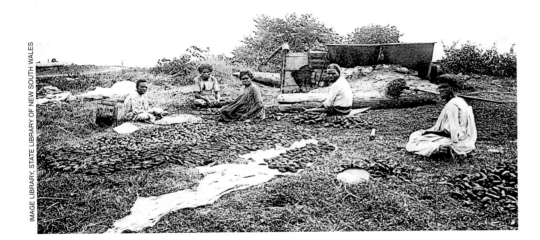

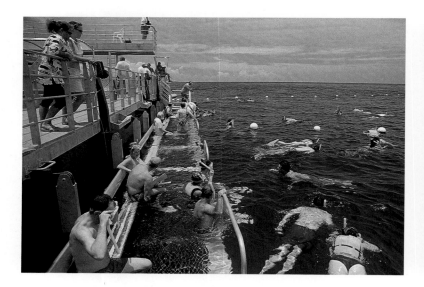

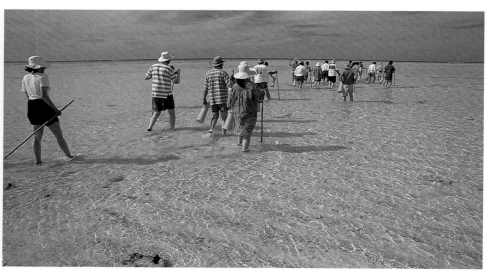

Although supervised reefwalking tours, such as this one at Heron Island (top right), carry some slight risk of coral damage, the trade-off benefits are education and greater appreciation of the marine environment. It is sometimes said that mass-market tourism on the GBR can have effects that are not immediately obvious to the casual observer. An example of this is the amount of urine passed by the hundreds of tourists swimming around the reef pontoons daily (above), which has been cited by authorities as changing reef nutrient levels. However, as marine biologist Dr Walter Starck points out, "Common sense would tell you that this is ridiculous: this is one of the richest biotic communities in the world where the metabolism of virtually every animal produces urea as a by-product of protein metabolism – everything is urinating."

Tourism

There is no doubting the drawing power of the GBR in attracting overseas and inter-state visitors: while no firm figures are available, estimates suggest upwards of two million people visit the reef every year. This is said to contribute $1 billion annually to the Australian economy. Fortunately, according to scientists who have studied the reef for many years, such a volume of human visitors to the region isn't significantly degrading the reef's natural systems.

"Of the 2500 named reefs on the GBR, only about two dozen – or roughly one per cent – are regularly used by tourists and so the effect overall is minimal," said Dr Walter Starck, a marine biologist who operated his own research boat on the GBR for more than 17 years, and knows the region as few others do. "The prevailing notion is that any measurable change in the environment that's attributable to humans is by definition unnatural, and therefore bad."

Walter gave me an interesting example of this. "At Green Island they used to take all the food scraps from the restaurant and dump them in the water at the end of the pier. There were incredible masses of fish that fed on these scraps; it was an amazing thing to see. And what better way to get rid of these scraps? But several years ago the powers that be decided: 'This is unnatural; this is bad; and we have to stop it.' Now the scraps go into bins and are taken back to the mainland and dumped in a cleared mangrove area with a retaining wall and eventually covered with earth. So what was formerly being converted to healthy fish flesh is now rotting uselessly on the mainland."

Howard Choat is a professor of marine biology at James Cook University. He is

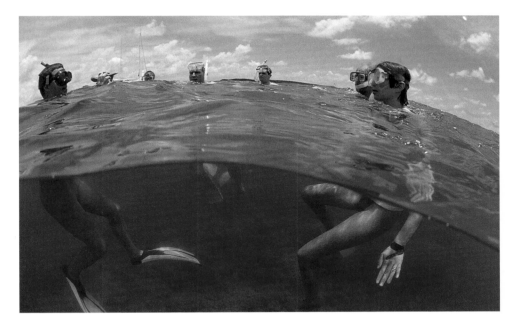

a colourful character with a turn of phrase that is earthy to say the least. His views on tourism and the reef reinforced Walter's. "Tourism is having some effect in some very localised areas – tourists may touch and break coral, but this has to be taken into account in terms of the GBR as a whole," he said. "You have to remember that the GBR is a robust and fairly resilient structure and there is an enormous number of natural events that damage the reef.

"For example, we once calculated that Cyclone Joy [in 1991] overturned about six million colonies of tabletop coral along a large stretch of the reef, but three years later when we went back, there were all these new colonies of young tabletops going all the way down to 25 m. This sort of event is occurring all the time.

"So while I think we do have to have some regulations in place," Howard explained, "human greed being what it is, I think we do have to look at human activity on the GBR in some sort of realistic perspective."

Warming to his subject, Howard went on to expound on one of his pet peeves regarding diving tourists. The Cod Hole near Lizard Island, north of Cairns, is home to a small colony of potato cod. These huge fish are incredibly valuable in terms of their drawing power for the diving tourist trade, with dive boats now visiting the Cod Hole on almost a daily basis.

"Because of this we have to consider a few things for proper management of the resource – these fish have a huge amount of dollars associated with them," Howard said. "When a hungry group of these large fish make a rush for a novice diver, it can easily cause that diver to panic, hitting or kicking the fish. This has happened and some cod have been injured."

Actually seeing the marine life of the GBR instils a greater awareness of the complexity and beauty of biological systems than words or pictures can achieve. Passengers on JOEY EXPLORER are enthralled by the view of Lizard Island's corals through the boat's glass bottom (above). For non-swimmers, glass-bottom boats and semi-submersible craft allow them easy visual access to the living reef. For the more energetic, there are interpretive snorkelling tours, such as this one at the Low Isles (top left) led by marine biologist Shawn Depper, at far left.

THE MARINE WONDERS OF THE
GREAT BARRIER
CORAL REEF

for particulars & bookings apply
QUEENSLAND GOVERNMENT TOURIST BUREAU, BRISBANE, SYDNEY, MELBOURNE.

THE ANGLERS' PARADISE
GREAT BARRIER REEF
QUEENSLAND GOVERNMENT TOURIST BUREAU
BRISBANE SYDNEY MELBOURNE

The Great Barrier Reef region has been a mecca for holiday-makers for decades. The wonders of the reef were touted by the Queensland Government Tourist Bureau in its 1933 travel poster (left). Visitors were encouraged to view the colourful marine life and the beauty of the coral reef. A 1950s poster (bottom left) promoted the excitement of fishing for big catches.

One visitor to Brampton Island in 1933, travelling there on the TSS KATOOMBA, took this photograph (below) of his fellow vacationers climbing palm trees for coconuts – the classic tropical holiday experience. Also included in his holiday album were these four photographs (opposite) showing the local dance hall and the delights of Brampton Island in the 1930s.

Huts and Dance Hall at Brampton Is.

Landing at Brampton Island.

Stan, Flo & Reg, eating Watermelons
at Brampton Island.

Reg, Flo & Stan with Cocoanuts on
Brampton Island.

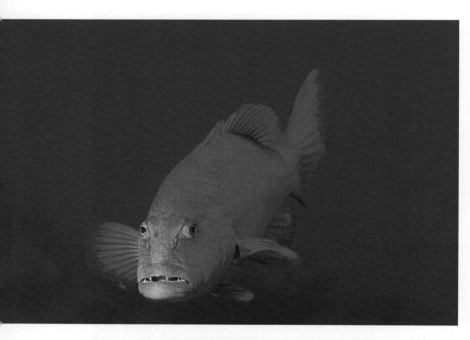

Fishing

Like tourism, commercial fishing on the GBR is no mean contributor to Australia's economy. The Great Barrier Reef Marine Park Authority estimates the industry generates $150–200 million annually, with some 1400 licensed vessels operating in reef waters. Like tourism, fishing has its detractors.

Conservationists argue that the diminishing catch of coral trout – one of the most sought-after reef species – equals diminishing fish stocks in general, citing overfishing as the primary cause. The fishing community essentially agrees with this statement but with a caveat: commercial fishermen blame recreational anglers, while the amateurs maintain that it's the commercial operators who are the real villains. But once again, the spectre of coral trout on the edge of extinction is not borne out by scientific study.

Walter Starck and I visited AIMS and spoke with Dr Peter Doherty, a specialist in larval fish populations on the reef. He explained that the commercial coral trout fishery takes about 1500 tonnes annually – this represents roughly 1 million fish – and probably about the same number are caught by recreational anglers each year.

"However, in spite of this catch size, our research indicates that coral trout populations are essentially stable when the GBR is considered as a whole," Peter said.

Walter nodded in agreement and took up the point. "It's only right off Cairns and other population centres, on weekends when the weather is calm, that there are quite a few recreational anglers – but most of them catch very little," he said. "To catch fish you have to know what you're doing; you have to work at it. A few do know what they're doing; they catch a lot, load their freezer, maybe give a few away – selling them is, of course, illegal. But overall the effect is trivial because what protects the GBR is its size, its distance from shore and the weather conditions. Most of the year the wind is blowing from the south-east at 20 knots and little boats simply can't get out there."

Howard Choat readily agreed with Peter's and Walter's sentiments when, a few days later, I raised the subject with him. "The hot topic at the moment is the live fish trade in the Maori wrasse," he told me. "Pound for pound it is probably the most expensive bloody fish you can get. There's lots of areas in the world where it's taken a hammering, but on the GBR, although they're catching quite a few, I can take you to any number of sites that are relatively pristine as far the Maori wrasse is concerned. No, I'm not overly impressed with arguments suggesting that the reef is fished out."

Understanding how fishes colonise coral reefs and maintain population densities involves field studies of their larvae. In the sea off Lizard Island Research Station (bottom), Australian Museum research assistant Brooke Carson-Ewart (left) and Danish marine biologist Ingvar Bundgaard Jensen examine a collection of larval fish. The coral trout (top) is a species much sought after by all anglers.

Great Barrier Reef management

In the early 1970s there was widespread concern about the future wellbeing of the GBR. Talk of oil drilling and mining, together with the perceived threat of pollution, did not sit easy in the collective public's mind, forcing the political powers of the day to take some action. Consequently the *Great Barrier Reef Marine Park Act* was passed in 1975, establishing both the park and its regulatory body, the Great Barrier Reef Marine Park Authority, or GBRMPA (known as "Garbrumpa" in spoken reference). GBRMPA is responsible for maintaining the balance of conservation, recreation, science and commerce in the park. Such a juggling act is not easy and predictably GBRMPA has come in for its share of criticism.

Howard put the work of GBRMPA into perspective for me. "The important things you have remember about the GBR is first its size and second the fact that it's organised under one nationality," he said. So, whatever our views on GBRMPA may be, it sits under a uniform legislation. In the Caribbean reef system – an area of comparable size – you may have up to 30 national entities involved. This means that we can sensibly use the GBR without the problems that we may face in other parts of the world due to nationalistic interests."

One of the most important management initiatives undertaken by GBRMPA has been dividing the marine park into four regional sections and establishing a range of zones within each of these sections. Each zone allows for certain types of activities ranging from the General Use zones, where most activities are permitted, to the Preservation zones, which are closed except for scientific study or in case of emergency. Zone maps are available from GBRMPA and they are also prominently displayed on noticeboards on all popular boat ramps throughout the marine park. If you're planning a private trip into the reef, you should consult these maps to ensure that your intended activities are permitted in the zone you want to visit. The Queensland Environmental Protection Agency is charged with policing GBRMPA's policies on a day-to-day basis and their vessels regularly patrol the park. Infringement of the zoning regulations can lead to hefty fines.

GBRMPA's stated goal is: "To provide for the protection, wise use, understanding and enjoyment of the Great Barrier Reef in perpetuity through the development and care of the Great Barrier Reef Marine Park". The authority's successful management of the GBR recognises that effective conservation policies and human activities – whether recreational or commercial – in the marine park are not mutually exclusive. As the picture at right shows, such recognition ensures that you can dangle a line like Dunk Island fisherman Les Lane, or paddle your surf ski like English visitors Kathryn Newman (at front) and Elizabeth Milburn.

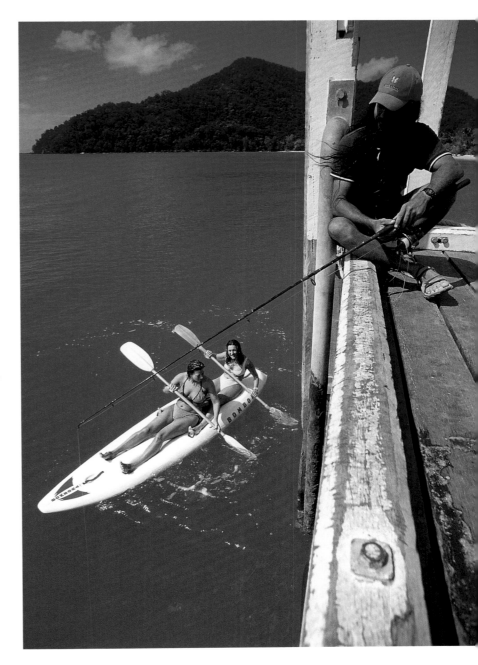

Reef research

The annual wet season is a perennial topic of conversation among the long-term residents of Australia's tropical north. Inevitably, comparisons of the current Wet are made with those past, and predictions made for those imminent. "You reckon this is a good Wet?" they'll say to newcomers. "You should have seen the one we had in such-and-such a year; it was a beauty!" But the history written in GBR corals tells us the true story; it reveals that the monsoons we experience now are relatively mild and the "beauties" were those of several centuries ago.

The work of AIMS scientist Peter Isdale and technician Bruce Parker on coral cores from Pandora Reef and Havannah Island, near Townsville, indicate that the period 1600–1800 had a much higher frequency of good monsoon rain and much higher run-off than the present. Their research on four centuries of annual growth layers in corals shows that we're currently in a drier period with lower run-off. Without the evidence provided by the coral cores, this low run-off might have seemed average, but indications now are that it is probably abnormal.

Coral-core sampling is one of the many fascinating outcomes of ongoing research

Dr Andrew Heyward of AIMS was one of the first scientists to observe synchronised coral spawning on the GBR in the early 1980s. To further research the phenomenon, he regularly visits the Lizard Island Research Station during the spawning season. At right, he shows Australian Museum crustacean expert Roger Springthorpe one of the living corals in the station's holding tanks. Dr Ove Hoegh-Guldberg of Sydney University has been conducting experiments to discover the reasons behind coral bleaching. At Heron Island Research Station (above) he examines a partially bleached coral.

At the core, a wealth of weather history

More than 25 years ago, US scientists working in Hawaii discovered that the limestone skeletons of some corals contain what are termed "annual density bands". These bands – which could be compared to the annual growth rings in trees – enable a coral colony to be accurately dated.

As a coral grows, certain trace elements are laid down in its skeleton in response to environmental changes. Scientific analysis of these elements, when considered in light of the known age of the coral, has enabled researchers to determine events such as changes in sea-surface temperatures, rainfall and salinity, as well as human-induced changes spanning many decades and, in some cases, even centuries.

The results are termed proxy environmental records, as they are not dependent on the use of meteorological instruments (which only provide environmental information for roughly the last century). Such proxy records allow greater understanding of present and future climatic events – such as El Niño – and also the possible consequences of human influence on the GBR.

Because they may be several hundred years old, the massive corals, such as *Porites*, contain a wealth of information on climate and environment. Several techniques are used to obtain samples. Colonies of *Porites* up to 50 years old and around 75 cm in diameter are collected whole, and vertical sections of around 7 mm thickness are cut from the centre with a special saw in the AIMS engineering workshop. These sections are x-rayed so the density bands can be counted, or examined under ultraviolet light, which reveals the bands that show weather history.

To examine larger *Porites* – which can be several metres in diameter – core samples 9 cm in diameter in sections up to 70–80 cm in length are drilled from the coral head to a depth of up to 8 m. The hole is then closed with a precast concrete plug. Vertical sections are sliced from the cores – which may represent up to 800 years of growth – and, as with the whole sections of smaller corals, they are x-rayed and their density bands counted to determine their age.

At AIMS, Dr Janice Lough (right) studies an x-ray of coral cores spanning a period of more than 30 years. Cores from living corals are able to provide proxy environmental records for the past several hundred years. Cores from dead and fossil corals are often able to provide similar records from the more distant past. AIMS is perfectly situated for work on coral cores, providing ready access to the GBR's abundant coral material. GBR coral cores are being compared with similar records from the Central Pacific and Indian oceans. These ongoing studies permit fuller understanding of past, present and future climatic variation and change.

Dr John "Charlie" Veron (above) examines a reef-building coral in the AIMS collection. In reference to the ideal geographic siting of AIMS for coral reef research, Charlie says: "If you look at coral reefs globally, about 70 per cent occur in the western tropical Pacific. Except for Australia in the south and Japan in the north, all these reefs occur in third-world countries. Reefs in these latter countries have been really hammered – mostly by the pressures of overpopulation, so we're a pretty important centre. Here in the Townsville region we have a museum, the aquarium, GBRMPA and, of course, AIMS."

into coral-reef biology conducted at AIMS. The institute is committed to tropical marine research and, like the CSIRO and GBRMPA, is a Commonwealth statutory body. Established in 1972, its headquarters are located at Cape Ferguson, about 30 km east of Townsville. There's another base at Dampier, in Western Australia.

Charlie Veron, in his own words, is the "old fossil" of AIMS; he's been there "since the beginning; longer than anybody else".

"It was never my intention to stay here this long," he said. "I've had many jobs – teaching psychology, working on genetics. My PhD was in neurosecretions; I really took up diving to get away from work!"

"AIMS really came about when there was talk of oil drilling on the GBR. Much American expertise was imported to determine the value of the reef and the government of the time realised that there was virtually no 'home' knowledge of its own GBR. So AIMS was started effectively for that reason."

Charlie explained that the institute's success is largely because of the mixing of disciplines. "Just along this corridor there's someone working on drug discoveries from marine organisms; someone else is working on ocean currents and how they disperse marine organisms; and along here there's a geneticist," he said. "So the biochemist and the geneticist and the oceanographer can all get together to pool their expertise. If you want some information, all you have to do is walk down the corridor and ask. Everybody does this – it has been the real delight of working here. There's so much intellectual cross-fertilisation going on."

The staff at AIMS have a lot of autonomy too. "If someone has a bright idea, it can get the ticks from the bureaucracy in a single day," Charlie said. "Here the big decisions are made by scientists, not bureaucrats. We are given the responsibility of doing the science the country needs and doing it in smart ways."

The history of scientific research on the GBR goes back a long way. As the resident naturalist on Cook's *Endeavour* in 1770, Joseph Banks was possibly the first European to note an interest in the "many curious fish and molluscs" of the reef. More than a century later, in 1893, William Saville-Kent published his *The Great Barrier Reef of Australia*, the first of many major scientific books celebrating the diverse nature of the reef's myriad life forms.

In 1928–29, the Great Barrier Reef Committee, which had been founded in 1922, undertook the first long-term study of the reef in cooperation with the Royal Society of London. Based at Low Isles off present-day Port Douglas, Sir Maurice Yonge and 23 scientists collected data for a huge range of natural processes, both biological and physical. The result of their work, published by the British Museum of Natural History over several decades, is used as a reference work to this day.

Howard Choat succinctly summed up our present-day relationship with the reef: "The GBR's a great living laboratory. Its size and its situation, the organisation of its management and its present state of conservation all combine to make it a pretty bloody interesting place for us to go and have a real good look at things."

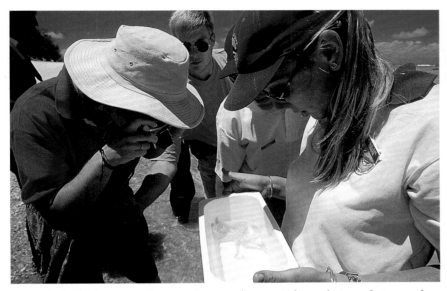

A good deal of present-day tourism on the GBR is biased strongly towards education. Such programs have been hugely successful, not only for their "getting-your-feet-wet" approach, but also because interpretive guides – often qualified marine biologists – are able to give detailed "live" commentaries on the biology and behaviour of the reef animals observed. At Lady Elliot Island, resort guide Jennifer Prerau (above) shows visitors a small octopus she has found in a rock pool before returning it to the sea. Later Jennifer and fellow guide Darren Sweetnam (in white shirt at right) join resort guests in feeding a school of mullet in the shallows on Lady Elliot's fringing reef (right).

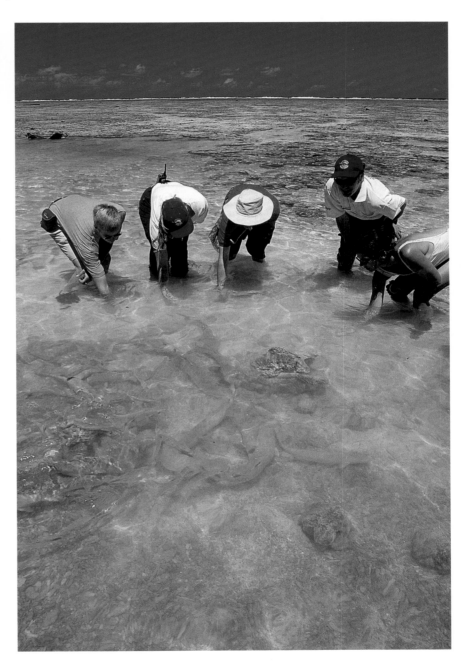

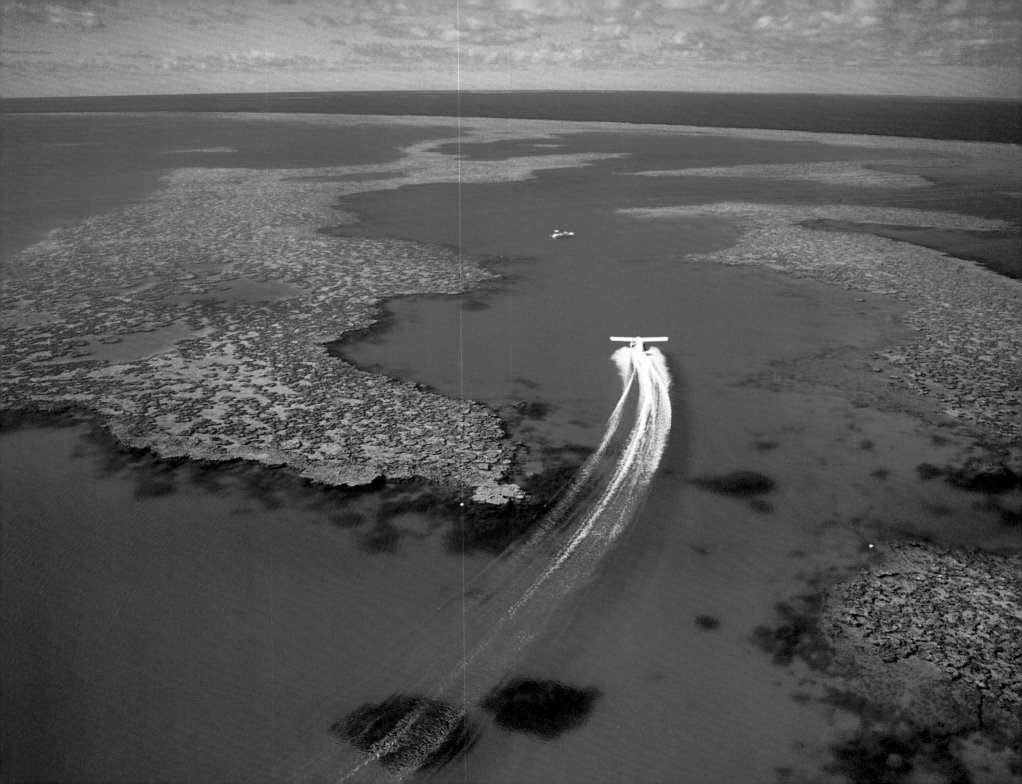

Wide waters and shining islands

The Great Barrier Reef: Southern Region

Its wake cutting a white ribbon through the deeper blue water between the corals, a floatplane lands at Hardy Reef, one of the Whitsundays' offshore GBR reefs. In the southern region of the GBR, because the most spectacular of the reefs are well offshore from the mainland, day-trip access by floatplane is a very popular option for both sightseeing and snorkelling.

Stretching nearly 1000 km from just north of Bundaberg to Dunk Island, the southern region of the Great Barrier Reef encompasses the 143,000 sq. km Mackay/Capricorn Section and the 75,850 sq. km Central Section of the Great Barrier Reef Marine Park. It also includes a new coastal section, Gumoo Woojabuddee, declared in January 1998. This 350 sq. km section stretches 70 km from just south of Yeppoon up to Delcomyn Island, east of Shoalwater Bay. The area is part of the traditional country of the Darumbal people, its name in the Darumbal language meaning "big water".

The eastern continental shelf is at its widest and most gently sloping in the southern region, and so the GBR extends seawards for a considerable distance, reaching its maximum width of almost 300 km in the Pompey and Swain reef complexes off Mackay. In spite of their distance offshore – or perhaps because of it – the Swain Reefs have a reputation as some of the finest fishing grounds in the world.

While the northern GBR is renowned for its reefs, the southern region's claim to fame lies in the diversity and number of its islands. In the Mackay/Capricorn Section especially there are numerous vegetated cays, while in the Central Section there are no cays but many continental islands lying close to the coast. In fact, a prime attraction of the southern region is the unparalleled beauty of, and ready access to, the Whitsunday Islands. In this area annual visitor numbers make up almost a third of the total for the entire GBR.

The southern region has less of the wet–dry seasonal difference and a greater range in annual temperature than occurs in the monsoonal northern region. This means that the southern region is more of a year-round destination – unlike the north where very humid summers and the December–April cyclone season see a marked decline in visitor numbers.

The southern GBR provides the setting for the classic tropical island experience – balmy days of brilliantly clear blue waters and sweeping expanses of white sand beaches. And visitors can choose just the experience they want – from the resort-style high life, to a low-key camping, fishing and snorkelling trip or a five-day hike through Australia's most beautiful island wilderness. But whatever the choice, coral seas will be sure to feature prominently.

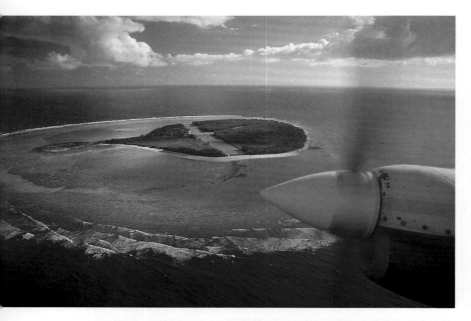

The vegetation on Lady Elliot Island (top) dates from 1969, when Don Adams, a keen conservationist, took a lease on the island, intending to establish a small-scale tourist destination. Building an airstrip in a mere 24 hours, he then commenced a revegetation scheme with casuarina, pisonia, pandanus and other tree species. The revegetation of the island has seen the return of nesting seabirds, such as these roseate terns (above).

Lady Elliot Island

"There, you can see it right ahead of us," said Alex Russo, pilot of the Nomad aircraft, as he pointed through the windscreen. I could just make out a light blue-green smear at the horizon where the hazy darker blues of sea and sky joined. This was Lady Elliot Island, the GBR's southernmost island. Alex had invited me to sit up the front with him for the 30-minute flight out to the island from the coastal sugar town of Bundaberg. "And that's Lady Musgrave off in the distance," he added, pointing to the north.

As Alex made a circuit of Lady Elliot before landing on the grass airstrip that bisects the island, I recalled a 1969 photograph I had seen of an aircraft landing on this same strip. In that image scarcely any vegetation can be seen; the island was then mostly bare coral rock – the result of years of guano mining and, later, grazing by goats. But now it appeared to be recovering, mantled for the most part with low trees and scrub.

I knew of Lady Elliot's reputation as an important seabird rookery; indeed, black noddies were everywhere, wheeling overhead and nesting by their hundreds in the trees throughout the resort area, oblivious to the human activity around them. On the north-east side of the island, 2000 pairs of crested terns had established a rookery. Unlike black noddies, crested terns are wary of human approach and easily disturbed. For this reason, guests are requested not to enter the rookery area. Other bird species noted on the island include bridled, roseate and black-naped terns, red-tailed tropicbirds, eastern reef egrets, white-faced herons, and brown boobies.

As I wandered around the island, photographing and chatting with guests and staff of the Lady Elliot Island Resort, I realised it was a low-key place where diving, snorkelling and reefwalking, or simply lying back in a beachside deckchair, are the main preoccupations. Although the majority of the island's guests come to enjoy the snorkelling and diving – there are 19 regularly dived sites around the island – the number of bird species found on Lady Elliott attracts birdwatchers from all over the world.

Given island guests' interest in the natural world, I wasn't surprised that the resort balanced its own needs with those of the environment by generating its own power, desalinating its own water, composting food scraps and irrigating with its "grey water". All hard rubbish that can't be composted is sorted and shipped to the mainland for recycling. "The surrounding sea here is our prime asset," resort manager Peter Matthews told me. "So we don't dump anything in the water."

Cruising yachts are not encouraged to call at Lady Elliot. In fact, there are no good anchorages; the only easy access to the island is by plane – Lady Elliot is the GBR's only coral cay with an airstrip. The resort, on land leased from Marine Parks, has a self-imposed limit of 120 visitors at any one time, which reduces environmental pressures and gives it a decidedly uncrowded and very relaxing atmosphere.

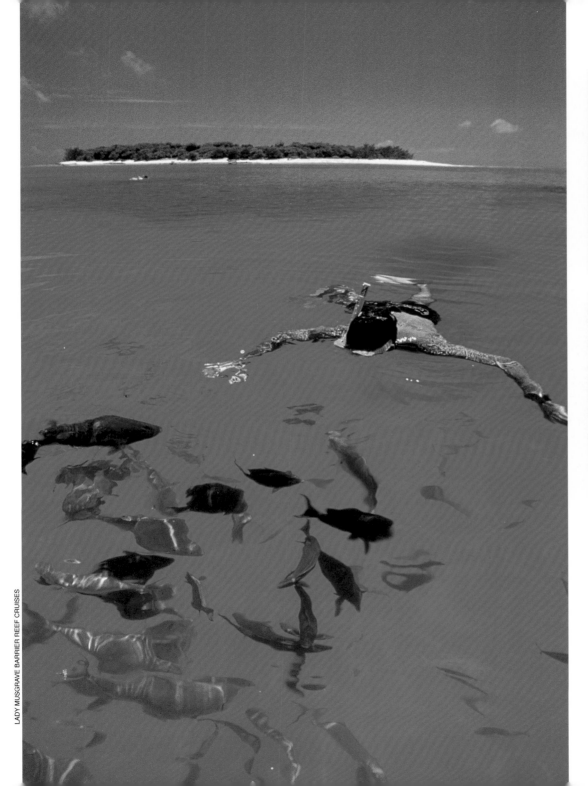

Access to Lady Musgrave Island, some 40 km north-west of Lady Elliot, is by fast catamaran from Bundaberg and Seventeen Seventy several times a week, weather permitting. Camping is available on the island by permit only. On Lady Musgrave's fringing reefs a snorkeller becomes the focus of attention for schools of inquisitive reef fish (left), while a red-tailed tropicbird, an uncommon species in the southern GBR, soars over-head (top). On the island a black noddy sits on its nest (above). Black noddies seasonally nest in their hundreds of thousands on the cays of the southern GBR; and draw birdwatchers from around the world to islands such as Lady Elliot, Lady Musgrave and Heron.

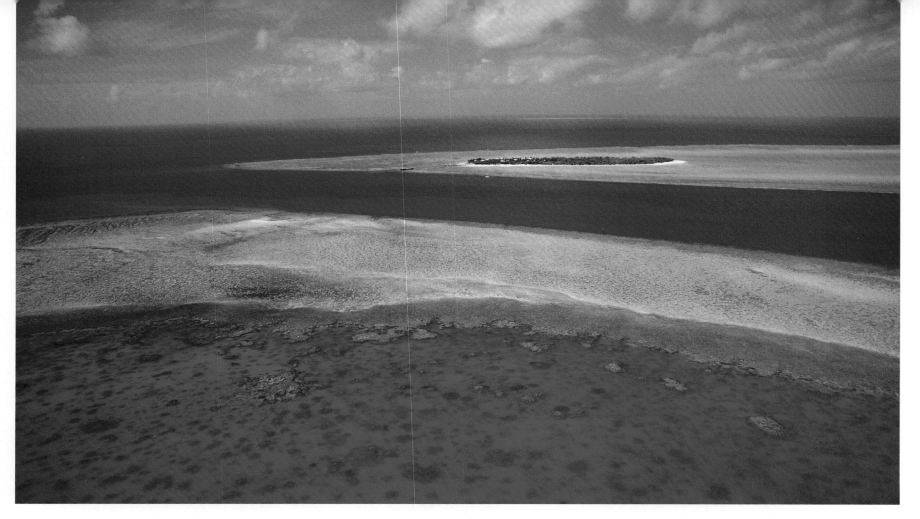

The 35-minute helicopter transfer flight between the mainland town of Gladstone and Heron Island passes over Wistari Reef (above) affording passengers some magnificent reef scenery. During the winter months humpback whales are occasionally spotted moving through the deep-water passage, which can be seen here, separating Wistari Reef and the platform reef, called Heron Reef, on which Heron Island is situated. In Heron Island Resort's pool (opposite bottom), resort-course divers Graham Robinson and Bryan Tonkinson pay close attention to divemaster Troy Wekwerth as he emphasises a point by hand signal. Although much of Heron Island Resort's activities are water-based, there's always time for simple terrestrial pursuits, such as a game of chess on the resort's balcony (opposite top).

Heron Island

I have a real fear of flying. But the scene below me – I was hanging out of a helicopter's open door to take photographs – was certainly enough to take my mind off the problem. We were skirting the edge of Wistari Reef, between the mainland and Heron Island, at an altitude of 1500 feet. The shallow turquoise water on the reef top was studded with micro-atolls – irregularly shaped-and-sized brown coral outcrops forming an intricate maze. A line of surf marked the reef crest where the coral shelved steeply away into the deep blue of the open sea. I could feel the helicopter begin its descent and, without taking my eye from the camera viewfinder, I knew we must be close to Heron.

A coral cay of the Capricorn Group (Heron's reef straddles the Tropic of Capricorn), Heron has a rich biological calendar. Some of the highlights are the passage of migrating humpback whales from June to September; peak seabird breeding activity from October to March, when tens of thousands of birds descend on the

island; turtle nesting from November to March; coral spawning in November or December, and the hatchling turtles making their frantic way to the sea from late January to April.

Like its equivalent on Lady Elliot, Heron Island Resort – the only place to stay on the island as no camping is permitted (though school and university groups and scientists do stay at the research station) – operates in both a marine park and a national park. So the needs of guests must be balanced against those of the immediate delicate environment, both above and below the water. Heron is also promoted as *the* place to dive in the southern GBR and has an international reputation in this regard.

From the moment I entered the water, Heron lived up to expectations. The water was clear and the coral growth prolific. Fish too were abundant. There were hovering schools of bluestripe seaperch, foraging pairs of gold-and-royal-blue bicolor angelfish and blue-spotted coral cod peering from beneath coral overhangs.

When my underwater explorations were terminated after two dives, due to an ear problem – the bane of the diver – I visited Heron Island Research Station, adjacent to the resort. Established in 1951 to promote education and research on the GBR the station is now operated by the University of Queensland (UQ). Director Dr Ian Whittington explained that in an average year the station hosts 60–80 research projects. "Right now, for example, we've got work going on with turtles, coral trout, fish parasites, ciguatera, shark tagging, tropical abalone and, of course, with corals – particularly coral bleaching," he said. "There's also the terrestrial work with tropical botany and the bird life on the island."

I certainly knew about the turtle nesting: it was one of the main reasons I had come to Heron in November. It also being the seabird nesting season, black noddies and wedge-tailed shearwaters were everywhere throughout the resort grounds, the shearwaters' nesting burrows pockmarking the sandy soil. At night these dark brown seagull-sized birds sit at the entrance to their burrows, wailing mournfully. As I negotiated the track to the beach by moonlight that night – I didn't want to discourage nesting turtles with my torch – I had to be extra careful of the shearwaters. The squawk of one bird at the last possible moment just stopped me from stepping on it. "Sorry, mate," I muttered.

Just after 1 a.m. I came across a small group of people clustered around a turtle in a casuarina grove in front of the resort. I recognised UQ turtle biologist Mark Hamann, whom I'd met at the research station.

"She's starting to dig the egg chamber now," Mark said to the group. "When she starts to lay, she'll go into a kind of trance and you'll be able to turn on your torches and get some photographs."

"How long will that be?" someone whispered.

"In about 10 or 15 minutes," Mark replied. "And you can talk normally. It appears that turtles have limited hearing on land; at least, they don't react to the frequency of a human voice."

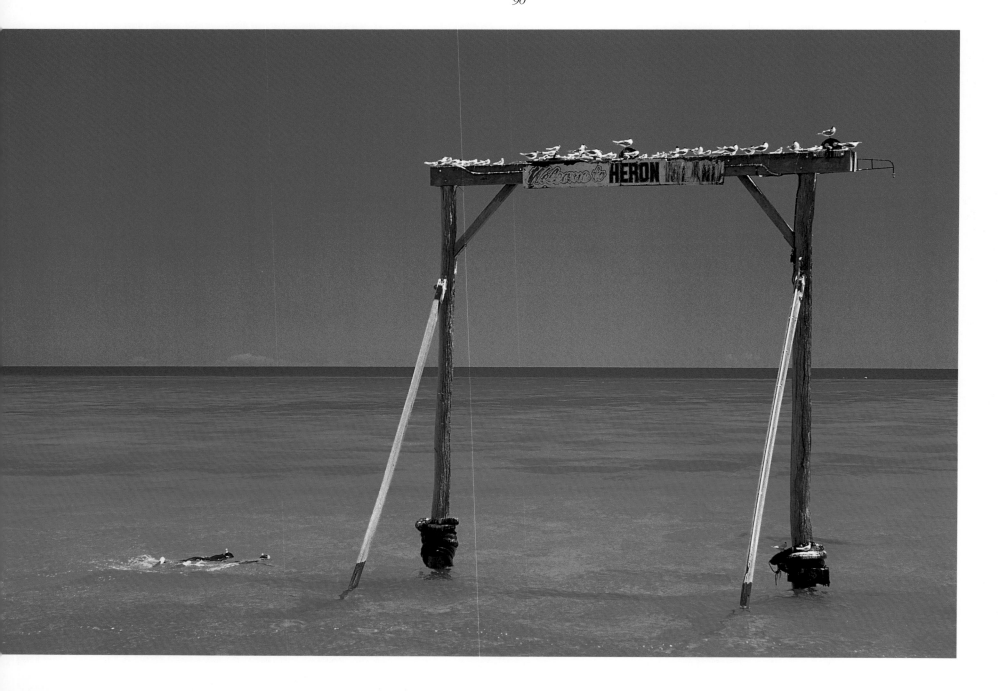

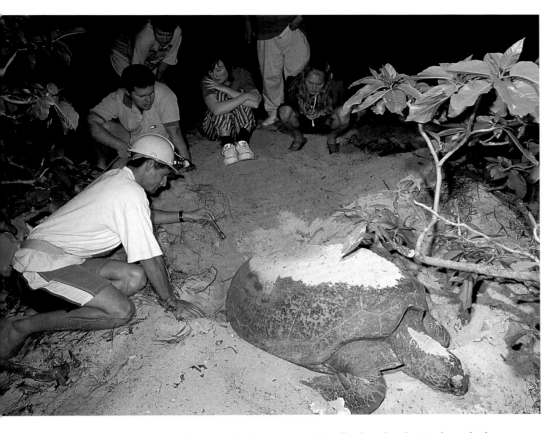

As the turtle neared the end of laying and the flashes fired, Mark took the opportunity to measure its carapace and attach a tag to its flipper, recording the details in his notebook for a Queensland Parks and Wildlife Service (QPWS) study on sea-turtle biology and conservation. Some 50 minutes later, egg laying was finished and the turtle began the work of filling in the egg chamber and covering the site as best it could by flicking sand in all directions.

Mark explained that only about half the turtles that come ashore on any given night will lay. "But I don't think it's only people using torches or camera flashes at the wrong times that deters them. With a nearly full moon like we have now, lots of things can put them off laying – moving shadows and tree branches swaying in the wind," he said. "Or they might choose a site, start digging, then encounter a tree root, or simply decide the site is just not to their liking and head back into the sea."

By 3 a.m. the turtle had concealed the nest and began to make its way back down the beach, pausing frequently, and emitting a wheezing sound as it expelled air.

Snorkellers pass by the remains of an old gantry on Heron Island (opposite). Once used to keep the island's motor launch upright as the tide receded, it now provides valuable roosting space on its cross bar for terns and gulls. During the November turtle-nesting season, turtle biologist Mark Hamann checks the progress of a laying green turtle watched by resort guests (top left). Tagged Heron turtles have been found as far afield as Solomon Islands, New Guinea and Indonesia. As it departs Heron for the mainland, the transfer catamaran passes by the rusting bulk of the PROTECTOR (above), a former naval vessel towed to Heron in 1943 to form a breakwater.

Great Keppel Island

The Aboriginal inhabitants of Great Keppel were the Woppaburra, whose name means "resting place" – the antithesis of modern Great Keppel. Nowadays the island is promoted as an "active" place, with lots of watersports and land-based activities to keep you busy. Though the reef proper is some 90 km to the east, there are several decent dive sites, the most notable being Parker's Bommie off Coconut Point to the south-east of the island. Lying 13 km off the mainland, and the largest of the 14 islands of the Keppel Group, Great Keppel's proximity to the coast, variety of accommodation options and the beauty and abundance of its beaches – renowned as among the best of the reef islands – make the island a popular destination for daytrippers and backpackers.

To get the lie of the land, I took a guided walk with Russell Watson, a former national parks ranger who now works for Great! Keppel Island Resort. Russell's walks include a "beach tucker tour" – and a jaunt of nearly 3 km out to the old Leeke family homestead in the middle of the island (the Leekes grazed sheep on the island during the years between the World Wars) – as well as interpretive wildlife tours.

"We've recorded 105 species of bird – about half are residents, such as the lorikeets, while the others are migratory – and we've got carpet and black-headed pythons and green tree snakes," Russell said with enthusiasm – this was obviously a subject close to his heart. "Sand goannas are very common, and there's a few species of frog including the large green tree frog. We also have the common water rat." Koalas and brush-tailed possums were introduced to the island many years ago

from the mainland, probably for the fur trade. "The koalas died out but the possums are still here," Russell said.

During a "beach-tucker tour" – and a jaunt, many of the plant species pointed out were familiar to me, but their uses for traditional medicines, food or implements by Aboriginal people were not. Indian or sea almond kernels are eaten raw, as are the flowers and young leaves of the coastal hibiscus, or cottontree. The fibrous bark of the cottontree is rolled into string and plaited into strong ropes for catching dugong and turtle. The purple-horned fruit of the pigface that commonly grows on coastal and island dunes is also eaten raw and tastes like salty strawberries, while the young leaves, when crushed, produce an effective antidote to bluebottle stings.

I was also surprised to learn that Great Keppel, unlike almost all other GBR islands, is not a national park. "And it probably never will be," Russell said. "There are still feral goats here and about half a dozen sheep." And peacocks and guineafowl and geese, as well as the flocks of ducks and chooks that quickly surrounded us as we arrived at the old Leeke homestead.

From the homestead, walks lead north – to picture-postcard Second, Svendsens and Sandhill beaches – and east to Bald Rock Point lighthouse. Views of the surrounding waters are spectacular from the ridge north of Leekes Creek, which has a high point of 170 m – just 5 m lower than the island's highest point, Mt Wyndham. Another popular walk leads from the resort, along the edge of the airstrip, and out to the superbly beautiful Long Beach on the south-west corner of the island. Above Long's south-western end, about 50 m inland, is an Aboriginal shell midden.

Running up on the sandspit at Fishermans Beach on Great Keppel Island, the daily catamaran passengers disembark (opposite top) after the half-hour crossing from Rosslyn Bay, 5 km from Yeppoon on the mainland. While guests at Great! Keppel Island Resort take it easy by the pool (above), a peacock displays its plumage at the Old Homestead (opposite bottom left). Originally transported from the mainland by barge in the 1920s, the homestead has been renovated by the resort and is now a small museum operated by the resort and a local caretaker. The point at the intersection of Fishermans and Putney beaches on Great Keppel's western coast affords a good view of Middle Island (left). From Great Keppel it is a brief trip by launch to Middle Island and its small underwater observatory a short distance offshore.

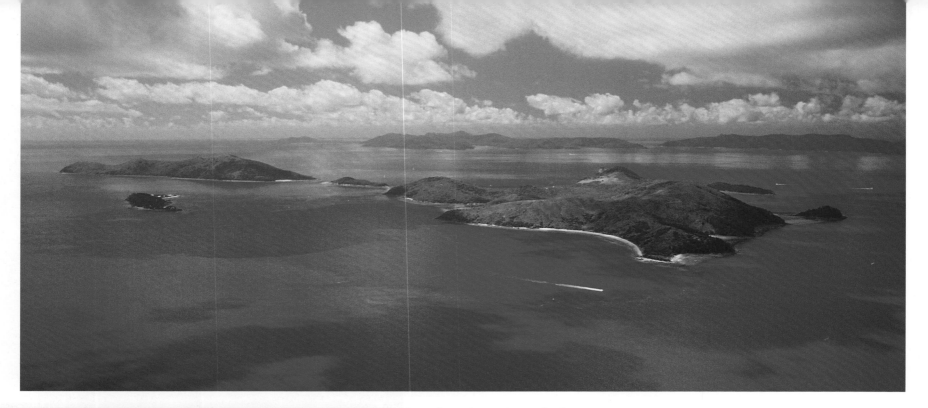

The Whitsunday Islands

Most developed – and probably most widely known – of all islands in Great Barrier Reef waters, the Whitsundays are continental islands, and the GBR proper is 50–60 km distant from them. Many of the islands do, however, have fringing reefs, some of them quite extensive, with a variety of corals represented. James Cook named the group when he sailed through it aboard *Endeavour* on what his log indicated as Whit Sunday – the seventh Sunday after Easter – in 1770. In fact, the usually meticulous Cook hadn't allowed for his crossing, earlier in the voyage, of the international date line, and was thus a day late with his name.

The 90-odd islands and islets of the Whitsunday group, forming the east coast's largest island chain, are the peaks of low mountains, volcanic in origin, drowned when sea levels rose at the end of the most recent ice age about 6500 years ago. They account for about 30 per cent of all GBR visitors, second only to the Cairns–Port Douglas region in numerical terms. All but four of the islands are national parks; the largest, at 10,900 ha, is Whitsunday Island, and the group's highest point – Hook Peak, on Hook Island – rises to an impressive 459 m. Given the stunning beauty of the region and the easy access to the many islands of the group, it came as little surprise to me that Airlie Beach – the Whitsundays' mainland gateway – had developed exponentially since I first visited the Whitsundays in the 1960s.

Airlie's main street had been lined with simple little weatherboard holiday cottages and corner grocery stores that doubled as petrol stations. Now in their place

The beauty of the Whitsundays is typified by this aerial view over the Molle Islands group (opposite top), where an inter-island ferry leaves a wake as it passes South Molle Island. The palm-fringed beach at South Molle Resort (opposite bottom) frames the view northwards towards Mid Molle at left and Whitsunday Island at right. Late afternoon light gilds this street scene in Airlie Beach (left), where terraced rows of apartments crowd the hillside.

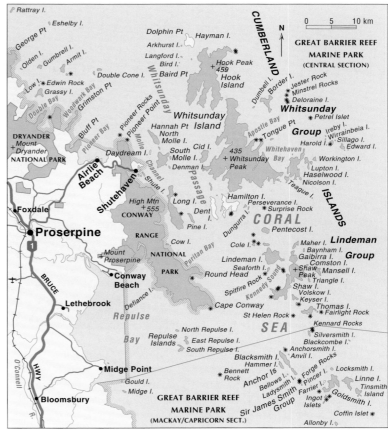

were hotels, motels and blocks of apartments; an array of restaurants, fast-food outlets and coffee shops – not as quaint, perhaps, but testament to the boom that tourism has brought to the region.

The best way to get an overall feel for the Whitsundays is from the air, so I spent three hours on a floatplane tour engrossed in some of the most spectacular scenery I've ever seen, as roll after roll of film rattled through my camera. From Whitsunday Airport, we took an easterly track directly over Shute Harbour – departure point for many island and outer-reef cruise vessels – and, a few minutes later, flew over the southern end of 400 ha South Molle Island, about 4 km from the mainland coast. It was a beautifully clear day, and to the north I could see the thin sliver of Daydream Island – formerly called West Molle and at 17 ha the smallest of the Whitsundays' resort islands – with its newly built resort stretching along its eastern shore. To the south, appropriately named Long Island – 9 km north–south but only 1500 m at its widest – paralleled the coastline, while further out across Whitsunday Passage, the highrise apartments of Hamilton Island contrasted starkly with the forest-covered hills of the other islands. Hamilton is by far the most developed of any island in the Whitsundays, indeed in the entire GBR region.

"The little island below us is Cid Island," said pilot Jon Davies in response to my question. "The passage between it and Whitsunday – the large island right ahead of us – is Cid Harbour, one of the best anchorages in the group." Crossing the width of Whitsunday Island, we descended for a landing on the sea off its east coast, near the

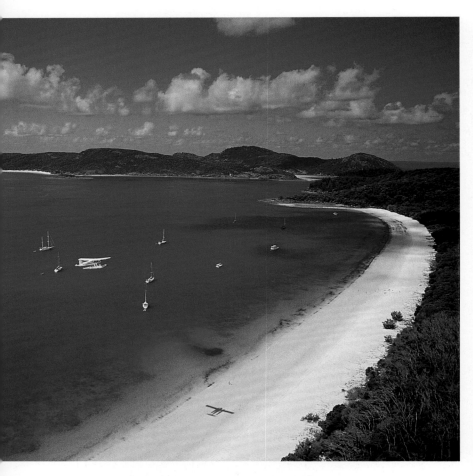

The pure white silica sands of Whitehaven Beach (above), trapped in this location by winds, waves and tides, are a remnant of past glacial times and reflect the geological history of the Whitsundays. The aerial tours of the Whitsundays invariably include Hill Inlet (opposite) at the northern end of the 6 km beach, where the tidal flow cuts a maze of channels, forming a stunning display of colours and textures.

magnificent 6 km expanse of Whitehaven Beach, one of the Whitsundays' icons and, judging by the number of boats, one of the most popular destinations for the yachting fraternity. There were perhaps 40 anchored yachts, the majority congregated at the southern end of the beach, where the 87 m high basalt headland provides shelter from the south-easterlies and a habitat for the unadorned rock-wallaby. There's also some reasonable snorkelling on the coral bommies just out from the headland.

It's estimated that up to 500 people visit Whitehaven at any one time, so management of the area is a serious task for park rangers. Artie Jacobson, district manager for the (QPWS), later told me that Whitehaven was a classic example of the challenge of allowing reasonable and wise use of an area while maintaining its natural attributes. "A place that is scenically very attractive, usually because of its diversity, is also going to have certain environmental sensitivity," he said. "It's places like Whitehaven that attract large numbers of visitors, thus threatening that very diversity. A classic case of being 'loved to death'."

After a brief stop we were airborne again, this time heading north-east to the outer GBR. Jon descended to about 300 m and slowed down as we passed over the "shank" of Hook Reef on our approach to Hardy Reef. Hardy is the most popular of the Whitsunday area's reefs for divers, and I noticed several boats moored in its lee. Hook, Hardy, Bait and Black reefs are all accessible by fast boat from Shute Harbour and various Whitsunday islands.

While snorkelling and diving are the most immediate ways to view coral and other marine life, operators offer an array of options for people who'd rather stay dry, including glass-bottomed boats and "submarines" that partly submerge, known as semi-submersibles. One of the most unusual reef experiences available at Hardy is the opportunity to stay overnight on a moored reef pontoon (see p. 98).

Our flight back from the outer reef took us over 400 ha Hayman Island, northernmost island in the group, before following the western coast of much larger Hook Island (5300 ha) to the south. These two islands are prime destinations for Whitsunday visitors seeking isolation: Blue Pearl Bay on Hayman's north-west coast and the deserted beaches and bays of Hook Island are some of the best spots. The waters around both Hayman and Hook islands appeared very clear with well-developed fringing reefs here and there, and Jon confirmed that these islands have some of the best scuba diving and snorkelling in the Whitsundays proper, especially along their protected northern shores.

There are also Aboriginal art sites on Hook – there's a boardwalk at one site at Nara Inlet, a popular deep-water anchorage at the southern end of the island. The Ngaro people were accomplished mariners, travelling between islands in canoes of sewn bark. Middens and the remnants of quarries and stone fish traps are to be found on a number of the Whitsunday islands. The Aboriginal name for South Molle is Whyrriba, meaning "stone axe", a reflection of the fact that the island had good-quality cutting stones.

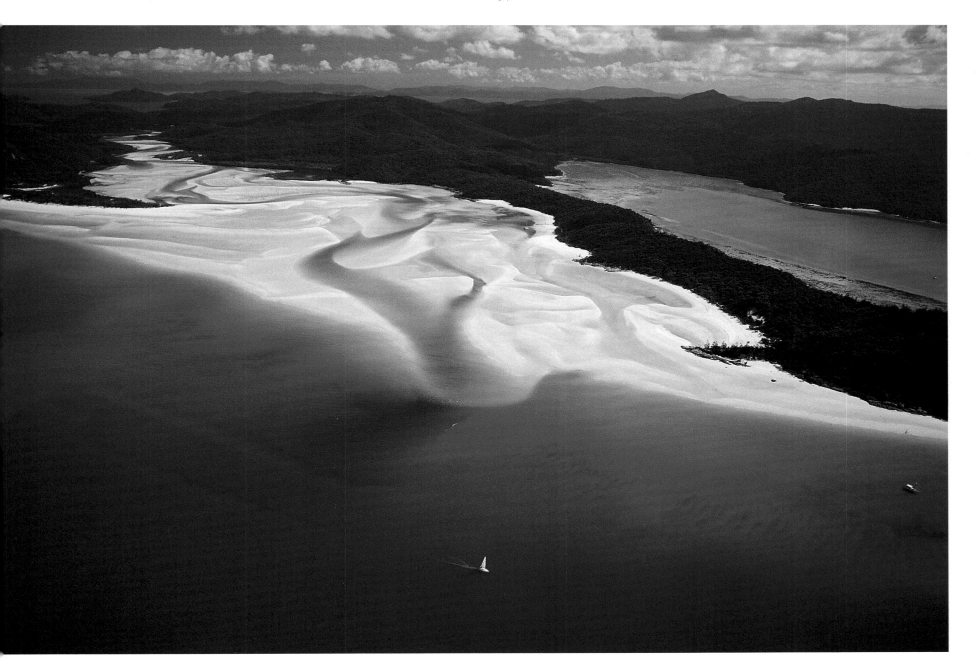

QUEENSLAND TOURIST AND TRAVEL CORPORATION

The Whitsundays have a distinctive bush environment enhanced for visitors by magnificent views of the encircling sea. Stately hoop pines, also known as Moreton Bay or colonial pines, some up to 60 m high, with their distinctive horizontal branches and dense tufted foliage, stand out from the vine forests of many of the island interiors. There is also some rainforest, with eucalypts (particularly the poplar gum), wattles and elegant grasstrees on the drier slopes, while open grass-lands are a feature of a number of the smaller islands.

Apart from the unadorned rock-wallabies that inhabit Whitsunday Island and the Proserpine rock-wallaby, found on Gloucester Island, the animals most commonly encountered on the islands are sand goannas, brush-tailed possums and mosaic-tailed rats. Birds abound – more than 150 species have been recorded – and some camping grounds on national park islands are closed during nesting season. The beach stone curlew, while an endangered species on the mainland, is common in the protective isolation of South Molle Island. Raptors such as wedge-tailed eagles, white-bellied sea-eagles, ospreys and Brahminy kites are also numerous in the region. From July to August, when the humpback whales come to calve, whale-watching is virtually obligatory for Whitsunday visitors, and is a feature of all the daily cruises.

As my subsequent explorations proved, getting around the Whitsundays at water level is no problem. The variety of vessels and the type and duration of trips they offer is staggering: there are fast water taxis to zip you to resort islands; sleek, fast twin-hulled ferries that journey to the outer reef; and magnificent and well-known yachts, such as Sydney–Hobart veteran *Apollo*, on which you can take a day trip and help the crew hoist and trim the sails. Bareboat charters, where you hire a fully equipped boat but provision and sail it yourself, are another alternative (see pp. 150–153). This latter mode of travel has the advantage that you can pretty well set your own itinerary, dependent only on whim and the weather.

Early morning bushwalkers on Lindeman Island in the southern Whitsundays enjoy a sunrise from the 210 m summit of Mount Oldfield (top left). An aerial view of Shute Harbour (left), one of the mainland ferry terminals servicing the Whitsundays, is ready testimony to the region's advertising slogan, "The Whitsundays – Out of the Blue". The turquoise colour of the water is due to the suspension of very fine sand particles that scatter sunlight and reflect its blue-green components. The pontoon at Hardy Reef on the outer GBR (opposite) offers overnight accommodation and, situated in the shelter of a deep-water passage between two reefs, is protected from the trade winds and open sea swells for the whole year.

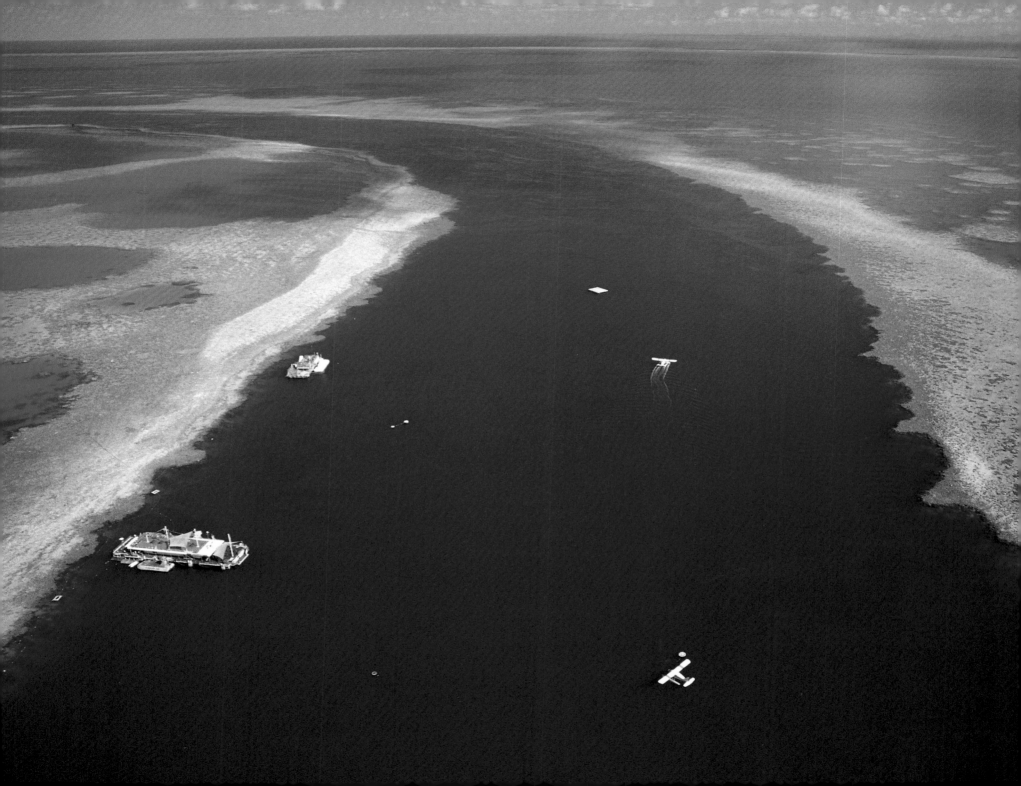

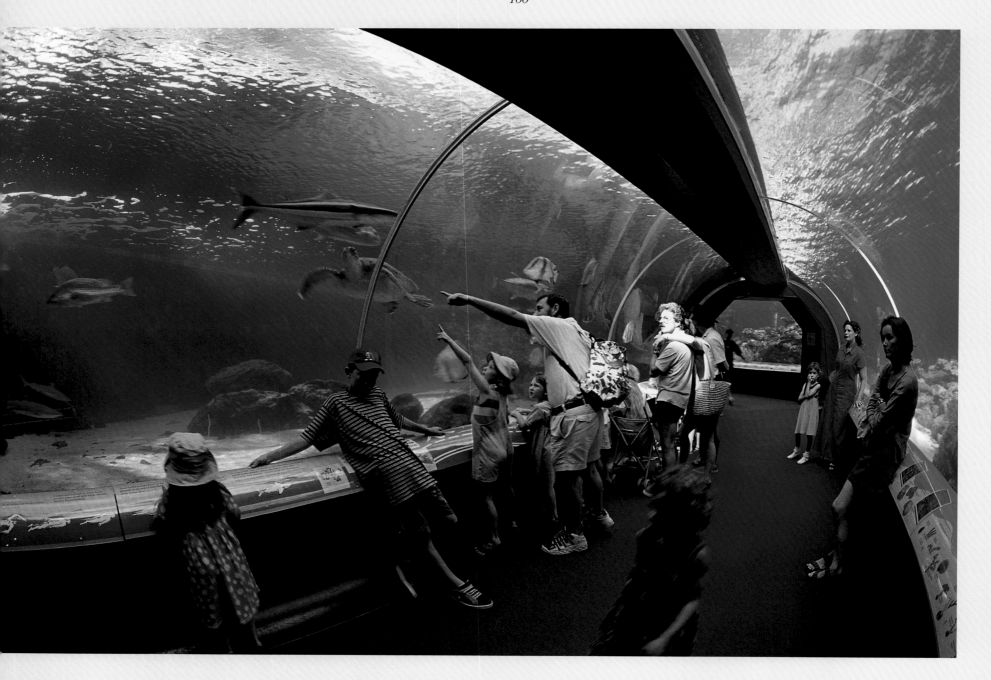

Townsville and the GBR Aquarium

The city of Townsville, north Queensland's administrative and manufacturing capital, has a population of about 130,000. The busy port area handles minerals from Mount Isa, beef and wool from the western plains and sugar from the coastal regions.

It is also one of Australia's major learning and research centres for coral reef biology. It's the home of JCU, the GBR Aquarium (now known as Reef HQ), GBRMPA headquarters and, of course AIMS, which is 40 km south at Cape Ferguson. As Charlie Veron of AIMS put it, Townsville really is the "global centre of coral-reef knowledge".

Townsville's main attraction for reef visitors is probably the aquarium, which opened in 1987. Home to approximately 1000 colonies of hard and soft corals representing 100 species, and more than 200 species of fish, it is also the only aquarium in the world to have mass coral spawning coinciding with spawning on the natural reef.

"A lot of visitors to this region just never make it out to the reef," explained Reef HQ director Martin Jones. "So the idea was to build this place to fill that gap."

Martin was recruited from AIMS, having worked there as a marine scientist for 12 years. "I certainly learned more about coral reefs in the first two years here than I had in all my years at AIMS," he said, describing how the complexities of coral reefs

The 20 m long acrylic viewing tunnel at Reef HQ (opposite) separates the 2,500,000-litre Coral Reef Exhibit and the 750,000-litre Predator Exhibit, and allows land-based visitors a very realistic experience of the reef proper. Reef HQ has a strong educational program catering for local schoolchildren. At the touch pool (right), Townsville residents John Male, Bruce Lavarack, Caitlin Lavarack and Emily Caleo get a hands-on feel for creatures such as starfish and sea cucumbers. Reef HQ is situated on Ross Creek, walking distance from Townsville's CBD. Viewed from Castle Hill the city of Townsville (top right) spreads around the shores of Cleveland Bay from the mouth of the Ross River.

were greatly amplified in a closed-system aquarium. By way of example, Martin explained the need to constantly finetune the salinity in the main displays, adding filtered fresh water or concentrated salt water, as appropriate, to compensate for the effects of rainfall into and evaporation from their two main display tanks.

The need for a problem-solving approach to the exhibits also provides opportunities for the type of research that can assist the protection of the reef proper. "We're looking at ways to culture coral, for example," Martin said. "We're already culturing other invertebrates and fish. I'd like to develop this further and commercialise it to provide species for the aquarium trade, so we can take the pressures off natural communities."

Mike Townsend, the water-quality supervisor at Reef HQ *(left) uses state-of-the-art technology to monitor the aquarium water for concentrations of certain chemicals that can be measured in parts per billion. Interns Julian Cocks and Masaharu Mizukami feed quarantined fish before introducing them into the main displays (above). Such screening procedures ensure all the aquarium inhabitants – vertebrate and invertebrate – remain in good health.*

Magnetic Island

Only 8 km offshore from Townsville and easily reached in 20 minutes by ferry, Magnetic Island is often seen as simply a suburb of that city. But, landing on the wharf at Picnic Bay, I could feel the comfortable seclusion that an island lifestyle creates, an atmosphere quite different from a city.

Marine biologist Dr Rick Braley, an old friend and now a Magnetic Island resident, confirmed my initial impressions. "It's an easy, quiet island; the nice thing about it is that we have all the home comforts here but without the pace of the city," Rick said.

I was captivated by the rugged beauty of Magnetic: gum-tree-clad hills interspersed with stands of majestic hoop pine; splendidly secluded beaches tucked between headlands of weather-smoothed granite boulders.

Magnetic Island has a resident population of around 2500 people, concentrated in several small "towns", which are really extended communities. Picnic Bay, the main point of entry for visitors, is on the southern tip of the island, Nelly Bay and Arcadia on the eastern side, with Horseshoe Bay on the northern coast. The remainder of the island – about 70 per cent of its 5200 ha – is national park.

Rick took time out from running his small aquarium, now open to the public and predominantly stocked with his beloved giant clams, in order to give me a guided tour of the island. As we drove to Radical Bay at the island's north-eastern tip I was able to appreciate Magnetic's diverse range of vegetation – dry rock-studded scrublands, open eucalypt forests, small pockets of rainforest and coastal mangroves. It

Returning from Magnetic Island, the commuter ferry approaches its Townsville terminal in Ross Creek (top left). Captain James Cook named Magnetic Island in 1770. As he sailed by, he noticed his compasses behaving strangely and attributed this to the island's "magnetic" influence, a phenomenon that has never been detected in modern-day studies. Magnetic resident Rick Braley has his own explanation: "The people around here like to use the term magnetic; they say there's some kind of attraction that always pulls them to the island." Uncrowded beaches and clear warm waters, such as at Alma Bay (above) certainly number among Magnetic's attractions.

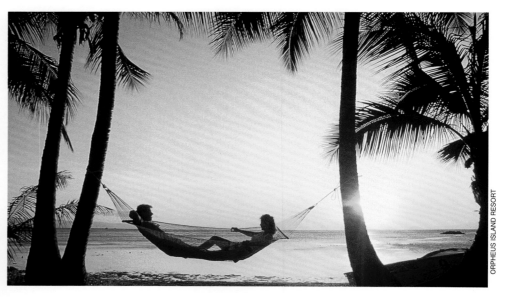

ORPHEUS ISLAND RESORT

Dr Rick Braley and his daughter Fia do the morning inspection of the giant clams in Rick's Aquasearch Aquarium (above). Rick's long-term plan is to establish a breeding colony of these giant molluscs in the sea off the island. At Orpheus Island, 60 km north-west of Magnetic, a holidaying couple (top right) enjoy the tropical sunset.

was no surprise when Rick told me that the wildlife these habitats support is equally varied. "We've got possums, echidnas, flying foxes, rock-wallabies and, of course, the koalas that were introduced in the 1920s," he said. I also knew there are many types of lizards, from tiny skinks to large goannas, several varieties of snakes, including death adders, and the ubiquitous green tree frog. But it's birds that catch the eye: over 166 species have been recorded. Rick counted off a few on his fingers: "Rainbow lorikeets and sulphur-crested cockatoos, noisy friar-birds, both laughing and blue-winged kookaburras, orange-footed scrubfowl and boobook owls."

Rick was carefully negotiating the steep road down to the bay at the island's north-eastern tip, driving slowly to avoid the many potholes and washouts. "Not too many people come down here since the resort closed," Rick told me, indicating the derelict buildings in the scrub above the beach. "But it's a great place for a barbe-cue and a swim; I often bring the family down here," he said. I could see what he meant: clear calm seas and wide golden sands overhung with large shady trees, in one of which perched a magnificent white-bellied sea-eagle.

The diving around Magnetic is passable, though the water is often murky and coral growth is sparse. You can catch a day cruise to some good dive sites on the outer reef, such as Kelso Reef about 70 km north of Magnetic, en route from Townsville. During the warmer months, from October to April, box jellyfish may occur around the island, but there are protective nets for swimmers at Picnic and Horseshoe bays.

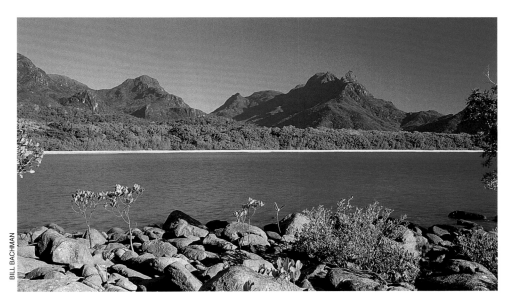

BILL BACHMAN

The view north-west from Zoe Bay (left) on Hinchinbrook's eastern coast, is dominated by Mt Bowen (1121 m), the island's highest peak. The craggy peaks of Hinchinbrook's skyline, made of very hard, erosion-resistant rock, form the most rugged coastal scenery in Queensland.

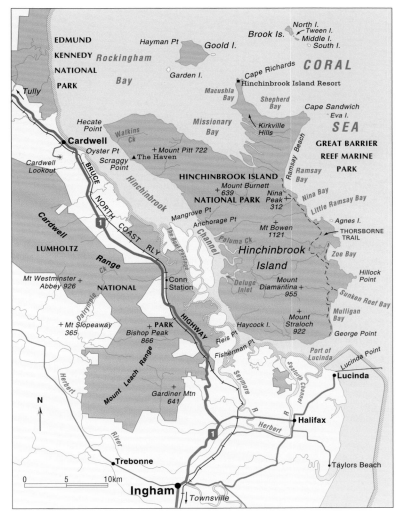

Hinchinbrook Island

Whenever I see Hinchinbrook Island, with its dramatic silhouette of towering craggy peaks, I am reminded of nothing so much as the archetypal islands of the South Pacific, and magical names like Bora-Bora, Moorea and Nuku Hiva spring to mind. Setting foot on the island completes the image. Here are long stretches of white beaches with no signs to indicate human presence, magnificent rainforest, waterfalls and mountain streams. Pristine, lush, primal – Hinchinbrook Island truly rates these descriptions like no other island in the GBR region; indeed it's unique in Australia.

In fact, although Hinchinbrook is indeed an island, its southern end is separated from the mainland only by a relatively narrow open channel and a labyrinth of mangroves. There's no coral growth in the seas immediately surrounding the island, though you can take a charter vessel to the Brook Islands, just 8 km to the northeast of the Hinchinbrook Island Resort, for some reasonable snorkelling.

With an area of almost 40,000 ha, Hinchinbrook is Australia's largest island national park. It reaches a height of 1121 m at the granite summit of Mt Bowen – the north face of which features spectacular cliffs plunging to dense forest on the lower slopes almost to sea level. First declared in 1932, and enlarged in 1960, the park includes a 32-kilometre walking track, the Thorsborne Trail, which extends from the southern end of Ramsay Bay to George Point. The walk takes 3–4 days, taking in numerous creek crossings, rock hopping and a climb to around 260 m, and is recommended for at least moderately experienced bushwalkers.

BILL BACHMAN

Guests from Hinchinbrook Island Resort, ferried on THE MORAY, land on South Island's sandy beach for a day's snorkelling and a picnic lunch (above). South Island is one of the Brook Islands, situated about 9 km north-east of Hinchinbrook's Cape Richards, which can be seen in the background. When Cook sailed by Hinchinbrook in 1770, he was not aware that he was passing an island; he assumed it was part of the mainland. It is separated from the mainland only by a narrow channel and a great expanse of mangroves.

There are also several walks around Hinchinbrook Island Resort, at Orchid Beach on Cape Richards at the north-eastern tip. The only development on the island, the resort was established as an ecotourism venture during the 1970s, and expanded in 1990 to its present status as a low-key resort.

The Thorsborne walk, however, is ideal for visitors who seek encounters with Hinchinbrook's abundant wildlife. The island's animals include agile wallabies and common wallaroos, bandicoots, sugar gliders and short-beaked echidnas, various species of bat and the white-tailed rat. Among the reptiles is Australia's largest snake, the amethystine or scrub python, which can reach a length of more than 4 m.

Among the island's 200 species of bird is the intriguing orange-footed scrubfowl, a megapode, which builds leaf-litter mounds up to 2 m high. The heat produced by the decomposing vegetation serves to incubate its eggs.

Hinchinbrook is also the only GBR island to support a population of estuarine, or saltwater, crocodiles. They stay fairly exclusively around the mangrove inlets on the west side of the island, the mangroves at Zoe Creek and potentially at the lagoon at Little Ramsay Bay on the east. The mangrove areas in Missionary Bay and the Hinchinbrook Channel represent one of the largest remaining stands of mangrove in Australia, with 31 species.

"Mangrove forests are usually well defined from surrounding vegetation," Russell Cumming, senior botanist with the Queensland Herbarium in Townsville, told me. "But on Hinchinbrook the mangroves at the backs of the inlets often grade into the rainforest. There are several unusual mangroves around Hinchinbrook – a 2 m fern mangrove, a palm mangrove with no aerial stem, various shrub and tree mangroves, as well as epiphytic ferns and orchids – plants that grow in trees, without being parasitic," he said.

Hinchinbrook supports an amazing variety of plant species in addition to mangroves, a diversity assisted in the past by the practice of regular patch burning carried out by the island's Aboriginal inhabitants, the Banyin people. Russell explained that the lack of this regular firing had allowed the rainforest to encroach on more open eucalypt forest. Controlled burns are again being conducted by the QPWS to assist species that rely on heat for seed germination, such as Dallachy's blue banksia, named for its unusual blue-grey flower heads. "Hinchinbrook has several rare plants, such as this banksia, that are only found in the mountain-top heath of the island and on parts of the adjacent mainland," Russell said.

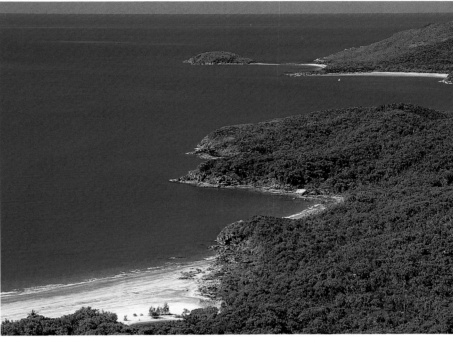

Nina and Little Ramsay bays (above) are typical of Hinchinbrook's eastern coastline. Hinchinbrook's 32 km coastal walk, usually taking four to seven days, from Ramsay Bay to George Point (see map on page105) is reputedly one of the best island walks in the GBR region. In the open forest along South Zoe Creek, lianas (left) entwine the rainforest trees in their quest to reach the sunlit upper canopy.

PHOTOS: BILL BACHMAN

Dunk Island

Shelly Parer was living up to her vocation as activities manager at Dunk Island Resort, setting a fine pace on the track through the rainforest from the resort to Muggy Muggy Beach. The track to Muggy Muggy skirts the edge of a headland and is totally enveloped by rich greenery on each side and overhead.

About 70 per cent national park, 1000 ha Dunk Island has 13 km of walking tracks on its western half, allowing easy access to dense, luxuriant rainforest. While Dunk has little by way of large land animals, it does have the fawn-footed melomys (a native rat), echidnas and several species of bat. What Dunk does have in abundance is bird life, with over 150 species recorded, including spectacled monarchs, yellow-bellied sunbirds, metallic starlings and various species of kingfishers, herons, pigeons and terns. Bird calls filled our ears as we marched along.

Earlier on our walk we'd visited the Banfields' grave in the rainforest, a short distance from the resort. E.J. Banfield and his wife Bertha are synonymous with Dunk in the minds of many people because of E.J. Banfield's famous *The Confessions of a Beachcomber*, published in 1908, the first of four books he was to write about his life on the island. In fact it is due to Banfield's admiration for Aboriginal people that much of Dunk's Aboriginal history is recorded. The Djiru people called the island Coonanglebah, meaning "peace and plenty" and evidence of their time there remains in the form of several rock-art sites.

Muggy Muggy is one of the more popular beaches on Dunk, and there were already quite a few people snorkelling, swimming and soaking up the sun when we arrived. Although Dunk is a popular resort destination for stays of several days, it

also attracts a large number of daytrippers and campers; it's only 4 km from the mainland town of Mission Beach.

I took my time getting back to the resort. Leaving the track, I cut through the bush to the shore and walked along the reef platform exposed by the low tide. An occasional flash of electric blue in the trees marked the flight of a Ulysses butterfly, perhaps the best known of the beautiful – and abundant – butterflies for which Dunk is renowned. The shale gave way to the sands of Brammo Bay, mottled with leaf fall from the overhanging Indian almond trees. By the time I reached the resort, I'd worked up a good sweat, so I bought a cold drink and walked out to the island's wharf to rest.

Dunk has had an artists' colony since the early 1970s. Over the years resident and itinerant potters, weavers, sculptors and other artists have sold their wares to visitors from the resort, several kilometres to the north. Susi Kirk, now the resident silversmith in the artists' colony, has lived on the island for a number of years and loves the life. Her son takes the water taxi to school on the mainland, though he complains that school "interferes with his fishing".

Susi talked animatedly about diving around Dunk. "I just throw on a facemask and I'm down there," she said, describing how just off the southern end of the island she'd seen giant clams, unicorn fish and leopard sharks. "And there'll be moray eels coming out to meet me – there's a lot of life down there." She went on say how she believed many people have a childhood dream of living on an island. "Some people make it a reality and some people leave it as a dream," Susi said. "Dunk is my reality."

Dunk Island is only a short distance offshore from Wongaling Beach (opposite top), where water taxis make frequent daily runs to the island. The resort on Dunk Island offers numerous interpretive rainforest tours for its guests (opposite bottom left). The resort fronts Brammo Bay (opposite right), and occupies the site of the home of Dunk's original beachcombers, E.J. and Bertha Banfield. Leaf fall from Indian almond trees dapples the beach at Brammo Bay (top right). The fruit of the Indian almond is an edible nut with a taste similar to its namesake and is found on many GBR islands. At right, an instructor of water sports at Dunk Island Resort takes a turn around Brammo Bay against a backdrop of Dunk's lush rainforest.

For general information about the GBR Marine Park, and to obtain zone maps of it, contact GBRMPA (☎ 07 4750 0700, fax 07 4772 6093, web www.gbrmpa.gov.au). Other useful web sites for GBR visitors include: Tourism Queensland (www.tq.com.au); and the Great Barrier Reef Visitors Bureau home page (www.greatbarrier reef.aus.net).

Almost all GBR islands are national parks and camping is allowed on many of them subject to certain conditions. Camping permits, which carry small fees, are required in advance from QPWS (all cities and most major towns in coastal Queensland have a QPWS office). For office locations, general information or to obtain the booklet *Camping in Queensland*, contact the Naturally Queensland Information Centre (☎ 07 3227 8185, www.env.qld.gov.au).

Lady Elliot Island Reef Resort has accommodation either in safari-type tents with shared bathroom facilities or motel-style units or cabins. Camping is not permitted. The only access to the island is by air; Whitaker Air have daily flights from Bundaberg and Hervey Bay; bookings are made through the resort. Contact Lady Elliot Island Reef Resort (☎ 1800 072 200, fax 07 4125 5778, email ladyelliot@coastnet.net.au).

Lady Musgrave Island has no facilities but camping is permitted. Ferries run 5 days a week from Bundaberg Harbour (20 km from the city). For information contact Lady Musgrave Barrier Reef Cruises (☎ 1800 072 1109, fax 07 4159 5085).

Heron Island Resort offers resort accommodation in cabins with shared facilities or suites. There is no camping. Contact P&O Australian

Resorts (☎ 13 24 69, fax 02 9299 2477, email resorts_reservations@poaustralia.com). Access is by catamaran from Gladstone Marina (contact P&O Australian Resorts); or by air with Marine Helicopters (☎ 07 4978 1177, fax 07 4978 1003).

There is a wide range of accommodation on offer at Great Keppel Island, from safari-type tents, backpacker-style dormitories and beach bungalows to resort motel-style accommodation. Contact Keppel Tourist Services (☎ 07 4933 6744, fax 07 4933 6429) for ferry and accommodation bookings, or Great! Keppel Resort Reservations (☎ 1800 245 658, fax 07 4939 1775, email gkeppel@gkeppel.com.au). Access is by boat from Rosslyn Bay (bookings through Keppel Tourist Services) or 15-minute flight on Whitaker Air from Rockhampton (bookings through Great! Keppel Resort Reservations).

Many of the visitors to the Whitsunday Islands arrive and depart via the jet airport on Hamilton Island, with direct flights or connections from major Australian cities, or via Proserpine Airport. Water taxis and ferries connect Hamilton and the mainland and a number of other islands in the group. For information regarding the range of accommodation available in the Whitsundays, contact Tourism Whitsunday Information Centre (☎ 1800 801 252, fax 07 4945 3182). The main ferry/cruise operators are Fantasea Cruises (☎ 1800 650 851, fax 07 4946 5520, email info@fantasea.com.au) and Whitsunday All Over Cruises (☎ 07 4946 6900, fax 07 4946 5763). For aerial sightseeing or charter flights contact Air Whitsunday Seaplanes (☎ 07 4946 9111, fax 07 4946 9100, email greatbarrier reef@bigpond.com). For Whitsunday camping

regulations, contact QPWS at Airlie Beach (☎ 07 4946 7022).

For detailed information about GBR research and coral reef biology check the web sites for Townsville-based, AIMS (www.aims.gov.au/), the GBR aquarium (www.aquarium.org.au/), and the JCU Department of Marine Biology (www.jcu.edu.au/school/mbiolaq/).

Magnetic Island is a popular destination for backpackers, with cheap and comfortable accommodation widely available. For island access contact Sunferries (☎ 07 4771 3855). A bus service runs between the population centres, and bicycles, motorcycles and Mini Mokes are available for hire. Sunferries offer ferry/bus and ferry/Mini Moke packages. For general information on the range of accommodation and island activities, contact The Island Travel Centre (☎ 07 4778 5155, fax 07 4778 5158). Pure Pleasure Cruises (☎ 07 4721 3555, fax 07 4721 3590) operates an outer reef trip from Townsville several days a week, weather permitting, which calls at Magnetic Island.

The only accommodation on Hinchinbrook Island is at Hinchinbrook Island Resort (☎ 07 4066 8585 or 1800 777 021). Access to the island is by ferry from Cardwell; contact Hinchinbrook Island Cruises (☎ 07 4066 8539) or Hinchinbrook Island Ferries (☎ 07 4066 8270, fax 07 4066 8271). For bareboat or houseboat cruising around Hinchinbrook, contact Hinchinbrook-Rent-a-Yacht (☎ 07 4066 8007, fax 07 4066 8003, email www.hinchinbrookrentayacht.com.au). For information about, or permits for, camping on Hinchinbrook contact QPWS Cardwell (☎ 07 4066 8601).

Dunk Island Resort offers motel-style accommodation; contact P&O Australian Resorts (see Heron Island entry). For information about, or permits for, camping on Dunk contact the island's QPWS office (☎ 07 4068 8199). Access is by air from Cairns and Townsville (contact P&O Australian Resorts or your travel agent); for the ferry from Clump Point contact Dunk Island Ferry & Cruises (☎ 07 4068 7211) or Quick Cat (☎ 07 4068 7289); for water taxi from Wongaling Beach contact Dunk Island Water Taxi (☎ 07 4068 8310) or for cruise vessel from Cairns and Townsville contact Coral Princess Cruises (☎ 1800 079 545, fax 07 4721 1335).

Constructed by backpackers, this "dogodile" basks in the afternoon sun at Airlie Beach in the Whitsundays (above), while a little distance offshore, a cluster of small craft ride at anchor (opposite). Airlie Beach and surrounding areas contain the majority of moorings and marina facilities for the Whitsundays.

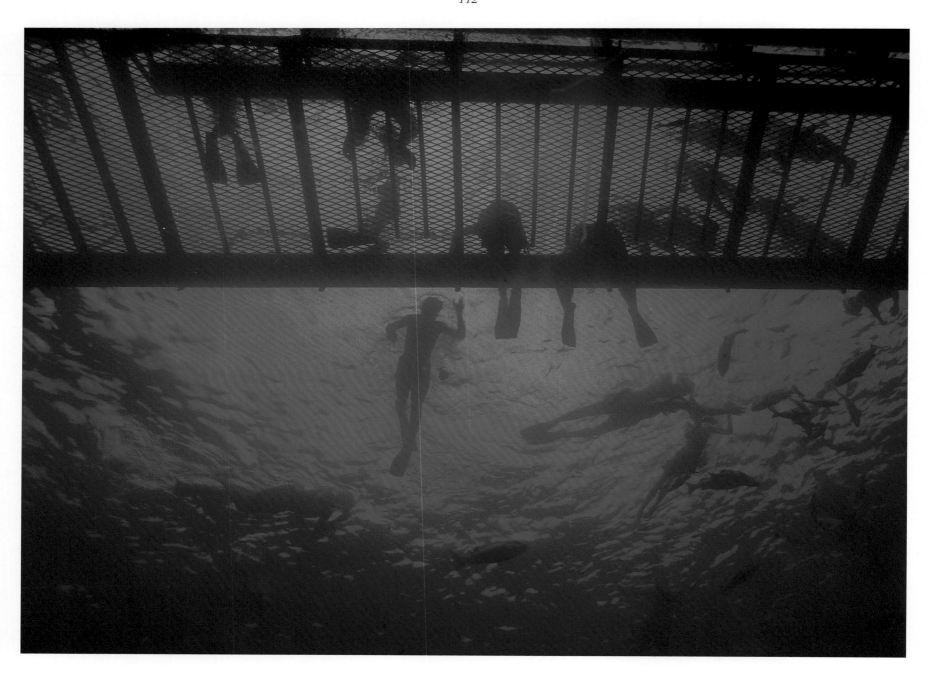

The Coral Coast

The Great Barrier Reef: Northern Region

The Great Barrier Reef's northern region is its outback – vast, and in the far north isolated and rarely visited. It's made up of the 35,000 sq. km Cairns Section (Dunk Island–Lizard Island) and the 85,050 sq. km Far Northern Section (Lizard Island–Cape York) of the GBR Marine Park. The continental shelf – and so the width of the reef – is at its narrowest in this region, averaging around 60 km wide throughout the Cairns Section down to little more than 20 km wide off Cape Melville to the north. Off Cape Weymouth, in the Far Northern Section, it begins to widen again – the outer reef is 160 km east of Cape York.

From around the Agincourt Reefs northwards, the continental shelf abuts the Queensland Trough, which drops to abyssal depths of more than 3000 m. Troughs generally tend to accumulate nutrients and occasionally, as a result of upwellings – a type of slow vertical movement of oceanic waters caused by changes in water density at different depths – these nutrients are carried to shallow surface waters, resulting in a plankton bloom. This may happen once or twice a year in the far northern outer reefs, with the resultant increase in the level of nutrients and plankton contributing to their overall biological richness. It is a region where sharks and other big predators, turtles, whale-sharks and marine mammals occur in numbers seldom seen in the central and southern GBR.

The outer reef north of Port Douglas is characterised by ribbon reefs, the most distinct reefs of the entire GBR. North of Raine Island, about 650 km north of Port Douglas, these ribbon reefs begin to break up into a series of "deltaic" reefs. They are so named because their characteristic U-shape is thought to resemble a river delta. Deltaic reefs also occur in the Pompey complex in the far southern GBR.

Although the Cairns Section is the smallest of the four main sections of the marine park, it attracts the most people – around 70 per cent of all GBR visitors, almost 1.5 million people annually. Because the GBR is so narrow here, the magnificent outer reefs are most accessible in the Cairns–Port Douglas region. The true tropical climate of the region is also a big attraction, and its tourist infrastructure – developed over the past two decades – is virtually unparalleled in Australia. North of Port Douglas, visitor facilities are very limited.

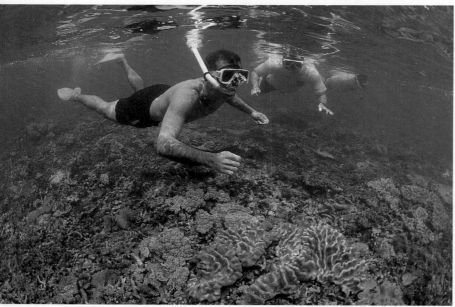

Frankland Islands

"What's your favourite Great Barrier Reef island?" I was often asked on my travels. Each island has its own distinctive character, making comparisons unfair, but if I was compelled to make choices the Frankland Islands would be near the top of the list. While Hinchinbrook would win hands down for sheer beauty, its size is perhaps a little daunting. I like small islands, preferably with no indication of human influence. And by that yardstick, the Franklands definitely qualify. They really are the "little-known secret" of the reef.

The group's five islands – Normanby, Mabel, Round, Russell and, a few kilometres to the north, High Island – are about 40 km south-east of Cairns. Russell Island is a Commonwealth lighthouse reserve; the others are all national parks, declared in 1936 due to their popularity as fishing and boating destinations. Their accessibility to the mainland also meant that the islands were a rich hunting and fishing ground for the region's Aboriginal people, particularly the Gungandji and Mandingalbay Yidinji clans.

Normanby is the only island serviced by daily cruise vessel from Deeral, a 45-minute drive south of Cairns. Beginning in the Mulgrave River, and following its mangrove-lined shores for 30 minutes before the short sea crossing, this cruise gives you a day to explore Normanby Island above and below the water.

Unfortunately, most of Normanby's fringing reef was dead when I visited; the skeletal remains of what was obviously once lush coral growth were covered in algae. Tanya Martin, a marine naturalist and guide with the cruise, explained that much of the die-off was due to the effects of Cyclone Justin in early 1997. "The waves caused a lot of damage for sure," she said, "but what really killed the corals was the silt and freshwater run-off from the Mulgrave and Russell rivers." There were, however, some large colonies of leather corals, some more than a metre across. It didn't surprise me that these soft corals had survived, as they have a high tolerance for reduced salinity and silty conditions. Together with the occasional giant clam, they were the most obvious invertebrate life on Normanby's reef.

Prone to the effects of seasonal floods, corals growing in the vicinity of rivers always have a tenuous existence. But I knew that, as with all such natural occurrences, the demise of Normanby's corals was only temporary, part of the ongoing

At Normanby Island in the Frankland group, dive instructor Mark Blanch instructs a group of introductory divers in scuba theory (top). Despite the lack of spectacular marine life on Normanby's fringing reef, snorkellers are nonetheless enthralled by their first experience on a coral reef (left). The groups that visit the Franklands are comparatively small (opposite left); the islands are not a mass-market destination. The Franklands day-cruise boat rides at anchor, framed by driftwood (opposite right), probably trees carried to the island from the mainland during flooding.

cycle of death and rebirth that occurs on all coral reefs – although the flooding that followed Cyclone Rona in February 1999 may well put regrowth back a few years.

In contrast, the forest on Normanby was lush and obviously thriving. Guide Kate Richards led the small group of visitors along the shore for a short distance before entering the cool shadows under the casuarina groves.

There is no surface water on the Franklands and during the winter dry season much of the vegetation either browns or dies off. With the summer rains, it comes to life again with bird's-nest ferns, native nutmeg, figs and Indian almonds once more regaining their vigour. Bird life abounds and, in addition to pied imperial-pigeons, the islands' forests are home to the rose-crowned fruit dove, white-breasted woodswallow and the varied honeyeater, while along the shoreline ruddy turn-stones, grey-tailed tattlers, lesser sand plovers, whimbrels, and bridled, black-naped and Caspian terns are regular visitors.

We soon emerged on the island's southern shore where coastal plants such as Cardwell cabbage and octopus bush formed a dense barrier along the beach and stands of mangroves extended out to the reef flat. It was low tide and the exposed reef extended out for more than 100 m. White reef herons wandered about, ever watchful for small fish in the pools left isolated by the tide. An osprey watched us with a steady gaze from its perch in a tree overhanging the beach. Kate lifted several large slabs of coral rock in the rockpools and, to the delight of visitors, she pointed out the numer-ous small crabs, brittle stars and sea cucumbers that were sheltering underneath.

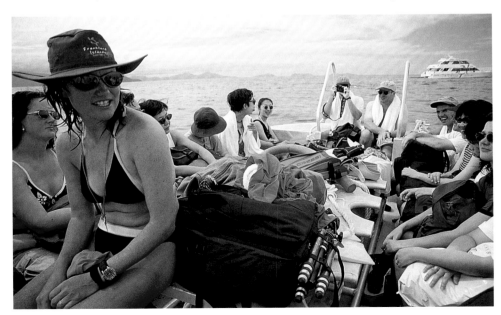

Many of Cairns' buildings (above) date from the late 1800s and, in keeping with the architectural fashions of the day, were not designed for the tropics – though nowadays they are all air-conditioned. At Marlin Marina advertising placards are testimony to the many options available for getting out to the reef (top right). The Cairns Esplanade park (right) is well used by both visitors and locals alike; professional tree climbers regularly crop the fruit from the many coconut palms to avoid injury to passersby. Berths at the Marlin Marina are in high demand during the peak tourist season in the winter months (opposite top), and craft of all sizes and types – such as these returning to Cairns after a day on the reef (opposite bottom) – generally operate to capacity during this time of year.

THE REEF'S BOOM TOWN

Cairns was founded in 1876 as a customs headquarters and port of entry, following various gold strikes in the region. The town began to flourish in the early 1880s, with the tin rush on the nearby Atherton Tableland and the establishment of sugar-cane plantations in the Mulgrave and Russell river valleys to the south. Cairns officially became a city in 1923 and over the following decades it grew steadily.

Nowadays Cairns is undeniably the GBR region's number one tourist city, and its volume of annual visitors outweighs the resident population (estimated to be around 130,000, and rapidly growing) many times over.

When you walk past the shopping malls, duty-free stores, tour agencies and smart restaurants, it's hard to believe that until the late 1970s this was just another country town – a pub on every other corner, laid-back and lazy as such tropical backwaters tend to be – and the end of the road north for all practical purposes. Then, in the early 1980s, Cairns was "discovered" by the tourist industry, the GBR its main attraction, and by 1984 Cairns airport had been upgraded to international standard. Fortunately, despite the cosmopolitan front it presents to the world, Cairns is still a country town at heart.

The Cairns Esplanade, with its 2 km of landscaped lawns and shady gardens bordering the tidal mudflats of Trinity Bay, attracts many visitors, particularly backpackers, as it's the city's fast-food restaurant strip. At the southern end of the Esplanade, on the waterfront, is the very popular Pier Marketplace. The Pier includes a hotel, souvenir and specialty shops, bars and myriad eateries, as well as a small aquarium. It also houses the ticketing offices for many of the cruises and tours operating out of Cairns.

Marlin Marina, stretching along the front of The Pier, is the main berth for most of the cruise and dive vessels and floatplanes, as well as the gamefishing fleet. During early morning and late afternoon, when the dozens of cruise boats depart and return to their berths, Marlin Marina is abuzz with activity, with visitors crowding the jetties and footpaths.

As Cairns is only 16 degrees south of the equator, the summer months – December to March – are typically very warm, with daytime temperatures around 30–34°C, falling to 20–24°C at night. This is also the wet season, and periods of very heavy rain and constant high humidity are the norm. In late summer, February–March, cyclones may develop in the northern GBR region, and visitors should know the necessary emergency precautions.

The cooler months, from May to August, are the main tourist season in the region, with temperatures ranging from 24–27°C during the day to around 16–20°C at night.

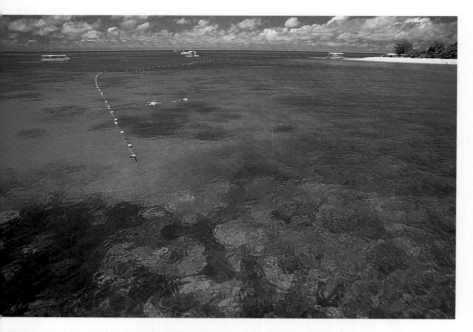

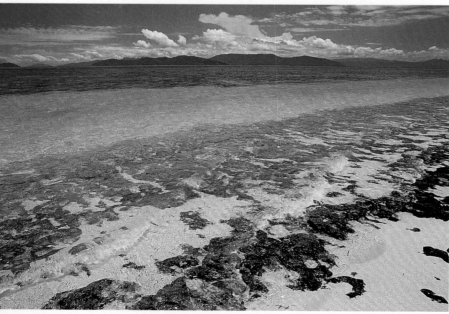

Green Island

I had good reason to remember my previous trip to Green Island in 1966 – I'd missed the afternoon ferry back to Cairns and spent the night in a deckchair on the beach. As my wife Annie and I disembarked from the ferry after the 90-minute run from Cairns (the faster ferry takes only 45 minutes), it appeared that not too much had changed. The 250 m long jetty that ran out from the beach was still here – though looking considerably sturdier since my last visit. And there was the renowned underwater observatory. When the observatory was built, a world first back in 1954, it was an innovative way to view the splendour of the reef. It's now augmented by the popularity of semi-submersibles and glass-bottomed boats. As we walked off the jetty and onto the island, I could see some changes. A sand-coloured retaining wall had been built along the north-western foreshore, and the Green Island Resort, opened in 1994, sprawled among the trees.

Situated 27 km off the coast, Green Island is the most accessible stable-vegetated coral cay on the GBR. A national park since 1937, its 13 ha can get a little crowded nowadays when the daytrippers arrive, particularly on weekends. It's by far the most popular offshore destination from Cairns, with more than 200,000 visitors annually. Numerous ferries, floatplanes and helicopters do the trip daily.

We spent most of the day away from the resort side of the island, walking the wide sandy beaches, still as beautiful as I remembered them, and exploring the densely wooded interior – easy to do since QPWS have established boardwalks with detailed interpretive signs. In the 1870s, bêche-de-mer were harvested in their thousands from the surrounding reefs. Most of the island's trees were cut down to fuel the fires for boiling the sea cucumbers so, although there are some trees over 30 m tall remaining, the majority of the island's forest cover is relatively young. Snorkelling, swimming and sunbathing are the most popular activities for the day visitors, and with over 40 species of bird noted on the island, it is also a good spot for amateur ornithologists.

The snorkelling area at Green Island is marked by a floatline (top). Visitors straying outside this area run a risk of serious injury from the propellers of the many craft that operate daily around the island. Beach rock – such as this at Green Island (left) – is the chemically solidified remains of coral rubble and occurs around the periphery of stabilised cays – or low islands – throughout the GBR. Semi-submersible vessels, with their large viewing windows and their ability to transport passengers over large areas of the reef in air-conditioned comfort, make them a must for day visitors to the reef's resort islands. In the Green Island semi-submersible (opposite) Annie McCoy is delighted by a passing giant trevally, or turrum.

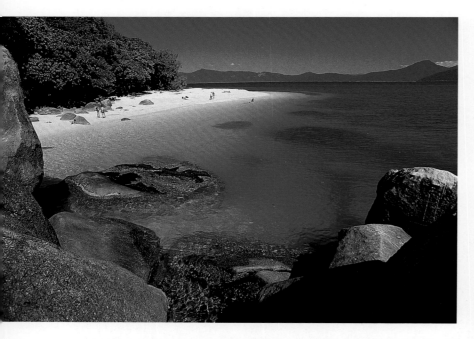

A 15-minute rainforest walk from the ferry wharf, the beautifully clear turquoise waters and white sands attract both locals and visitors to Nudey Beach at the western point of Fitzroy Island (above). A number of the schools in the Cairns region make annual day trips to the island, where both reef and rainforest tours form part of their environmental studies curriculum. At the Moore Reef pontoon (opposite below), a group of introductory scuba divers (opposite top) practise their breathing technique as they wait their turn to enter the water under the supervision of a dive instructor. Both the Moore and Arlington reef pontoons offer snorkelling, and introductory and certified diving. Moore Reef has better examples of hard corals while Arlington Reef has soft corals.

Fitzroy Island

Tucked in close to the coast behind Cape Grafton to the east of Cairns, Fitzroy Island is, like Green Island, a popular destination. Aboriginal people of the Gurubana Gunghandji tribe call the island Gabara, meaning "one wrist" – the name given to it by Gulnyjarubay, a Creation ancestor. Like Green Island, 400 ha Fitzroy was also a site for the collection of bêche-de-mer in the 1870s and 1880s and Aboriginal labour, voluntary and coerced, may have been used. Although today the island is a national park managed by the QPWS, Aboriginal people still maintain sacred sites on the island and utilise its sea and land resources.

Fitzroy is completely covered with rainforest and dense stands of eucalypt and wattle, with a central peak rising to 270 m. Its beaches are bordered with pandanus and casuarina; the fringing reefs offer good snorkelling, with reasonable coral growth and plenty of fish life. There are also excellent bush walks on well-defined trails through the island's interior. The summit walk is one of the most popular, although at two hours, including some steep ascents, it's rather strenuous. The track begins at the northern end of Welcome Bay, near the resort, and climbs to the lighthouse at the island's north-eastern end (approximately a 40-minute walk), before it reaches the peak's summit, with its arrresting 360-degree panorama.

Wildlife is abundant on Fitzroy, with several species of snakes and lizards – including the major skink, a 40 cm long, beautifully patterned brown-and-black animal – spectacled flying foxes, goannas and butterflies. Migratory birds include the pied imperial-pigeon and the buff-breasted paradise-kingfisher. Resident birds include the emerald dove, sulphur-crested cockatoo, osprey, spectacled monarch and the orange-footed scrubfowl.

Michaelmas and Upolu Cays

Michaelmas Cay and neighbouring Upolu Cay, 35 km and 30 km east of the mainland respectively, are the only other islands off Cairns that are regularly visited by day cruises and, weather permitting, floatplanes. Upolu Cay is a small bare sand spit, while Michaelmas Cay, which rises only a few metres above sea level, is covered by grasses and other low-growing plants that provide an ideal habitat for thousands of ground-nesting seabirds. In fact Michaelmas, a national park, is one of the most important seabird breeding sites on the GBR and during the September–April breeding season is closed to visitors, though snorkelling and diving on the surrounding reef are still allowed. At least 14 species of seabird have been recorded on Michaelmas, six of which breed there. During peak breeding time, more than 30,000 birds have been observed on the cay, with sooty and crested terns and common noddies the main nesting species.

The diving around Michaelmas and Upolu cays is reasonable. As they are both situated on inshore reefs the underwater visibility is limited by usually turbid waters and the coral growth and fish life is not as rich as on the outer reefs.

Reefs off Cairns

Directly north of Michaelmas Reef are three isolated platform reefs; south–north they are Hastings, Saxon and Norman reefs. Strictly speaking, they are not outer GBR reefs, though they are often promoted as such. These reefs are visited regularly only by several dive operators in Cairns. However, the largest reef in the area – Arlington Reef, does have a moored pontoon that's visited daily by fast catamarans out of Cairns. Snorkelling, glass-bottomed boating and scenic helicopter flights are on offer at this pontoon, and certified divers are also catered for. Another two tourist pontoons are situated at Moore Reef, about 25 km south-east of Arlington.

Due north of Moore are several reefs that are very popular with divers: Milln, Flynn, Euston and Thetford. These reefs are also promoted as outer GBR reefs though, like Hastings, Saxon and Norman reefs, they lie about 5–10 km inshore of the GBR's outer edge. Dive sites at these reefs are selected by the dive operators each day on the basis of weather and sea conditions.

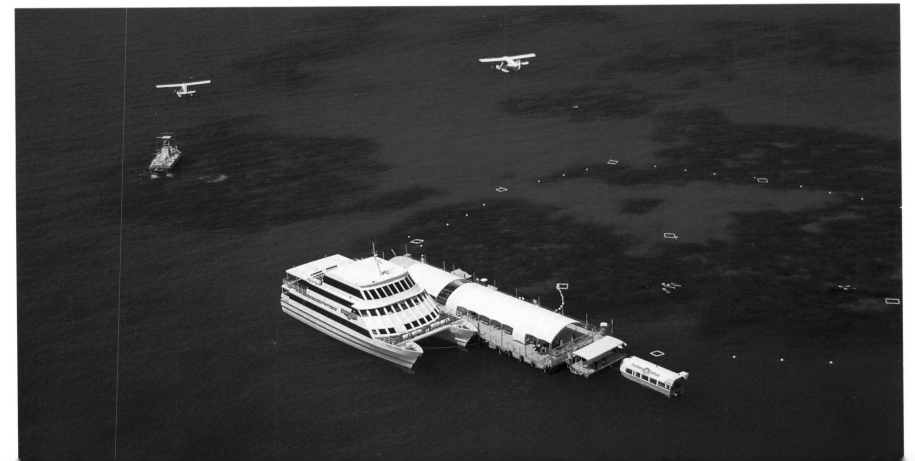

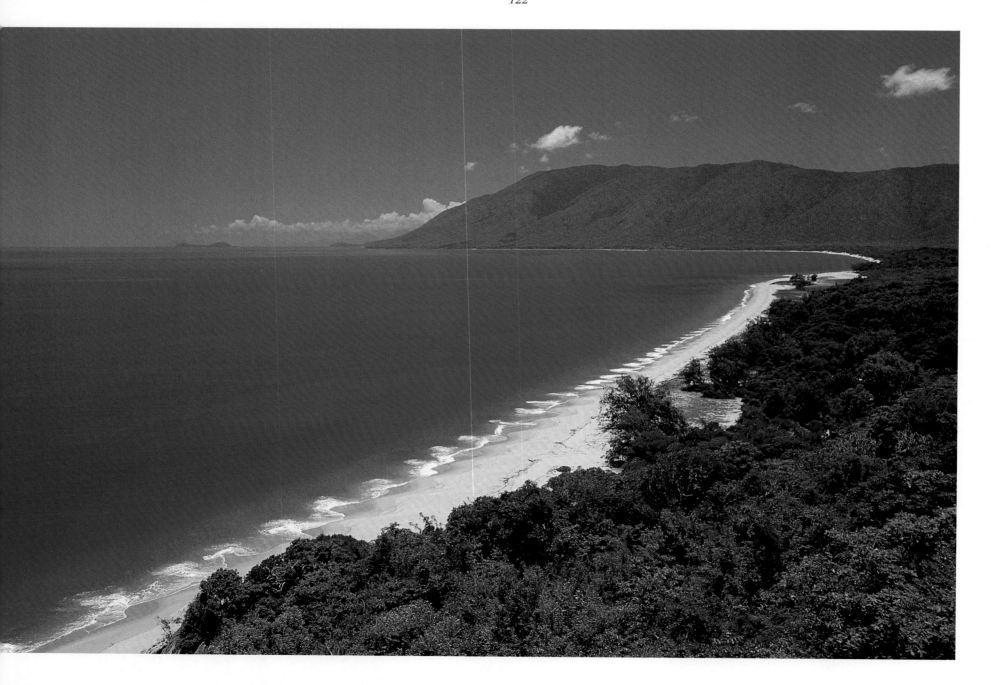

Port Douglas

The town closest to the GBR proper, Port Douglas was the first to offer outer-reef cruises, in the early 1980s. The 65 km Cairns–Port Douglas coastal drive is one of Australia's most spectacular, its northern portion characterised by high steep slopes of thick eucalypt forests to the west, and, in the east, long stretches of golden sandy beaches with the rich blues of the Coral Sea extending to the horizon.

Port Douglas still retains some vestiges of its early days, when, as recently as the 1960s, it was little more than a fishing village. Nowadays it's home to some of the most exclusive accommodation in the GBR region, with high-season room rates approaching $1000 a night. Foreign heads of state, movie stars and others of similar ilk are regular visitors. Many of the private vessels berthed at Port Douglas marina are impressively opulent. The marina also has a veritable smorgasbord of

The view southwards from Rex Lookout at White Cliff Point, on the highway between Cairns and Port Douglas (opposite), is truly spectacular and typical of the scenery along the coastline. For summer visitors from southern states, the complete absence of swimmers at the more remote beaches in the Cairns–Port Douglas region appears very unusual; it is the seasonal presence of the deadly box jellyfish that is responsible. However, the box jellyfish does not occur on the outer reefs of the GBR, such as Agincourt Reefs, where lifeguard Steve Davenport (below left) directs a straying swimmer back to the pontoon.

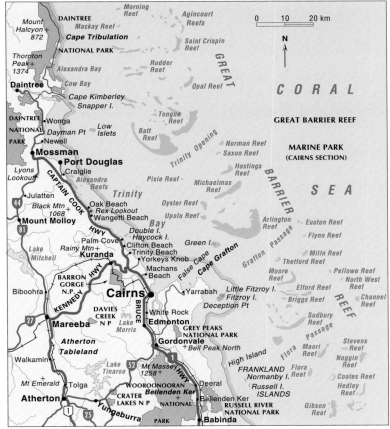

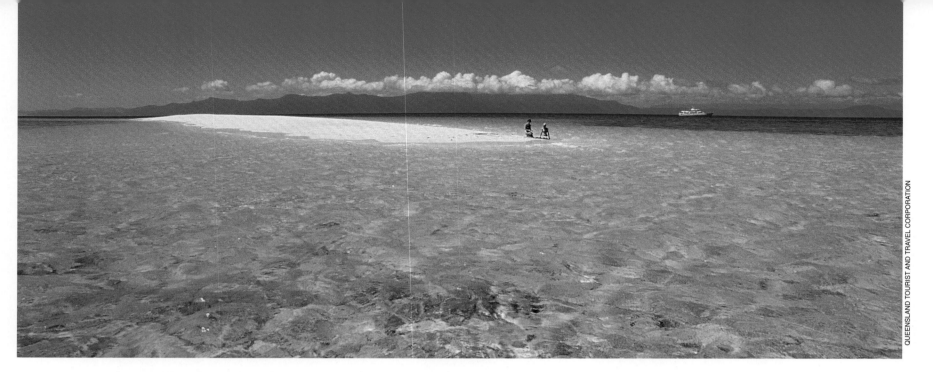

QUEENSLAND TOURIST AND TRAVEL CORPORATION

Undine Cay (above) is a developing sand cay about 45 km north-east of Port Douglas. Without stabilising vegetation, its existence is tenuous, and is largely at the mercy of winds and waves, and the destructive energy of cyclones. It is a popular stopover for day cruises out of Port Douglas, where, for several hours, guests can snorkel and swim or work on their suntans. Several tour operators – both ship and helicopter – use Undine as a "shipwreck" site; offering their patrons the novel experience of being marooned on the island for several hours – with chilled champagne, picnic lunch and sun shelters.

cruise and dive vessels – sail and power boats, large and small – that offer everything from day trips to the nearby Low Isles and other reefs, to week-long live-aboard dive holidays.

The GBR's largest day-cruise operator is based at Port Douglas and its vessels can carry more than 700 people to the outer reef daily. Together with operators of similar – though smaller and slower – vessels running out of Cairns and the Whitsundays, they account for upwards of 2 million visits to the reef each year. Concentrating reef visitors in certain areas is a key part of GBRMPA's conservation strategy. Without the large operators there would be many more smaller vessels on the GBR and, as large operators use the same dive sites and pontoons for many years, other reefs are left in a relatively pristine condition.

The fast wave-piercing catamarans *Quicksilver V* and *Quicksilver VIII* do the daily run to the Agincourt Reefs, 70 km north-east of Port Douglas. Cruising at more than 30 knots, they reach the moored pontoons in 90 minutes. This reef complex is at the southern end of the ribbon reefs and, being on the outer GBR proper, has some magnificent diving. Because of Agincourt's distance from the coast, good visibility is the norm and the coral growth and fish life are abundant and varied.

There are many excellent dive sites within a kilometre or two of the Agincourt pontoon, and certified divers can make a morning and an afternoon dive on different reefs. When I dived there, there were never more than a dozen certified divers in the water at one time, including the divemasters. The many introductory scuba divers are taken into the water in small groups at the pontoons, not at the sites reserved for certified divers.

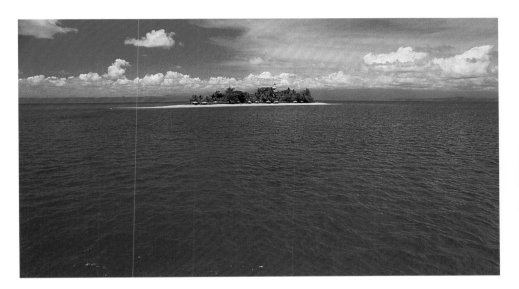

Low Isles

The Low Isles – both of which are national parks – lie about 15 km north-east of Port Douglas. QPWS has an ongoing ranger-training program here that includes people of the Kuku Yalanji and Yirrganydji clans, both of which have interests in the islands. Situated on a large coral platform, the Low Isles consist of a small vegetated coral cay, Low Island, and a much larger mangrove island, Woody Island, which is a major rookery for thousands of pied imperial-pigeons. Both islands are surrounded by mudflats, beds of seagrass and coral reef – a very unusual combination of diverse ecosystems in the one location.

As I sipped a coffee at Port Douglas marina while waiting to board the luxury sailing catamaran, *Wavedancer*, for my day trip to Low Isles, a large group of high-spirited schoolkids, primed on end-of-year exuberance, took up their positions at the boarding gate. They were Mossman Year Seven students, travelling to Low Isles as part of the cruise operator's environmental awareness program. After classroom lessons in the workings of coral reefs, the kids get to experience the reality of a living coral reef – a major advantage of growing up in the area, I thought.

Shawn Depper, one of the Reef Biosearch team of marine biologists who conduct interpretive talks and tours for the cruise operator, led a snorkelling tour of Low Island's reef. Because of its proximity to large coastal rivers such as the Daintree, Low Island's reef is somewhat sparse. Soft corals do well in the silty conditions, but the hard corals need clearer water to thrive. "Visibility here averages 3–5 metres – it can reach 15 metres at times," said Shawn. "Although that's not as good as the outer reefs, for someone who's never snorkelled on a reef before, it's still a great experience."

On my day trip to Low Island (top left) I met Francis James O'Rourke from Mossman who told me that he used to go out to the Low Isles for school holidays more than 60 years ago when he was about nine years old. "My uncle Bill was the lighthouse keeper at the time," he said. "We used to go over in a 30-foot launch from Mossman. It took the supplies for the lighthouse keeper once a fortnight. A lot of fishing boats would go over too; they'd fish the reefs all around and shelter at Low Isles when the weather got rough." Today, Low Island sees many thousands of visitors every year. In order to reduce their impact on the surrounding reefs, cautionary signs (above) have been erected at several places on the shore.

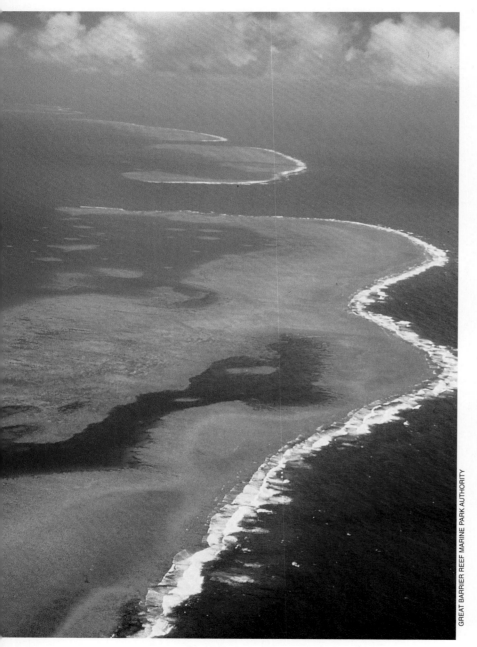

GREAT BARRIER REEF MARINE PARK AUTHORITY

Cairns to the Cape

The outer far northern GBR may well be one of the most pristine coral-reef systems on Earth; certainly it is one of the least known, largely due to the area's inaccessibility. There are almost no human settlements on the coast between Cooktown and Cape York and, although there are numerous islands – both continental and cays – inside these far northern reefs, with few exceptions they are uninhabited and rarely visited.

The ribbon reefs, on the edge of the continental shelf, typically form steep (often vertical) walls on their seaward faces, which drop to great depths. From around the Agincourt Reefs northwards, where the reef systems are very close to the edge of the continental shelf, divers will see fish species that only occur on the outer reef proper – species such as the rare silver-and-black-striped *Genicanthus* angelfish, the elongated sand-dwelling tilefish and the silvertip whaler, a potentially dangerous shark that reaches a length of 3 m. Species such as these are not encountered in the southern region, where the outer reef edges are far beyond the resort islands and outside the range of the dive boats.

Lizard Island, about 250 km north of Cairns, is essentially the northern limit of the GBR tourist trail. North of Lizard is a region very few reef visitors are lucky enough to experience. At the time of writing, only one cruise vessel was making regular scheduled runs between Cairns and Thursday Island, about 35 km northwest of Cape York.

The numbered ribbon reefs – barrier reefs that indicate the edge of the continental shelf – begin with Ribbon Reef No. 1, offshore from Cape Tribulation, and extend to Ribbon Reef No. 10, off Cape Flattery, north of Cooktown, a distance of around 100 km. At left, the view northwards is of Ribbon Reefs 2 to 4. While diving, snorkelling, boating and fishing are permitted at most of the Ribbon Reefs, Ribbon Reef No. 6 is classified by GBRMPA as a Preservation Zone, with only authorised access permitted. One of the purposes of a Preservation Zone is for study as a long-term control, using its untouched ecosystems as a yardstick to gauge the effect of human activities on neighbouring reefs.

A cruise through the far northern Great Barrier Reef

It was the late-afternoon rush hour. As we slowly negotiated our way seawards through Cairns' main shipping channel a steady stream of vessels, large and small, passed us as they returned to their berths after a day on the reef.

A couple of hours earlier, I'd boarded *Kangaroo Explorer*, a 25 m purpose-built luxury catamaran designed for extended cruising and capable of carrying up to 40 passengers and 10 crew. For the next six days, we would work our way through the maze of shoals in the far northern GBR, relying on accurate charts and the satellite navigation system that would have been beyond the imaginings of the early seafarers. But I recalled how, following the *Bounty* mutiny in 1789, Captain William Bligh, together with 18 of his loyal crew, had successfully navigated these same waters in a small open boat without even so much as a compass.

Liz and Andy "Rondy" Simons' reasons for taking the cruise were typical of most passengers aboard. "We wanted to see the reef, we wanted to see Cape York and I wanted to dive at the Cod Hole," Rondy told me. "And this is the only way to do it all – by sea – and we get to cruise through a section of the reef that few people ever visit."

Cape Tribulation (bottom left) can be reached by vehicle from Cairns, and is a popular destination for 4WD tours. Like so many locations in the GBR region, it was named by Cook in 1770. When ENDEAVOUR grounded on a reef on its voyage through the northern GBR, Cook noted in his log book that it was the culmination of troubles that had started as he passed a certain cape, 35 km to the south-west – hence Cape Tribulation. On board KANGAROO EXPLORER, mate Steve Walker cleans a freshly caught mackerel held by deckhand Bobby Jones (below). Most fish caught on the KANGAROO EXPLORER cruises – either by crew or passengers – are served up for meals within hours.

KERRY TRAPNELL

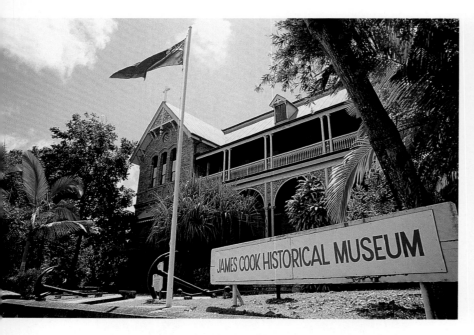

A visit to the James Cook Historical Museum in Cooktown (above) is a must for all visitors to the town, where the rural lifestyle is typified in this image of the Country Women's Association meeting hall in the main street (right). Cook careened his damaged ENDEAVOUR *on the banks of the river that is now named after it. This event is celebrated annually by Cooktown residents, who hold a re-enactment of Cook's landing. In 1995 the event had special significance as the* ENDEAVOUR *replica (opposite) called at Cooktown on its voyage up the eastern Australian coast. Prior to arrival at Cooktown, the replica had made a slow circuit of Endeavour Reef, 50 km to the south-east, where a cannon salute paid tribute to the spirit of the crew of the original vessel.*

Cooktown

After steaming through the night, we arrived at our first port of call before dawn, Cooktown, on the banks of the Endeavour River, 175 km north of Cairns. The main street is rich in history, with many grand century-old buildings testimony to the wealth of gold that came from Palmer River deposits, 120 km south-east of Cooktown, in the late 1870s and early 1880s. Back then it was a thriving community, and the oft-quoted figure of almost 40 pubs in the main street is a reflection of its boisterous boom times. Nowadays there are three hotels, and small-scale tourism is the main industry. The town also boasts the James Cook Historical Museum, where a cannon from Cook's *Endeavour* – one of six thrown overboard when the vessel struck a reef on 11 June 1770 – is on display. Late morning we cast off from the wharf and headed out to sea, anchoring for the night in the lee of an outer reef.

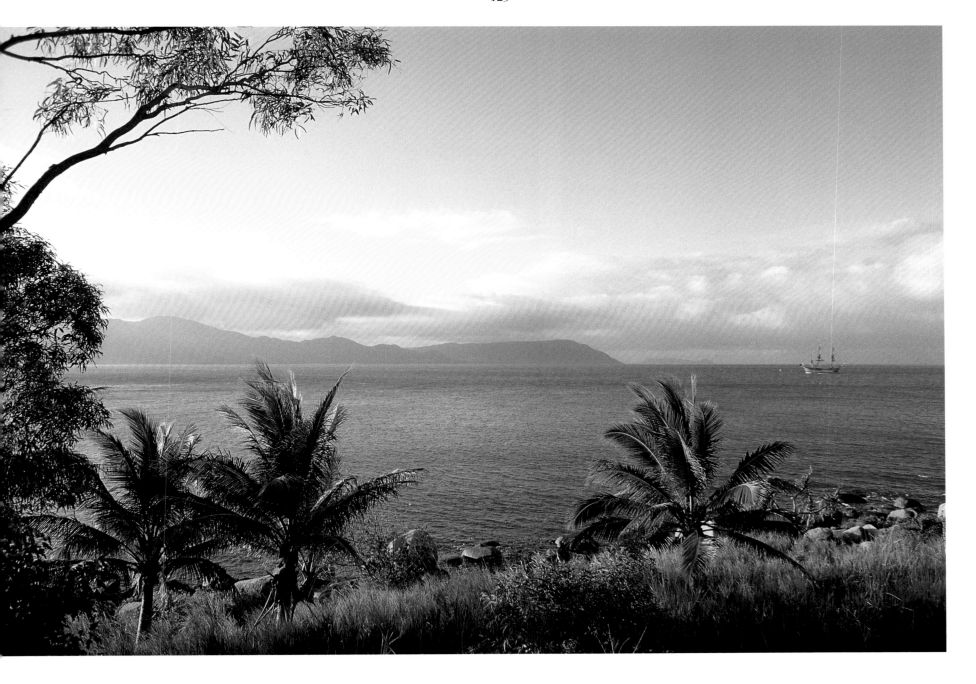

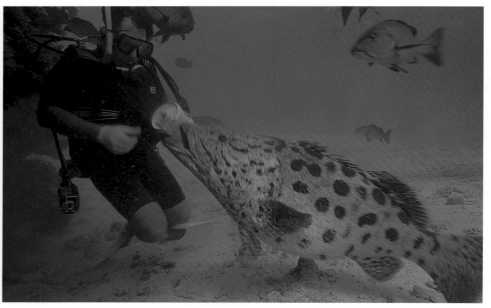

At Pixie Pinnacle Rondy Simons snorkels with his daughter Florence, while other passengers from KANGAROO EXPLORER — *at anchor in the background — view the corals through the glass bottom of* JOEY EXPLORER *(above). With a blur of movement, a giant potato cod takes a piece of fish offered by* KANGAROO EXPLORER *mate Steve Walker, while several red emperors wait their chance for leftovers at the Cod Hole (right). Arguably the* GBR's *most famous single dive site, the Cod Hole attracts thousands of visitors every year, a cause of concern for some conservationists who argue that the cods' natural behaviour has been irreparably modified by contact with humans. However, many marine biologists refute this claim, saying the cod are perfectly capable of looking after themselves should the handfeeding stop.*

Pixie Pinnacle and the Cod Hole

The next morning we steamed to Pixie Pinnacle, an isolated patch reef 75 km north-east of Cooktown. *Kangaroo Explorer* isn't strictly a dive boat, but it does carry a compressor and airtanks and several sets of scuba for certified divers. Rondy and I joined mate Steve Walker for a sampling of Pixie's renowned submarine walls, ramparts of living corals clouded with huge schools of small fish — yellow basslets, blue-green pullers and purple anthiases. The remaining passengers were ferried to the shallow reef top in the appropriately named *Joey Explorer, Kangaroo Explorer*'s glass-bottomed tender, for coral viewing and snorkelling. Our dive was most enjoyable, but it was the next dive that I was looking forward to. It would be at the Cod Hole, about 25 km north of Pixie at the northern end of Ribbon Reef No. 10, arguably the GBR's best-known single dive site.

As we made our way down the mooring line at the Cod Hole the tide had reached its peak and the current had stopped. Steve carried a small plastic bucket full of fresh fish chunks, and the cod, long used to being fed from such containers, quickly homed in on him. There were 8–10 of them, all over a metre in length and weighing at least 50–60 kg. I had expected the feeding to be a sort of near-frenzy, but instead I found the cod to be remarkably well mannered, politely waiting for Steve to hand out each piece of fish — which they swallowed in an instant. Joining the cod for the free lunch were hordes of red bass. These 50–75 cm dark-red fish are voracious, with none of the manners of the cod. "Keep an eye on those buggers," Steve had warned us before we entered the water. "If they think you've got food, they'll have a piece out of you if you're not careful."

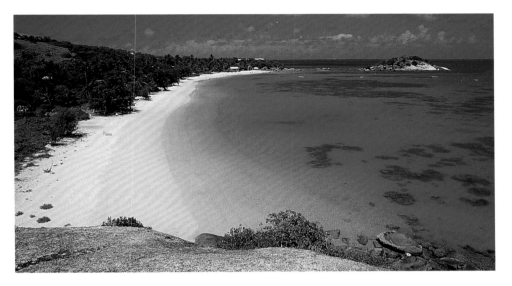

Lizard Island is reputed to have some of the best beaches in the entire GBR. This view from Chinamans Ridge down to Lizard Island Lodge beach (left) lends weight to that claim. The diving around Lizard is reasonably good. Although the island is continental in origin, it lies 30 km off the mainland and its extensive fringing reefs (below) support a rich variety of marine animals. Although the promontory at right is known as Lizard Head, this is not the origin of the island's name. It was Cook who named the island – after the many goannas or monitor lizards he saw there. The descendants of these 1.5 m terrestrial lizards are still abundant on the island.

Lizard Island

The sun was setting as we dropped anchor in Watsons Bay at Lizard Island, called Jiigurru by the Dingaal people. That night I joined the other passengers for an hour of nocturnal coral viewing. A coral reef is a very different place at night. Not only can you see coral polyps extended and feeding, and foraging seashells moving about, you might also glimpse the occasional nocturnal predators, such as eels or octopus. At night, because you're viewing the reef with artificial light, you see all the colours of the spectrum, many of which are absent during the day due to the fact that sunlight's component colours are selectively absorbed by water (see p. 26).

Lizard Island Lodge is one of the GBR's most exclusive resorts, and casual visitors – yachties, campers and the like – are requested not to enter the resort grounds. However, at certain times of the year, visitors can still enjoy a cold drink at the famous (or notorious, depending on your point of view) Marlin Bar, on the beachfront at the far eastern end of the resort. In addition to the typical resort offerings – diving, snorkelling, sailing, fishing and the very best in fine dining – the lodge arranges regular visits to the Lizard Island Research Station. The previous year I'd spent a week at the station, exploring the beaches and bushlands, diving on the reefs and photographing the annual coral spawning (see p. 37).

Lizard Island Research Station was established in 1973, when the Australian Museum negotiated a lease on part of Lizard Island National Park. Its aim was to establish a world-class research facility to further the existing knowledge of the GBR. The station is unique among reef field stations in that it has no direct government support, being funded by fees paid by visiting scientists and by donations

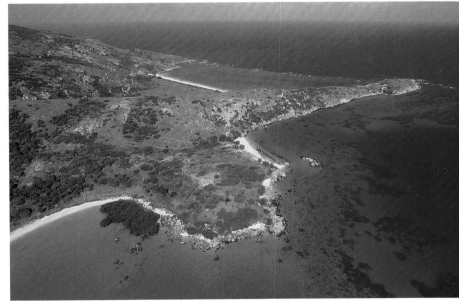

from individuals and organisations like the Australian Geographic Society. From humble beginnings – a series of tents on the beach – it now boasts three laboratories, a flow-through seawater aquarium system, four visitor houses and excellent dive facilities, with a high-capacity compressor, more than 50 scuba tanks and 13 small outboard-powered boats. Around 60 research projects are carried out at the station annually by Australian and overseas scientists. While most research is on coral reef biology, the station's facilities are also used by terrestrial biologists and geologists. Additionally, some 2000 people – Lizard Island Lodge guests as well as campers and passengers from tour boats and yachts – visit the station annually.

Early the following morning several of *Kangaroo Explorer*'s more energetic passengers decided to attempt the ascent of 361 m high Cooks Look before the day got too hot. This is the highest point on Lizard; from here, Cook scanned the surrounding seas to find a safe passage through the reef. However, the majority, myself included, opted for a more leisurely day on the island, swimming in the beautifully clear waters of Watsons Bay and dozing in the shade of the few casuarina groves on the beach. Late in the afternoon the anchor was winched up and we steamed north.

Once out of the island's lee, the ever-present south-east trade winds picked up, and set us rolling in the swells. These seas – too rough to anchor in – prompted a slight change in schedule: our next planned stop had been at a remote sand cay on one of the outer reefs, but by 6 a.m. we were way past the cay and making our way to Forbes Island.

From Lizard Island's One Tree Coconut Beach (below), the view to the south takes in neighbouring Palfrey Island and, at left, just visible behind the granite beach boulder, South Island. The skeletons of forams, single-celled marine animals, make up a large component of some of Lizard's beaches. Aboriginal people regularly visited the Lizard Island group over thousands of years, paddling their bark and dugout canoes from the mainland. The seas around the islands provided an abundance of edible molluscs for these people, the shells of which are the main component of the several large middens on the island. When walking around Lizard, it's advisable to take a supply of fresh water, use sunscreen and wear a hat; the island tends to be very hot and dry in the summer before the rains start.

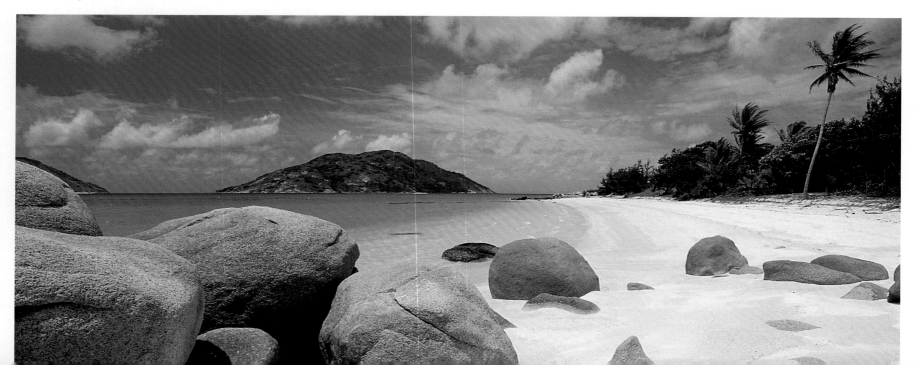

Forbes Island

Forbes is a small, remote continental island of several square kilometres lying 35 km offshore from Temple Bay – proposed site for the world's first commercial spaceport – about 200 km south of Cape York. The low, granite-encrusted hills of Forbes are covered for the most part with coarse grass and scrub with a scattering of grasstrees and termite mounds. In the early 1900s it was the site of a dugong-processing factory, though all that remains of this ill-fated venture is the lonely grave of one of its instigators, a few steps inland from the beach.

When *Kangaroo Explorer* dropped anchor off the northern beach, Steve, Rondy and I took *Joey Explorer* to look for a good dive site on the reef off the point at the western end of the beach. What we saw through *Joey*'s glass bottom was discouraging: some large colonies of leather corals and a few colonies of staghorns, but much of the reef was dead, the coral skeletons covered with algae. I recalled Cairns photographer Roger Steene telling me how he had dived on this same reef 10 years previously and that the coral growth at that time had been, "absolutely bloody exquisite". What had happened in the intervening years to destroy this reef is difficult to pinpoint – cyclones and storms, perhaps the crown-of-thorns starfish or the current bleaching phenomemon – we had seen several of the starfish and the occasional dead and whitened coral skeleton as we slowly motored over the reef. But as with so many of the reef's riddles, there is no single simple explanation to account for the dying of Forbes' corals.

KANGAROO EXPLORER rides at anchor off Forbes Island's northern beach, buffeted by the south-east trade winds (bottom left). Part of Forbes is national park, and part is private crown leasehold, and in recent years coconut palms have been planted in the leasehold. Although coconut palms are regarded as synonymous with tropical islands, the fruit providing a very refreshing drink on a hot day – as the KANGAROO EXPLORER guests could attest to – Queensland Parks and Wildlife regard them as an introduced pest species, their growth displacing the native strand vegetation on the beaches of many of the reef's islands. On the sand flat off Forbes' northern beach, KANGAROO EXPLORER hostess Tania Smith finds a dead clam shell while snorkelling (below). Pieces of coral and shells, even though dead, are not allowed to be taken from the GBR's island national parks.

After deciding against the dive, I climbed the rounded hill – perhaps 50 m high – at the southern end of the beach. The hilltop was mostly barren, buffeted by the almost constant trade winds, with a vista reinforcing the isolation and bleakness of the island: the lack of trees, the yellowing tufts of grass and the grey wind-chopped sea. But there was a real beauty here too, of the lonely savage kind, more sensed than seen. This was one of those truly wild places where you will always feel like an intruder.

We left Forbes around 4 p.m. as storm clouds gathered over the island and the first heavy drops of rain pummelled the surface of the sea. Overhead, a pair of frigatebirds wheeled gracefully, riding the thermals before the approaching front, behaviour typical of these powerful, long-winged, forked-tailed seabirds. *Kangaroo Explorer* would be under way all night, to make landfall early the following morning at Cape York.

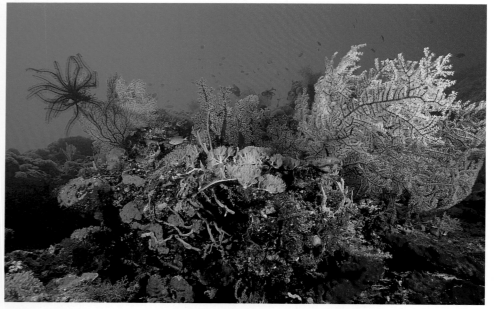

With mate Steve Walker at the helm, JOEY EXPLORER *passengers watch me through the tender's glass bottom as I photograph the sand-dwelling animals in the shallow water off Forbes' northern beach (left). On the outer reef north of Forbes, the marine life of the GBR is at its richest, and gaudy reefscapes, comprising soft corals and sea fans (above), are commonplace.*

RAINE ISLAND

On the far northern GBR the outer reef is an almost continuous barrier with occasional narrow breaks. Just a few kilometres off the outer barrier, and some 200 km south-east of Cape York, isolated peaks rise towards the surface: Great Detached Reef, Northern and Southern Small Detached reefs, Yule Reef and, in the north, Raine Island. Raine is the smallest of the group and is the only reef where an island has formed above the surface.

Several ships were wrecked on reefs in the area before the middle of the 19th century. The most famous, and probably earliest, of these was HMS *Pandora*. In 1791 the 24-gun frigate was returning from Tahiti with 14 *Bounty* mutineers on board when it hit reefs just north of Raine Island, losing 31 crew and four of the manacled prisoners.

In 1844 a 15 m high tower, a beacon that would also give refuge to shipwrecked mariners, was built on the island with convict labour, mostly skilled stonemasons.

Raine Island, a sand cay where beach rock has formed a core to a height of about 3 or 4 m above sea level, is surrounded by a beautiful white-sand beach. This white sand, contrasting sharply with the surrounding cobalt blue water, provides the first glimpse of the island for Andrew Taplin and Cathy Bone (below), perched at the bow of their yacht.

GRAHAM ROBERTSON

They cut limestone blocks from the island's beach rock and, using timbers from wrecked ships, built several floors in the roofed tower, which was stocked with fresh water and non-perishable foods. As a beacon, however, the tower wasn't entirely successful, with more than a dozen ships foundering in Raine Island waters over the following 15 years before a safer passage to Torres Strait via the Great North East Channel was surveyed.

Raine is the world's largest nesting site for green turtles; in some years there can be more than 15,000 turtles on the beach at one time. When the turtles are nesting in November, big tiger sharks circle the island, cruising the edge of the reef to feed. During the seabird nesting season in October–November, Raine is wall-to-wall with birds: the island is a major rookery for two species of frigatebird, three species of booby, terns and, occasionally, red-tailed tropicbirds. Because of Raine's importance to wildlife, you must have permission from QPWS to go ashore.

The walls of Raine's fringing reef drop away steeply into very deep water. There are no decent anchorages; the north-west end gives limited shelter from south-easterlies, but swells come around the island and boats tend to roll a lot. It's not a place to stay overnight because a north-west squall – which occasionally blows through – could drive you onto the reef. The nearest reasonably safe night anchorage is at Great Detached Reef, about 15 km south, which has a good lagoon and reef-protected waters.

Raine Island sees very few human visitors and consequently much of the wildlife there is quite tame. These brown boobies are not at all perturbed by the presence of visitor Chiaki Matsumoto (below). Lesser frigatebirds soar above Raine's tower (bottom right) The tower has stood through many cyclones over more than 150 years. With walls nearly 2 m thick, it's still very sturdy, although the wooden floors have long gone. Carved graffiti adorns its outer walls, names of the convict builders and of visiting boats dating back to the 1800s.

DR WALTER STARCK

GRAHAM ROBERTSON

Great Barrier Reef shipping

That evening we carefully threaded our way through the treacherous reefs and islands of Paluma Passage, where the GBR'S major shipping route is at its narrowest. Before dinner, *Kangaroo Explorer*'s master, captain Gill Cook called me to the wheelhouse.

"Take a look at this," he said, pointing to the north. What looked like the lights of a small town were shimmering in the rain haze. "It's an oil rig being towed by a couple of ocean-going tugs," Gill informed me. "I heard them on the radio; the rig's come from Western Australia and is heading to Gladstone to change crews and then off to parts unknown."

Like the towed oil rig, *Kangaroo Explorer* was plying the inner GBR's main north–south shipping channel – the famous Inner Passage, which stretches for 2000 km from Cape York to the Tropic of Capricorn. Gill told me that there were also three east–west channels running from the mainland to open waters beyond the reef. "Hydrographers Passage links the coal port of Hay Point near Mackay with the Coral Sea," he said. "Palm Passage is the Townsville channel, it also serves Lucinda and Abbot Point. Likewise Grafton Passage serves Cairns, Cape Flattery and Mourilyan."

Gill explained that certain vessels using the Inner and Hydrographers, Palm and Grafton passages were required by law to carry licensed pilots. These are ships more than 70 m in length and *all* oil, gas and chemical carriers, regardless of their size. "But for environmental reasons and public image, most oil company vessels use the Outer Shipping Passage, beyond the reef, even though sea conditions are milder in the Inner Passage," he said.

GBR'S TRAFFIC WATCH

To reduce the risk of pollution or other environmental damage from shipping incidents in the GBR, a 24-hour mandatory ship-reporting system called REEFREP operates in reef waters. The system, formally adopted by the International Maritime Organisation (IMO) in 1996, is run by Queensland Transport at REEFCENTRE, the ship-reporting centre at Hay Point, near Mackay. The need for such a system is reflected in the number of ships over 50 m in length plying GBR waters – a total of 5771 in 1998 – and the fact that the GBR is the only area in the world formally recognised by the IMO as a Particularly Sensitive Sea Area.

REEFREP covers both Torres Strait and GBR waters between the mainland and the outer edge of the reef, from the latitude of Cape York, south to Capricorn Channel, north-east of Rockhampton. The system is uses radio voice reporting through a network of 14 sites – called reporting point positions – that are 80–100 nautical miles (1 nm = 1.852 km) apart along the mainland coast and Torres Strait Islands.

When leaving a port within the GBR region, or entering the area from the open sea, vessels over 50 m in length, and all oil tankers, liquefied-gas carriers and chemical tankers, regardless of size, are required to provide an initial position report and details of their identity, intended route and cargo. Ships continue to report to REEFCENTRE when within 2 nm of any reporting point position so that their progress through GBR waters is continually monitored. Although naval and government-owned or operated vessels are exempt from REEFREP, they are encouraged to comply with the system on a voluntary basis.

After leaving Cape York, Captain Gill Cook (left) steers KANGAROO EXPLORER *on a course through Torres Strait for Thursday Island. The waters of the strait are treacherous, with many hidden shoals and raging currents. Even with modern navigation equipment, negotiating these waters requires a good deal of skill and experience, traits Gill has in abundance after his many years captaining a water-police boat in* GBR *waters.*

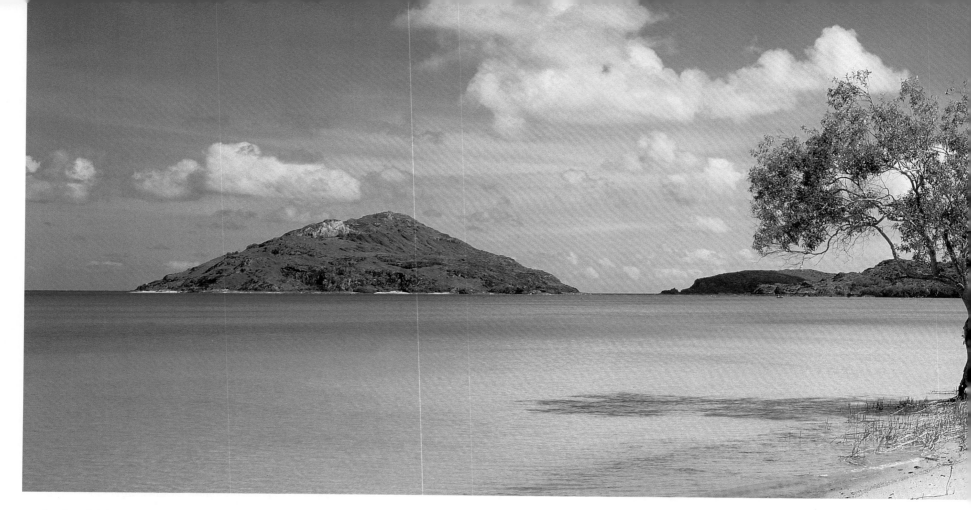

York Island (above) lies a short distance off Cape York – the northernmost tip of the Australian continent and the designated northern end of the Great Barrier Reef Marine Park. Having your photograph taken in front of the signpost at the water's edge at the cape is virtually obligatory for each and every visitor. KANGAROO EXPLORER *passengers Liz and Rondy Simons strike a pose (opposite left), before the 15-minute walk back down the granite headland with the other passengers to* JOEY EXPLORER *(opposite right).*

Cape York

The sun was not yet over the horizon as we boarded *Joey Explorer* for the short ride to the beach. Making our way over the rocky headland, it took only a few minutes to reach the signpost that informed us we were standing at the northernmost tip of the continent. After the obligatory group photographs, we broke out the champagne and sang a rousing rendition of *Waltzing Matilda*.

Cape York is also the northern limit of the GBR Marine Park, though it extends 260 km to the east. The reef itself continues as far as the Warrior Reefs, another 150 km to the north-east and less than 100 km from the mouth of the Fly River in Papua New Guinea, where the constant flow of muddy fresh water and shifting sandbanks prevent coral growth. As I sipped my champagne, I reflected on the fact that for me it was much more than the end of the cruise. It was also the end of my many months of GBR travel; on, above and below the water – a journey that had begun at Lady Elliot Island, some 2000 km to the south.

YOU ARE STANDING AT
THE NORTHERNMOST POINT
OF THE AUSTRALIAN
CONTINENT

For information on the range of accommodation, tours, cruises and local attractions in the northern region of the Great Barrier Reef, contact Tourism Tropical North Queensland (☎ 07 4051 3588). The Cairns OnLine home page (www.cairns.aust.com/) provides a useful guide to accommodation, attractions, tours and entertainment in the Cairns region, and includes a wide range of links to the web sites of major tour operators.

There is no accommodation available on any of the Frankland Islands but camping is allowed on Russell and High islands; call QPWS's Cairns office (☎ 07 4052 3096) for information or permits. Access to Normanby Island is by cruise vessel from Deeral, 45 minutes drive south of Cairns; contact Frankland Islands Cruise & Dive (☎ 07 4031 7766, fax 07 4031 0052). Access to the other islands of the group is by charter boat or private vessel.

Green Island Resort offers accommodation in motel-style rooms or in villas. Contact the resort direct (☎ 07 4031 3300) or book through Great Adventures (☎ 1800 079 080). Camping is not permitted on the island. For daytrip access by sea, contact Big Cat Green Island Cruises (☎ 07 4051 0444, fax 07 4051 8896, email: reservations@bigcat-cruises.com.au). For daytrip access by air, contact Aquaflight Airways (☎ 07 4031 4307).

Accommodation is in beach cabins or beach bunkhouses at Fitzroy Island Resort. Contact the resort direct on (☎ 07 4051 9588) or Great Adventures (see the Green Island entry). For camping information and permits call QPWS Cairns. High-speed catamarans do the run daily from Cairns in around 45 minutes. Contact

Seashells for sale at Port Douglas Sunday morning market (above). Collecting seashells and aquarium fish for personal use is permitted in areas of the reef designated as General Use Zones. Commercial collecting in these zones is also permitted, though permits must be obtained from GBRMPA.

Sunlover Cruises (☎ 1800 810 512, fax 07 4050 1313; email res@sunlover.com.au).

Sunlover Cruises has daily trips to its Moore and Arlington Reef pontoons by high-speed catamaran. Both the Moore and Arlington Reef pontoons have similar offerings: snorkelling, introductory and certified diving, and buffet lunches. Also, 10-minute scenic helicopter flights are available (Sunlover Helicopters (☎ 1800 240 069, fax 07 4035 9414). Great Adventures has daily cruises to its own pontoon at Moore Reef or Norman Reef.

Ocean Spirit Cruises (☎ 1800 644227 or 07 4031 2920, fax 07 4031 4344, email ospirit@internetnorth.com.au) offer daily cruises to Michaelmas Cay on its large sailing catamaran *Ocean Spirit*. Snorkelling and swimming on the surrounding reefs are the main attractions. The 18 m sailing catamaran *Passions of Paradise* (☎ 07 4050 0676, fax 07 4051 9505, email passions@iig.com.au) makes daily snorkelling and diving trips to the outer reef and Upolu Cay.

For general information about accommodation and activities in, and GBR cruises from, Port Douglas call Port Douglas Daintree Tourism (☎ 07 4099 4588, fax 07 4099 4994).

There's no visitor accommodation on Low Isles and camping is not permitted. Access by sea for day trips is on Quicksilver Connections' luxury 30 m sailing catamaran, *Wavedancer*, (☎ 07 4099 5500; fax 07 4099 5525, email quicksilver@quicksilver-cruises.com) and also the sailing catamaran *Sailaway* (☎ 07 4099 5599, fax 07 4099 5070).

Day cruises to Agincourt Reefs are operated by Quicksilver Connections, who have two pontoons several kilometres apart on these outer ribbon reefs. (Cairns passengers can travel to Port Douglas by Quicksilver bus, or on the high-speed Quicksilver catamaran that does the Cairns–Port Douglas run every morning.) Quicksilver Dive (☎ 07 4099 5050, fax 07 4099 4065, email quicksilver@quicksilver-cruises.com) offers diving at a number of different sites near the Agincourt pontoons. HeliAdventures (☎ 07 4034 9066, fax 07 4034 9077, email info@heliadventures.com.au) offers helicopter flights at the Agincourt pontoons.

Kangaroo Explorer's unique 6 nights, 7 days cruise through the far northern GBR takes in Cooktown, Lizard Island, Forbes Island and Cape York, with stops en route at several dive sites including remote sand cays, Pixie Pinnacle and the Cod Hole. The cruise's northern limit is Thursday Island. The cruise can be taken one-way or as a round trip, or you may board at various points en route for either a north- or southbound cruise. Contact Kangaroo Explorer Cruises (☎ 1800 079 141 for reservations; for general enquiries (07 4032 4000, fax 07 4032 4050, or www.kangaroocruises.com.au).

Motel-style accommodation is available at exclusive Lizard Island Lodge (☎ 07 4060 3999, fax 07 4060 3991). Lizard Island Research Station caters for visiting researchers and educational groups. However, limited numbers of volunteers are welcomed at certain times of the year. For details regarding the volunteer program, contact the Director at Lizard Island Research Station (☎ 07 4060 3977, email lizard@amsg.austmus.gov.au). Camping is allowed in specified areas on Lizard; for information and permits contact QPWS Cairns. There are daily one-hour flights to the island from Cairns; for information contact Lizard Island Lodge or your travel agent. Lizard Island is also a regular stopover for many cruise and live-aboard dive boats and the occasional floatplane on a scenic day tour. Access by sea can be arranged through Kangaroo Explorer Cruises.

There are no scheduled passenger services operating to Raine Island. Access is by charter boat or private vessel, and you must have a permit from QPWS to land on the island.

A 90-minute trip to the outer edge of the GBR is possible on the high-speed catamarans operating out of Port Douglas (left). Some authorities believe that technology will soon allow such catamarans to operate at speeds in excess of 50 knots, making more of the reef accessible daily. Marine engineers dispute this, saying the cost of the power to produce such speeds would not be economically viable.

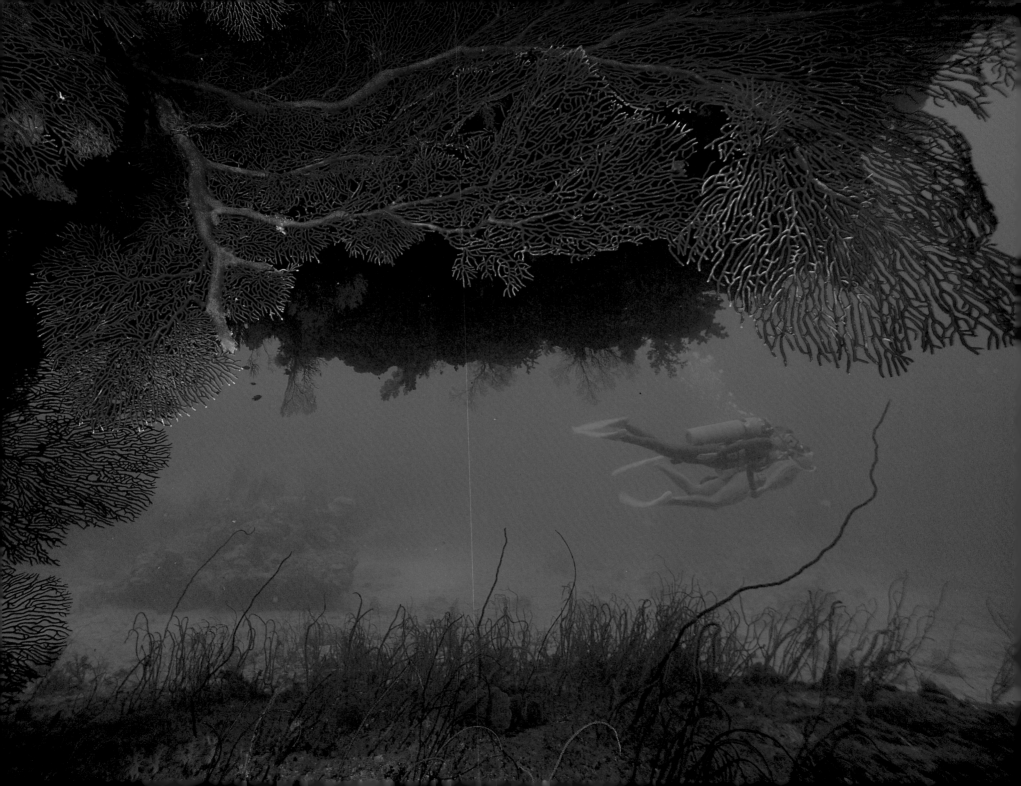

Exploring the Great Barrier Reef

Diving, sailing and skimming the waters

A rich growth of red sea fans on the roof of a coral cave forms an arch over divers in a GBR lagoon. Most visitors to the Great Barrier Reef who manage to get their heads under the water are snorkellers – or simply swimmers. Perhaps somewhat surprisingly, scuba divers account for only a small percentage of overall GBR visitors.

Diving

"They say this is one of the 10 best dive sites in the world." How many times had I heard that statement? It seemed that no matter where I was on the GBR, someone would invariably come out with it. In truth, a dive site can only be as good – or as poor – as your experience of it on any single dive.

Additionally, dive sites vary considerably from season to season, from day to day and from tide to tide. It's worth remembering that those oft-cited twin hallmarks of a "great" dive site – excellent underwater visibility and intense biological activity – are both variables, not constants. Coral reefs are highly dynamic systems; take each dive as it comes and make the most of it, no matter where you are on the Great Barrier Reef.

I'm always amused by the reactions of people when they surface after their first scuba dive, sporting ear-wide grins as the effusive adjectives flow: "Fantastic!", "Amazing!", "Incredible!" I know how they feel. Almost 40 years and perhaps 4000 dives after my first, I've never become cynical; I still love scuba diving as much as ever. You stand on the dive platform of the boat, weighed down with 30 kg of gear, cumbersome and sweaty – then you step off into the water. In an instant the sensation of weightlessness takes over, the bubbles of your entry disperse and the underwater panorama opens before you. Suddenly all the underwater movies and photographs you ever saw pale in comparison to the real thing.

Almost anyone can scuba dive on the GBR; no previous experience is necessary. The only requirements are to be reasonably fit and aged between 12 and 70. Virtually all the dive resorts and the popular day-cruise boats offer either "resort" scuba courses or introductory scuba dives to view the coral.

The former involves up to an hour of theory with a dive instructor, followed by underwater familiarisation with the equipment – usually in shallow water near the boat – and finally an open-water dive under the close supervision of the instructor. This can be undertaken in a single day. The introductory scuba dive – very popular at GBR pontoons – gets you under the water in short order. It involves a safe minimum of instruction in equipment use and the physiological aspects of diving before you're grouped with

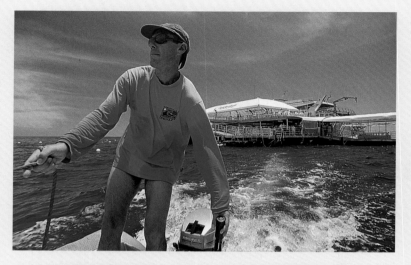

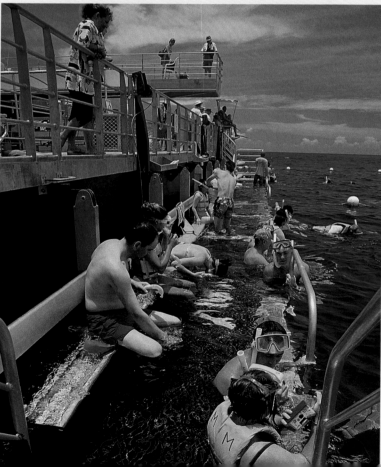

REEF PONTOONS

The first GBR tourist pontoon was established at Agincourt Reefs, north-east of Port Douglas, in 1984. There are currently 13 pontoons on the reef, ranging in size from 15–20 sq. m transhipping platforms to the largest GBR pontoon, the 1150 sq. m Agincourt Reefs platform.

The majority of reef pontoons are in the "larger" range, averaging around 800 sq. m in area. They incorporate features such as permanent roofs offering full weather protection, built-in underwater observatories, bench-type aluminium tables and seats for dining, and entry and exit facilities for both scuba divers and snorkellers. They also serve as berths for their own snorkelling and dive boats and semi-submersible coral-viewing vessels.

All pontoons in the GBR Marine Park require a marine park permit. Environmental factors considered before a permit is issued include the possible impact on the reef of snorkelling, diving, anchors and chains; the change in balance of fish communities; water-quality changes; increased nutrient levels from fish feeding and seabird droppings and aesthetic impact. Understandably, the pontoons must also be able to withstand severe weather conditions, by regulation defined as a category 4 cyclone.

Mike Burgess, managing director of Agincourt Reefs pontoon operator Quicksilver Connections, explained that operators used the same sites for many years, enabling them to maintain long-term best environmental practices.

"For example, one of our Agincourt pontoons has been there for around 14 years and in this time more than a million people would have visited it," Mike said "Our ongoing monitoring of this site indicates that the marine environment there is not only healthy, but positively flourishing, with the reef in growth mode," he said.

By GBRMPA regulations, the pontoons, their semi-submersibles and snorkelling and dive boats cannot be treated with antifouling agents. The pontoons and small craft are invariably made of marine-grade aluminium with stainless steel fittings, in order to reduce maintenance and the need for anticorrosive paints (although these aren't GBRMPA requirements). Likewise, the pontoons have no toilet facilities for day visitors; all human waste is stored in tanks on the large transfer vessels and taken back to the mainland for discharge into sewerage facilities.

Agincourt Reefs pontoon lifeguard Steve Davenport (top) patrols the perimeter of the snorkelling area, watchful for straying swimmers. Given the rich underwater scenery, it is easy for the many first-time visitors to the outer reef pontoons (left) to become totally absorbed while snorkelling and inadvertently drift away from the patrolled areas adjacent to the pontoon.

three or four other introductory divers and taken on a short underwater tour through the coral.

To attain full competency with scuba and be issued with internationally accepted dive certification – the so-called diver's C-card – involves a comprehensive course of theory and practical sessions for about five full days. Few people can afford the time out from their holidays to do this, though the resort course or introductory dive often whets their appetites and they vow to do the full course as soon as they get home. Those certified divers who opt for a serious GBR dive holiday will likely choose the live-aboard dive boats. Live-aboard cruises range from two to seven days, offering up to four dives a day including night dives. It's a somewhat energetic schedule and you do have to be physically fit to get the most from one of these cruises.

You don't need any of your own equipment for a GBR diving holiday. In fact, given airline baggage limitations, it's more convenient for intending divers to hire equipment from dive operators for a nominal charge. Air tanks and weight belts are always provided as part of the dive fees. If you prefer to use your own gear, be

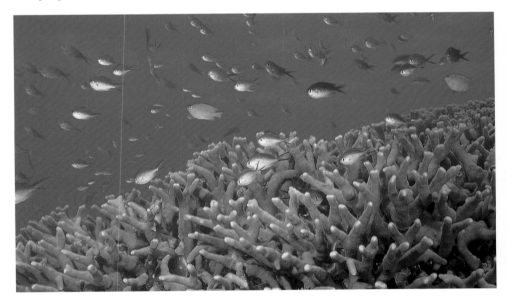

Silhouetted snorkellers, ferried to the outer reef by a cruise-boat tender, have a good all-over view of the reefscape from the surface (right), while scuba divers are able to appreciate the minutiae of reef life from a submarine perspective – such as these schooling damselfish (above) hovering over a grove of staghorn coral.

Accustomed to frequent contact with humans, inquisitive fish, such this long-nosed emperor (below) checking out diver Ian Kirton, make very obliging photographic subjects. Popular "still-life" photographic subjects on the reef include this close-up of a giant clam mantle and siphon (opposite top left); polyps of tern fern coral – one of the soft corals (opposite bottom left); and the vibrant colours of the arms of a crinoid, encompassing a featherduster worm (opposite right).

UNDERWATER PHOTOGRAPHY

People often comment on the large (and heavy) camera housing that I use for underwater photography, with its waterproof strobes on articulated arms. Serious underwater photography is a very complex craft. It takes a lot of practice, loads of patience and the equipment is very expensive.

If you're no expert but would like a personal record of your GBR diving holiday, a disposable underwater camera of the sort widely available at the major dive resorts and on the larger day-cruise vessels will do nicely. These cheap, simple-to-use cameras produce quite good results – certainly enough for the family album or to impress friends with your underwater exploits.

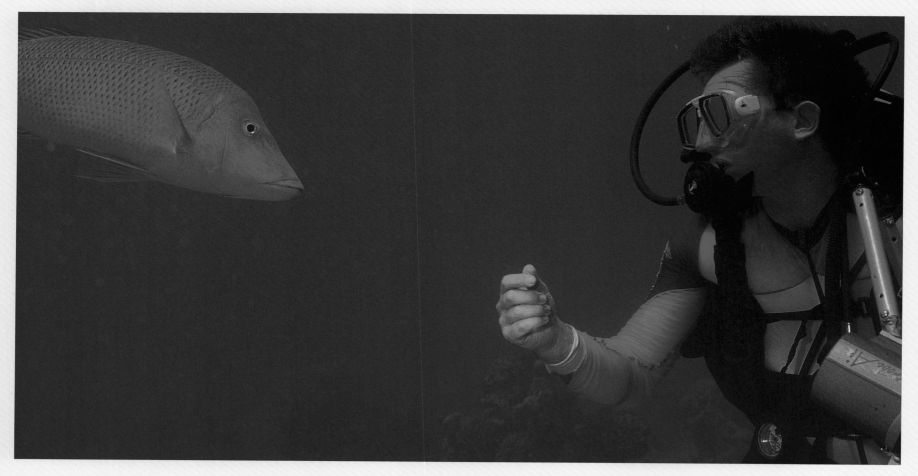

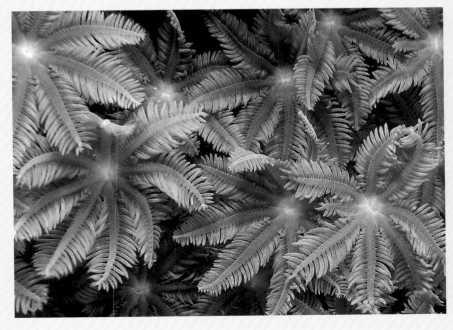

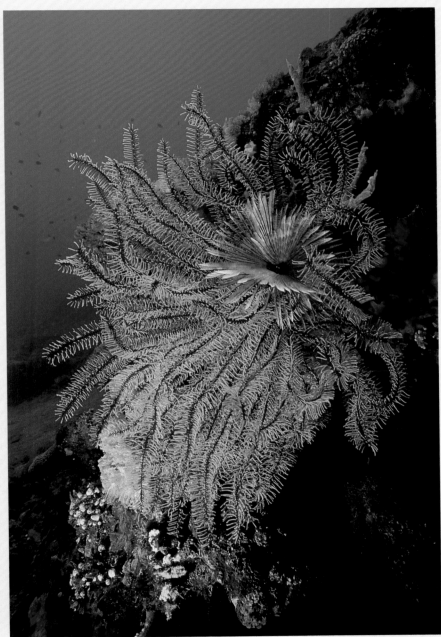

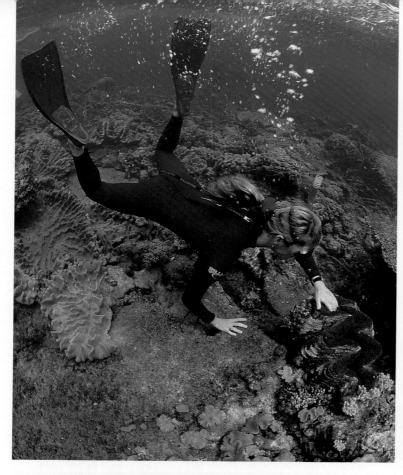

aware that current Queensland recreational diving regulations require you to have (in addition to a face mask, snorkel and fins): a regulator with an air-tank-contents gauge; an alternative air supply, most commonly in the form of an additional second stage on your regulator, termed an "octopus"; a buoyancy control device with a power inflator; a depth gauge; and an underwater watch for timing the dive. A submersible dive computer usually replaces the latter two items these days.

Some operators will ask you to prove your previous dive experience in the form of an approved dive log book. Dive operators will also provide wetsuits if you require them. Wetsuits with short arms and legs are adequate for most of the year, particularly in the northern parts of the reef. In the southern areas, full wetsuits are usually recommended in the winter months. A lycra body suit is also a good choice to bring with you; it prevents minor coral scratches and stings, as well as sunburn, and you can wear it under a wetsuit.

Scuba diving and snorkelling, while fantastic experiences, do carry elements of risk, and an increasing range of rules and regulations have been introduced (although among experienced divers there seems to be a consensus that over-regulating diving is by no means a good thing). The dive crews on all the large day boats conduct very thorough safety demonstrations before anyone is allowed to enter the water, and you are well advised to pay close attention.

Dive guide Tanya Martin inspects a giant clam on the fringing reef at the Frankland Islands, south of Cairns (top), while Heron Island Resort dive instructor Diana Doreian carefully shepherds a venomous lionfish into view for diving tourists (bottom). At the Agincourt Reefs pontoon, dive instructor Steve Anthony carefully strokes a resident humphead Maori wrasse (opposite) – to the delight of his group of introductory divers. Although it is recommended that marine life not be handled by visiting divers and snorkellers, professional people working on the GBR are trained in the right techniques as far as interaction with coral reef animals – which may include touching – is concerned. Such controlled contact with these animals does not cause them stress and, for GBR visitors, often represents the highlight of their reef experience.

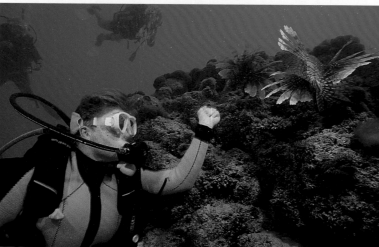

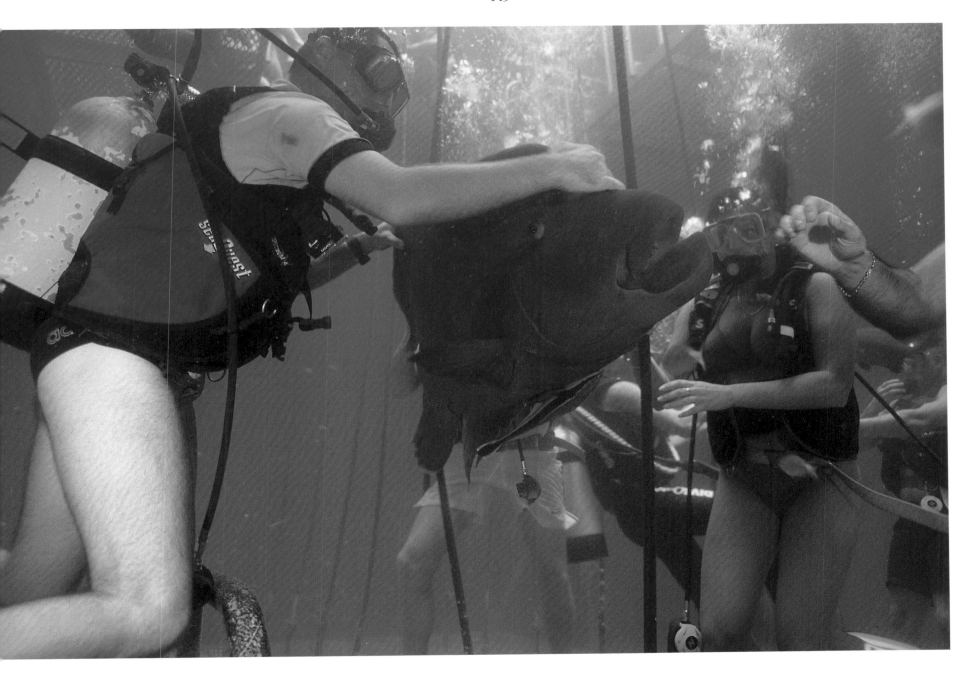

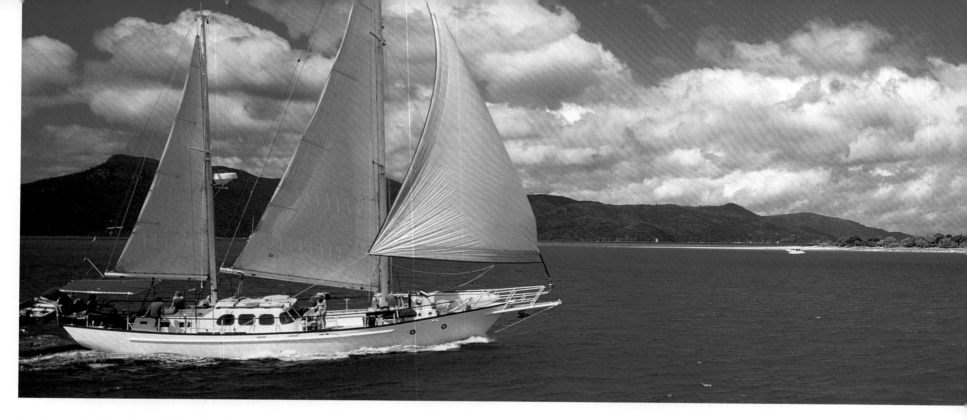

It's often said that the Whitsundays are among the best cruising grounds in the world. The relative isolation and the magnificent panoramic vistas of the group, whether viewed from sea level (above) or from the air (opposite), invariably enchant visitors to this region of the Great Barrier Reef. The cost of aerial tours through the GBR varies from around $100 for a 10-minute scenic helicopter flight from the reef pontoons, to several hundred dollars for lengthy flights of one or two hours duration. As they usually carry more passengers and have cheaper operational costs, fixed-wing aircraft flights are generally not as expensive as their helicopter equivalent.

Bareboating on the Great Barrier Reef

One tends to think of GBR waters – sheltered as they are by the outer reefs – as persistently tranquil. But from March to November, when the south-east trade winds blow, very choppy seas up to 3 m are often whipped up within reef waters and safe anchorages are few and far between. This is not to say that you can't have an enjoyable and safe cruising holiday on the reef, but to do so you need to charter a yacht in the undisputed capital of bareboating on the Great Barrier Reef – the Whitsunday Islands.

Bareboaters Gavin Kramer and Emma Dantzic were just tying up their yacht to the fuel dock at Abel Point when I arrived. I introduced myself and climbed aboard. "I'm into cruising yachts so I knew all about sailing in the Whitsundays," Gavin told me as we motored around to the Abel Point Marina after refuelling. "I looked on the Internet for information on bareboat charters in the Whitsundays, emailed a bunch of the operators asking for their brochures and decided on which company to go with."

At the marina, I stopped by the offices of Queensland Yacht Charters for coffee with owner Adrian Pelt. "Chartering a bareboat is basically like hiring a car," Adrian told me. "We provide only the boat, no crew – though we usually provision it, unless the clients want to shop for themselves." Adrian advises his clients that supplies can be topped up at many of the islands.

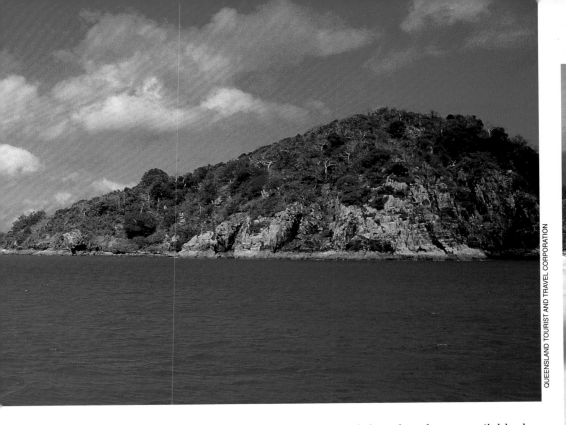

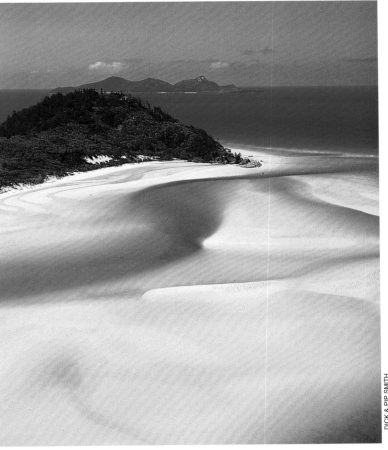

"Most of the resorts have good bakeries so fresh bread is always available, but for more variety, you can buy fresh food at Hamilton," he told me, adding that boats' freshwater tanks can be filled at Hayman Island. "People don't realise how quickly they can go through fresh water on a boat."

There are around a dozen companies in the Whitsundays operating about 240 boats, old and new, between them, and they all have their own view of the experience required by prospective bareboat sailors. Some will hire to raw beginners. Adrian said that his company's policy was never to hire a boat to a complete novice. "We insist that they have some experience – even if it's marginal – be it in dinghies, Hobie Cats or whatever."

Adrian explained that all his potential clients were taken for a supervised cruise before heading out by themselves. "Maybe for an hour or so," he said. "It's not a sailing lesson; we just want to demonstrate the workings of that particular boat and judge how capable they are at handling it." In a party of four or five there might be only one who has any sailing experience. What's important, as Adrian explained, is that person's expectations of the others, and how he or she communicates with them. Adrian said if it's apparent that a group isn't up to the task they can hire a skipper, though this costs around $150 a day.

I'd assumed that the bareboat industry was centred around sailing yachts, but Adrian corrected me: "I'd say we hire power boats to sail on about a 60:40 ratio."

FEELING QUEASY?

The peak GBR visitor season (May–August) is also the time of the south-east trade winds, which can make seas within the reef quite rough. People prone to seasickness should therefore take preventative measures before open-sea travel. The day before going out you should avoid alcohol and fatty, spicy or unfamiliar food. Pharmacies sell a variety of anti-nausea preparations, but some may cause drowsiness. Consider using a natural product, such as ginger tablets. If you're planning to dive, you should only take a natural product. Ginger tablets are provided on all the day cruise and live-aboard boats.

Adrian Pelt of Queensland Yacht Charters has the following advice on Whitsunday destinations for bareboaters (left): "Don't miss out on the top end of Hook Island and don't miss out on Whitehaven; these two places are absolutely beautiful and can give you the best idea of what the Whitsundays are all about." Adrian also recommends calling up one of the seaplane operators. "They'll land behind your boat and take you out to the reef for sightseeing and snorkelling. You can rendezvous with the dive boats too; they'll come by and pick you up for a day's diving on the outer reefs." At Abel Point Marina (insets, opposite) in the Whitsundays, Gavin Kramer and Emma Danzig return with their bareboat after a 5-day cruise. The background picture depicts the calm waters off Lizard Island, which provide safe anchorages for various craft.

QUEENSLAND TOURIST AND TRAVEL CORPORATION

He explained how unskilled sailors found it much easier to drive a boat than sail one. "But there is a cost factor to consider," he said. "The wind is free, fuel isn't."

Most people take 5–7 days to cruise the Whitsundays, taking advantage of the many uninhabited islands dotted throughout this glorious expanse of water. But there is an increasing demand for the "backpacker style" of bareboating where a group of 20 or so hire one of the larger boats for a two-day sailing party. "A couple of outfits here in the Whitsundays have focused entirely on the backpacker market and it's been hugely successful for them," Adrian told me. "For backpackers, this sort of cruise is right up there in the top 10 things to do in this country," he said.

Whitsunday bareboats are not permitted to travel to the outer reef; their cruising range is limited strictly to sheltered island waters. Detailed maps and brochures are provided, which indicate the cruising limits, safe anchorages and possible hazards as well as the GBR Marine Park regulations. "Everything is weather dependent; you've got to take every day as it comes," Adrian told me. "You wake up, look at the weather, check your map and decide where you're going that day."

Gavin had told me how each evening they'd anchored in a sheltered inlet, "and that was it, we had a bed for the night". And the nights were as good as the days, he said. "Just relaxing under the stars, it was beautiful." When I asked Emma how she'd taken to sailing, her reply was unhesitating. "I just loved it! I'd never been on a boat before – except for a cruise on a ferry down the Nile," she told me with a grin. "I still don't know what all these ropes and things do; I just did as I was told." She laughed at Gavin, adding, "The whole week's been brilliant, absolutely brilliant. It beats the Nile any day."

A sightseeing helicopter tour in the Whitsundays can land you on the secluded expanse of Whitehaven Beach (below). Above Hardy Reef (opposite), a floatplane appears as a toy against the immensity of the reef. Some of the most easily accessible areas of the reef for aerial sightseeing include the helicopter transfer flight between Gladstone and Heron Island; the Whitsunday Islands and their offshore reefs; Arlington, Norman and Moore reefs off Cairns, and the Agincourt Reefs off Port Douglas. Scenic helicopter flights are on daily offer at the pontoons on these latter three reefs. The round-trip aerial tour from Cairns to Cape Tribulation and the outer GBR will give you an excellent overview of both the coastal and offshore regions, while the flight between Cairns and Lizard Island offers excellent views of both the inshore reefs and the outer Ribbon Reefs.

Flying over the Great Barrier Reef

To truly *see* the GBR you have to fly over it, so consider taking one of the many aerial sightseeing tours that are on offer in most of the coastal cities, many of the island resorts and from some outer-reef pontoons.

The sight of the reef during a low-altitude flight is stunning; it's an experience that shouldn't be missed. Marine biologist Dr Walter Starck, who has studied the GBR for the better part of two decades, flew his own ultralight floatplane for many years as part of his research, but never lost his sense of wonder over the experience.

"It's incredible as you break free of the surface and start to lift," Walter told me. "At once you're looking down on a vast area, an absolute immensity of reefs; stretching off beyond the horizon to the north and south. And the colours – every shade of blue that you can possibly imagine. Because it's transmitted light reflected off the sand bottom and passing upward through the water, it has that beautiful luminous quality to it.

"One of the most inspiring things to me is when you look down on one of those pinnacle bommies that are scattered everywhere behind the outer reef and it's just a little spot of brown. But when you consider the reality of that little brown spot, having dived on it, you know it's actually a tower 30 m tall, sheer walled and totally enveloped in life. And you know that you could spend a lifetime just investigating that one pinnacle and never learn everything there is to know about it. That brings home to you the immensity of the Great Barrier Reef. It really is awesome."

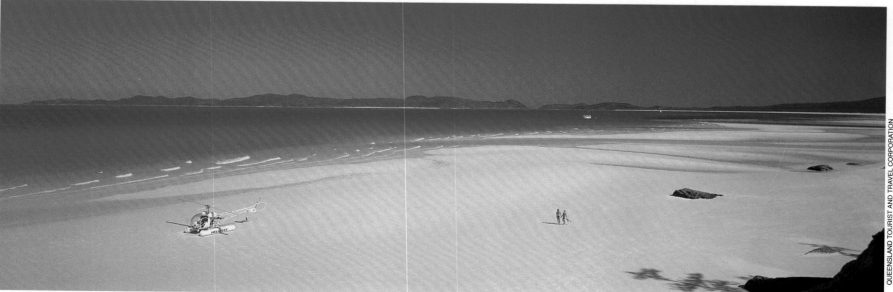

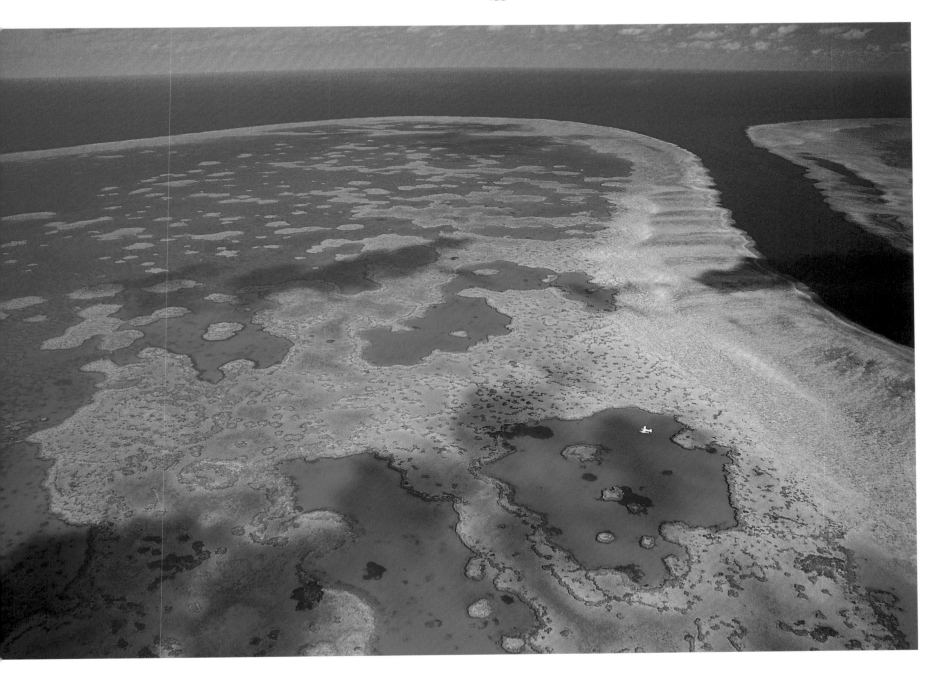

*At the Agincourt Reef pontoon (above), passengers are assisted
into the helicopter for a 10-minute aerial tour by Tom Cleator,
one of the operator's ground staff. These relatively inexpensive
low-altitude flights are very popular with day visitors to the reef
pontoons in the Cairns–Port Douglas region.*

Bundaberg District Tourism and Development Board Ltd
271 Bourbong Street
Bundaberg, Qld 4670
Mail: PO Box 930
Bundaberg
Qld 4670
☎ 07 4152 2333; Freecall 1800 060 499;
Fax 07 4153 1444;
email: bundytour@interworx.com.au;
http://www.sunzine.net/bundaberg

Capricorn Tourism
Capricorn Information Centre
'The Spire'
Gladstone Road
Rockhampton
Qld 4700
Mail: PO Box 1313
Rockhampton
Qld 4700
☎ 07 4927 2055; Fax 07 4922 2605;
email: captour@rocknet.net.au

Gladstone Area Promotion & Development Ltd
Gladstone Marina Ferry Terminal
Bryan Jordan Drive
Gladstone
Qld 4680
☎ 07 4972 4000; Fax 07 4972 5006;
email: gapdl@intertain.com.au;
www.mainmark.com.au/information/gapd.htm

Mackay Tourism & Development Bureau Ltd
The Mill
320 Nebo Road
Mackay
Qld 4740

Mail: PO Box 5754
Mackay Mail Centre
Qld 4741
☎ 07 4952 2677; Fax 07 4952 2034;
email: info@mtdb.org.au

Tourism Tropical North Queensland
51 The Esplanade
Cairns
Qld 4870
Mail: PO Box 865
Cairns
Qld 4870
☎ 07 4031 7676; Fax 07 4051 0127;
email: information@tnq.org.au; www.tnq.org.au

Townsville Enterprise Ltd
Enterprise House
6 The Strand
Townsville
Qld 4810
Mail: PO Box 1043
Townsville
Qld 4810
☎ 07 4771 3061; Fax 07 4771 4361;
email: tel@tel.com.au; www.tel.com.au

Tourism Whitsundays
Level 2, Beach Plaza
The Esplanade
Airlie Beach
Qld 4802
Mail: PO Box 83
Airlie Beach
Qld 4802
☎ 07 4946 6673; Fax 07 4946 7387;
email: tw@whitsundayinformation.com.au

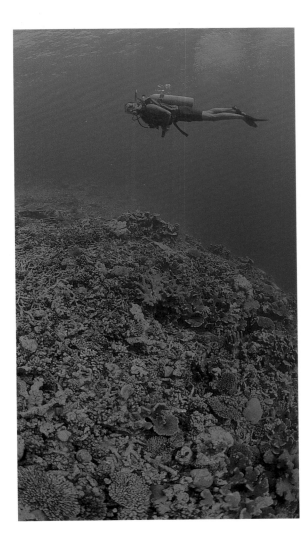

Against a backdrop of the richest blue, a diver (above) slowly fins over the corals on the reef crest after ascending from an underwater exploration of an outer reef face.

Index

Index